STUDIES IN MODERN ART 1

STUDIES IN MODERN ART 1

American Art
of the 1960s

THE MUSEUM OF MODERN ART

NEW YORK

Publication of *Studies in Modern Art* is funded for three years by a grant from the Andrew W. Mellon Foundation. Future issues will be supported in part by an endowment fund established by the Andrew W. Mellon Foundation, the Edward John Noble Foundation, and the National Endowment for the Humanities' Challenge Grant Program.

Produced by the Department of Publications
The Museum of Modern Art, New York
Osa Brown, Director of Publications

Edited by James Leggio and Susan Weiley
Design and typography by Michael Hentges
Production by Vicki Drake
Printing and color separations by Princeton Polychrome Press, Princeton, New Jersey
Bound by The Riverside Group, Rochester, New York

Published annually by The Museum of Modern Art,
11 West 53 Street, New York, New York 10019

Hardcover edition distributed in the United States and Canada
by Harry N. Abrams, Inc., New York, A Times Mirror Company

Hardcover edition distributed outside the United States and Canada
by Thames and Hudson Ltd., London

Cover: Carl Andre. *144 Lead Square* (detail of fig. 10, p. 27)

Contents

Foreword

In early 1989, Neil L. Rudenstine, then the Executive Vice President of the Andrew W. Mellon Foundation, discussed with me and other museum colleagues a grant program the Foundation was developing. Visionary in scope, it was intended to reinvigorate scholarly interest in the permanent collections of museums, a sadly neglected area of study in recent decades. At the same time, the program was to be based on a pragmatic recognition that the day-to-day administrative duties of museum work often make it difficult for curators and other museum professionals to find time to undertake research or to write. This initiative was most welcome and opportune, not only at The Museum of Modern Art, but in the museum community at large. With the sharply rising costs of large-scale loan exhibitions, and the investment of staff hours they also require, museums across the country have been seeking effective ways to devote more of their resources to the study and exposition of their permanent holdings. The Mellon Foundation's initiative helps to meet this need by establishing grants for programs — each tailored to the individual needs of participating institutions — that allow staff to spend more of their time on collection-related activities, the work for which they have been trained and have primary responsibility.

After much deliberation within the Museum regarding how such a project might best be structured at this institution, it was decided to establish the Research and Scholarly Publications Program, which, as one of its principal endeavors, would publish a scholarly journal, *Studies in Modern Art*. This journal, the chief means through which the fruits of the program's research are to be published, is presently the only scholarly, noncommercial journal dedicated to modern and contemporary art. Each issue is expected to focus on a selected topic: in the case of this inaugural issue, American art of the 1960s. Staff members from all six curatorial departments, as well as from Conservation, the Library, the Archives, Education, Exhibitions, and administrative departments, are encouraged to contribute to the journal; when appropriate, distinguished outside scholars are also invited to participate.

Staff contributors have available to them various kinds of research support, such as travel funds, research assistance, and time away from their

regular duties to concentrate on scholarly pursuits. Such active and pragmatic encouragement of research and publishing by museum staff is rare in the field and firmly reinforces the Museum's longstanding commitment to art scholarship.

John Elderfield, Director of the Department of Drawings and Curator in the Department of Painting and Sculpture, has assumed the burden of the program's administrative responsibilities and acts as Editor of *Studies in Modern Art*. With his customary diplomacy and his critical intelligence, he has guided the project through its formative stages to this, its first tangible result. He has been ably assisted in the day-to-day work on the journal by Joseph Ruzicka, Research Coordinator of the project, and James Leggio, Editor in the Department of Publications. These three, along with John Szarkowski, Director of the Department of Photography until his retirement in 1991, and Kirk Varnedoe, Director of the Department of Painting and Sculpture, constituted the Editorial Committee for this issue and were primarily responsible for developing its contents. In addition, an Advisory Committee addressed the Museum-wide questions that a project of this scope inevitably raised. The Advisory Committee is composed principally of the directors of Museum departments; besides those already named it includes: Mary Lea Bandy, Director of the Department of Film; Osa Brown, Director of the Department of Publications; Riva Castleman, Director of the Department of Prints and Illustrated Books, and Deputy Director for Curatorial Affairs; Antoinette King, Director of the Department of Conservation; Richard L. Palmer, Coordinator of the Exhibition Program; Clive Phillpot, Director of the Library; Waldo Rasmussen, Director of the International Program; Beverly M. Wolff, Secretary and General Counsel; Stuart Wrede, Director of the Department of Architecture and Design; and Philip Yenawine, Director of the Department of Education. Many other individuals in various departments of the Museum have generously contributed time and thought to aspects of the program. Indeed, one of the emerging benefits of the journal is the fostering of greater collaboration and cooperation among departments of the Museum, expanding opportunities for intellectual exchange.

Establishing a strong financial base for a program of this magnitude required very generous support from several sources, to whom we are deeply grateful. The Andrew W. Mellon Foundation's initial grant was intended to cover costs of the program for its first three years, and, with typical foresight, the Foundation also established a challenge grant toward an endowment to support the project in subsequent years. The Edward John Noble Foundation, which has a distinguished record of furthering art education and scholarship, responded to the Mellon Foundation's challenge by making an equally substantial gift. The National Endowment for the Humanities also recognized the important purposes of this program and awarded a major

grant, which is most appreciated. Such strong support for the research pro-
gram before the appearance of the first issue of *Studies in Modern Art* has
been enormously encouraging, and reflects the confidence inspired by the
Museum's continuing dedication to the highest standards of art-historical
scholarship.

In conclusion, I should like to express my special thanks to the
Andrew W. Mellon Foundation, to its President and trustees, to its knowl-
edgeable staff, and to Neil Rudenstine, for their sensitivity to changing needs
in the museum profession and their concern to address them imaginatively. I
also wish to note again the gratitude and admiration due John Elderfield. It
is his good judgment, connoisseurship, and full commitment, despite many
other demands on his time, which have shaped and guided this program and
given it every prospect of a productive future.

Richard E. Oldenburg
Director
The Museum of Modern Art

Preface

Studies in Modern Art is the creation of two convergent motivations, one longstanding and one immediate. For many years, a consensus had been developing at The Museum of Modern Art that a vehicle should be found to foster scholarship and publication based on the extraordinary riches of our collection as well as on the individual research interests of the Museum's curators and other members of its staff. Such scholarship and publication took place, but not as consistently as we wished, in part owing to the demands and enforced deadlines of loan exhibitions, and in part because there was no formally established program to encourage it. The recent offer of support from the Andrew W. Mellon Foundation, subsequently complemented by the Edward John Noble Foundation and the National Endowment for the Humanities, helped us to clarify and to consolidate our ideas for enhancing scholarly work at the Museum. This publication is the first result.

In the earlier history of the Museum, for some thirty years, from 1933 through 1963, there was a publication titled *Bulletin of The Museum of Modern Art* which, among its other functions, presented articles about works in the collection. However, it eventually began to serve as a surrogate exhibition catalogue and as a very inadequate vehicle for introducing recent acquisitions. Over the years, its frequency declined from a thriving nine issues per year to a sluggish three. Its informational functions have now been taken over by a calendar of events and by the quarterly, *MoMA*, distributed by the Museum to its members.

While the *Bulletin* was declining, a proposal was made by the Museum's Publications Committee that there be issued a regular "journal of criticism and commentary on all of the arts represented in the Museum's program" that would become "a forum for the objective discussion of ideas closely associated with the Museum's activities, as well as for marginal material of special interest." It would contain articles mainly by staff members but also by outside contributors and "would apply professional standards of criticism and scholarship to the arts of the twentieth century."[1] Nothing came of the idea. The Museum's short-lived International Study Center, which in the years around 1970 gave visiting scholars special access to our research facili-

ties, was an inspired way of facilitating study of our collections and of twenti-
eth-century art in general as well as of encouraging intellectual interchange
between the Museum's curators and the broader scholarly community. It
anticipated some of the functions of our new Research and Scholarly
Publications Program, which issues *Studies in Modern Art*. Unfortunately, it
was ahead of its time and proved impossible to sustain.

In the absence of an established program or vehicle for research and
scholarly publications, these activities nevertheless have been pursued within
the individual Museum departments. From the detailed critical catalogues on
our important holdings of Matisse, Miró, and Picasso (with a volume on
Dubuffet to follow next) to a series of acclaimed books on the works of Atget
in our collection, and from the basic checklist catalogues issued or in prepara-
tion by a number of our departments to the publications that accompany
major groups of gifts or bequests or that record selected masterworks in vari-
ous mediums, we have been slowly advancing understanding of the works of
art in our care. Recently, the Museum's Archives were formally established to
provide a resource for scholarly research. These, together with the Museum's
Library and the records maintained by the curatorial and support depart-
ments, give us an extraordinary collection of primary and secondary refer-
ence material on this century's art.

And yet, much remains to be done. The essential aim of our new
Research and Scholarly Publications Program is to help to make research and
publication on works in the collection and on topics relating to it an integral
and feasible part of the duties of curators and other Museum professionals.
The majority by far of the research and writing undertaken at The Museum
of Modern Art is produced on the occasion of loan exhibitions and is devoted
largely to borrowed works. These exhibitions and their associated scholarship
do enlarge understanding of the Museum's collection; because they study sub-
jects that are inevitably represented in some way in the collection, they show
in depth what the collection shows in part. But direct focus on the collection
is still needed. The holdings of The Museum of Modern Art are widely
acknowledged to be without parallel, in both scope and importance, among
collections of modern art. However, as the Museum's first director, Alfred H.
Barr, Jr., observed as early as 1944, arguing for collections research, "Whether
the work of art subsequently lives or dies depends partly on its intrinsic quali-
ties, partly on the attention we are able to give it by our continued interest."[2]
Many are the works of art in the collection Barr founded that await the atten-
tion they deserve.

Studies in Modern Art thus seeks to sustain the Museum's collection:
by detailed study of individual works and groups of works; by broader exami-
nation of those works in a variety of contexts; from consideration of the
Museum's own programs and own history; through publication of documents
from the Museum's as yet nearly unexplored Archives; through recording lec-

ture series and symposia on themes related to the collection. At times, a volume will serve as the accompanying publication for an exhibition based exclusively or closely on the collection. At others, a volume will collect essays written after an important exhibition that contains at least a core of material from the Museum. But mainly, it will be independent of temporary exhibitions, seeking to attract scholarly attention to the collection of the Museum in its six curatorial departments — Painting and Sculpture, Drawings, Prints and Illustrated Books, Architecture and Design, Photography, and Film — by encouraging research from within these departments; from, additionally, the departments of Conservation and Education, the Museum's International and Exhibitions Programs, Library, Archives, and Administration; and from any scholar interested in the collection or programs of the Museum. We will be particularly interested in previously unexamined topics, whether in contemporary or earlier modern art, and in works of art to which little attention has been paid. But we will continue to revisit even the most celebrated of our holdings, for even they will be diminished unless renewed attention is devoted to them from time to time.

In founding *Studies in Modern Art*, it was our aim that each volume should have a unifying theme; this would help to focus research within the Museum and would result in a useful work of reference on that subject, and specifically on the Museum's response to it. But additionally, we decided that wherever possible the unifying theme of each volume would be developed to elicit potential contributions from all the curatorial and the support departments within the Museum. Thus, for example, examination of selected periods or movements of modern art, as well as important conceptual or technical ideas, could serve to bring together curators from different departments and other professionals to foster scholarly discussion. We do not preclude volumes on narrowly defined themes, among them themes that might appear to curb our ecumenicism. Indeed, we plan to produce volumes even on individual works of art, viewing projects of this kind as another way of enlarging our scholarly forum by opening it to specialists outside the Museum. Our wish to create new contacts and collaborations between the Museum and the broader scholarly community is such that we will welcome external as well as internal proposals for contributions at any time. As a matter of principle we intend, wherever possible, to publish at least one distinguished contribution from outside the Museum in each volume. But the more specialized the volume, the more we will depend on the good will of our colleagues in the art-historical community at large.

The first issue of our publication is devoted to American art of the 1960s. It addresses a very broad range of topics in this area, from a neglected film and a surprising exhibition to a renowned series of prints and a most influential painter. It does not pretend to cover comprehensively the art of this decade or

the Museum's response to it. I doubt if any single volume could. In any case, comprehensiveness is not the aim of our publication. Its aim, rather, is to present original research and insightful writing, most of it by members of the Museum's staff, on illuminating topics within its chosen area. We believe that each of the contributions to this volume offers new understanding of its subject. We hope that together, with their varied interests and through their different voices, they will afford a sense of the diversity and richness of a fascinating decade.

We chose American art of the 1960s as the focus of this issue because it was the kind of subject that could encourage the interest of a broad range of contributions, and we are pleased that this has proven to be the case. Our seven contributions are from six Museum staff members, each from a different department, and one outside scholar. But we also chose this subject for other reasons: most important, that our collection has an abundance of works from this decade and the quality of many of them is high. Additionally, however, this decade seemed simply most requiring of attention in this first issue. The period of the 1960s was crucial in the creation of art in America as it appears today. The period was also crucial in the Museum's own history; during the 1960s, it now seems, took place the most important of the changes that transformed it from the institution founded in 1929 to the one that exists today. This period of transition is still in the process of both critical and creative reassessment, attracting keen interest both from historians and critics and from younger artists. Yet it is about to settle into history; the Museum has just dedicated permanent gallery spaces to this period for the first time. Therefore, now is the moment to offer this reconsideration of the 1960s, and to hope that further and more far-reaching reconsideration will follow.

There was a final reason for choosing this subject: we wished to signal our determination to extend the Museum's existing record of scholarship, which has tended to focus on earlier periods, into more recent art. It used to be said there was a moment at which the work of the critic gave way to, or made room for, the work of the historian. The concurrent development of the discipline of art history and of modern art itself has meant that the latter is delivered into the waiting arms of the former; modern art is more immediately lodged in history than any earlier art has been. And yet, as before, the historical understanding of art does not come immediately with it, but requires the distance that scholarship, more even than time, provides. We will encourage such art-historical scholarship for recent as well as for more distant art, and not only for the sake of purely historical understanding but also because it can foster critical understanding at the same time. Immunity from critical assessment may be sought in historical study. But so may more balanced critical assessment than practical criticism allows.

A range of approaches across these options characterizes the contributions to the present volume, which additionally roam widely and with vary-

ing degrees of specificity around its chosen theme, some managing to interconnect with each other just the same. Lynn Zelevansky argues that the work of Ad Reinhardt, by its suppression of the act of marking the surface and its reductionist approach to composition and color, is a crucial bridge between Abstract Expressionism and Minimalism. That same transition is very differently explored in my own study, developed around the Museum's Turner exhibition of 1966, of how changing attitudes toward earlier painting on the part of artists and critics in the 1960s informed and were informed by their attitudes toward contemporary painting. And it opens the article by Rosalind Krauss, the invited contributor from outside the Museum, who examines the sharply differing attitudes toward the physicality of art objects in Minimalism and in California light-and-space art.

Unfamiliar works by well-known artists are the subjects of two articles. Charles Silver reassesses Elia Kazan's neglected masterpiece, *Wild River* of 1960, viewing this lyrical romance, set in the New Deal era, as a rare example of an American film seriously confronting issues of social and political change. And Joseph Ruzicka traces Jim Dine's work in the performing arts from his Happenings of the earlier 1960s through his 1967–68 adaptation of Oscar Wilde's *The Picture of Dorian Gray*, intended for the London stage, considering his drawings and designs in the Museum's collection. The working proofs for Jasper Johns's 1964 lithograph *Ale Cans* are the principal subject of Wendy Weitman's article. She deciphers the artist's transformations of his sculpture *Painted Bronze* into two-dimensional images. And aspects of the 1960s are summarized and placed in historical context in the remaining contribution. Stuart Wrede interviews Robert Venturi about the genesis and the impact of Mr. Venturi's influential book *Complexity and Contradiction in Architecture*. Published by the Museum in 1966, it helped to usher in what became known as postmodernism.

Many people were involved in the deliberations that led to the Research and Scholarly Publications Program. The endeavor was initiated by Richard E. Oldenburg, Director of The Museum of Modern Art, whose enthusiasm for and support of this program have been vital. All of the Museum's curatorial department heads played an active role in determining the scope of the program. Additionally, they agreed to serve with other, noncuratorial department heads, on its Advisory Committee. All the members of the committee are named in the Director's Foreword; I thank them most sincerely for their counsel and their encouragement. The Museum's Deputy Director for Development and Public Affairs, Sue B. Dorn, and its Director of Development, Daniel Vecchitto, were indispensable to the foundation of the program; Osa Brown, Director of Publications, to the realization of the publication.

To my colleagues on the Editorial Committee go my particular thanks. Joseph Ruzicka, Research Coordinator of the project, and James

Leggio, Editor in the Department of Publications, are with me its permanent members and have been deeply involved not only with the production of this volume but with establishing the very nature of the research program and the format of the publication itself. The two other members of the Editorial Committee are appointed specifically for a particular issue of the publication. John Szarkowski, Director of the Department of Photography until his retirement in 1991, and Kirk Varnedoe, Director of the Department of Painting and Sculpture, generously found the time to serve for this first and consequently very demanding issue. Thanks are owing also to Michael Hentges, the Museum's Director of Graphics, for working with us so assiduously and creatively on the design of the publication; to Vicki Drake, for overseeing its production and printing; to Susan Weiley, for her editorial participation; to Catherine Truman, for her secretarial support; to Jennifer Hersh, for her research assistance; and to Kevin Robbins, Assistant to the Director, Department of Drawings, for assuming the additional duties my direction of this program entailed. We are deeply indebted to the anonymous outside readers who evaluated each contribution, often offering important criticism and advice. And of course, most important, we are indebted to the authors themselves; on their shoulders rests the responsibility for the success of this enterprise as a whole. We know that it is not easy for those with already busy schedules to undertake additional obligations of this kind. However, we know that the Museum's scholarly stature depends very crucially upon their willingness to do so. Publications remain after exhibitions disappear.

Finally, and of immediate relevance to this, we wish to remember on the present occasion a close friend of the Museum, Sir Lawrence Gowing, who contributed in 1966 the first of a series of brilliant essays for this museum's publications; who died as this volume was in preparation; and whose example is a beacon to us all.

<div align="right">

John Elderfield
Editor
Studies in Modern Art

</div>

Notes

1. "Subcommittee Report on the Proposed Journal of The Museum of Modern Art," unsigned and undated (late 1950s?). The Alfred H. Barr, Jr., Papers. Archives of The Museum of Modern Art.

2. "Research and Publications in Art Museums," transcript of a paper read at a conference on "The Future of the Art Museum as an Educational Institution," held in Chicago, March 24–25, 1944, published in *Museum News*, 23 (January 1, 1946), p. 8; reprinted in *Defining Modern Art: Selected Writings of Alfred H. Barr, Jr.*, ed. Irving Sandler and Amy Newman (New York: Harry N. Abrams, 1988), p. 209.

A Note to Contributors

Studies in Modern Art publishes scholarly articles focusing on works of art in the collection of The Museum of Modern Art and on topics related to the Museum's programs. It is issued annually, although additional special numbers may be published from time to time. Each number deals with a particular theme related to the Museum's collection or programs. A list of future topics may be obtained from the journal office.

Contributors should submit proposals to the Editorial Committee of the journal by February 1 of the year preceding publication. Proposals should include the title of the article; a 500-word description of the topic; a critical appraisal of the current state of scholarship on the subject; and a list of works in the Museum's collection or details of the Museum's program that will be discussed. A working draft of the article may be submitted as a proposal. The Editorial Committee will evaluate all proposals and invite selected authors to submit finished manuscripts. (Such an invitation does not constitute acceptance of the article for publication.) Authors of articles published in the journal receive an honorarium and complimentary copies of the issue.

Please address all inquiries to:

Studies in Modern Art
The Museum of Modern Art
11 West 53 Street
New York, New York 10019

Ad Reinhardt and the Younger Artists of the 1960s

Lynn Zelevansky

Ad Reinhardt's role in the development of American art of the 1960s has been both underestimated and overestimated, but it has never truly been examined in depth. An active if dissident member of the Abstract Expressionist circle, Reinhardt had subsequently followed a course independent of Abstract Expressionist concerns during the 1950s, with the result that, by the beginning of the sixties, his paintings appeared peripheral to mainstream art discourse. His work therefore received less attention than that of many of his New York School colleagues.[1] But as early as 1963 he was seen as a progenitor of what was soon to become known as Minimalism.[2] And by 1965 or 1966, Reinhardt's generative impact on it was touted to such an extent that even some sympathetic critics felt the need to counter this notion with a disclaimer, arguing that he had had no "direct" impact on the Minimalist aesthetic.[3]

The new "cool," "minimal," or "rejective" art — to cite just a few of its early names — had begun to emerge within the art world at the start of the 1960s. Although the artists involved did not share a body of beliefs or constitute a movement as such, they did share a disillusionment with what they saw as the emotional excesses of Abstract Expressionism. They sought an escape from the emphasis on subjective experience reflected in the theoretically "autobiographical," markedly painterly styles of the New York School, and deliberately downplayed the spiritual or psychological aspects of art. Focusing instead on the material qualities of the object, they favored reductive forms that they felt limited the possibilities for metaphorical interpretation.

Most frequently, these artists worked in three dimensions as a means of making the "concrete and literal" dominant in their work and avoiding the inherent illusionism of painting.[4] Donald Judd and Robert Morris are obvious examples of this approach, as is Robert Smithson, who, by the middle of the decade, had found in the regular, geometric structure of crystals a way of dealing with nature without the aid of biological metaphors.[5] Those who continued to paint, like Jo Baer, grappled with the medium's intransigent illusionism, generally opting for a smoother, relatively undifferentiated facture, less obviously indicative of a particular sensibility or temperament.[6] They often attempted to reduce the emotional thrust of color with palettes that

1. Ad Reinhardt. *Abstract Painting, 1957, 108 x 40"*. 1957. Oil on canvas, 9' x 40" (274.3 x 101.6 cm). The Museum of Modern Art, New York. Purchase

tended toward monochromy or, like Robert Mangold, by utilizing "generic or 'industrial' colors."[7] Artists such as Sol LeWitt and Carl Andre based their work on personal systems or guidelines that employed fundamental organizational elements like the grid and the module, frameworks that ensured a kind of objectivity in the final product. In camouflaging the individual brushstroke, or in having three-dimensional works manufactured by outside contractors, Jo Baer and Donald Judd downgraded the role of "touch," the significance of the artist's hand in the fabrication of the art work.

Although Reinhardt anticipated the Minimalist program more than any artist of his generation, he was not a Minimalist. His efforts to obliterate all extra-artistic meaning from his painting, as well as his use of rigorous geometry and standardized formats, did constitute a decisive break with Abstract Expressionism. But the poetry of his delicately nuanced surfaces and the contemplative character of his work tied it nonetheless to an earlier aesthetic, and were antithetical to the spirit of Minimalism.

Within the art world, a wider understanding of Reinhardt's contribution was almost certainly hampered by the fact that his painting was not classifiable within a category or movement then considered viable. It was probably also hindered by the artist's attempt, in what he termed his "ultimate" paintings of the 1960s, to achieve a kind of closure. The word "ultimate" would seem to refer to the last, or the most extreme, in a line. Though Reinhardt's use of the term was always ambivalent and satirical, critics and younger artists most often have interpreted him to mean that he was making the last paintings that could be made.[8] Reinhardt knew, of course, that this was not literally the case (his work did not herald the end of easel painting, even if, in the sixties and seventies, some thought this form was "dead"), but he does seem to have believed his work was the most extreme example of a particular tradition, that of purist abstract painting. If he was correct, then even in this second sense of "ultimate," his black squares should allow for no direct descendants.

Nonetheless, Reinhardt's art and ideas had a powerful impact on certain artists who, like Sol LeWitt and Carl Andre, were to become highly influential themselves. By adopting isolated formal and conceptual aspects of Reinhardt's work, rather than its look, these artists were able to pursue a variety of new directions.

The Black Square Paintings

By 1960, around the time the new generation began appearing on the New York scene, Ad Reinhardt had started to make the 60-by-60-inch "black" paintings that would occupy him almost exclusively until his death, in 1967. In 1952, he had begun making geometrically composed, symmetrical, monochrome paintings in either red or blue. In 1954, he reduced his palette to shades of black. With the further reduction of variables — the adoption,

in 1960, of the five-foot-square format, each painting divided into a nine-square grid — his painting entered its definitive phase.

Even in the early 1960s, when Abstract Expressionism still dominated the concerns of the contemporary art world, Reinhardt was not without partisans. Virginia Dwan, who offered him support at that time, remembers that he had a largely "underground" reputation.⁹ Dwan recalls first seeing Reinhardt's nine-foot black paintings (fig. 1) at the Betty Parsons Gallery in New York and, later, visiting the artist in his studio. Challenged and intrigued by the work, she mounted an exhibition of Reinhardt's paintings at her Los Angeles gallery in February 1962. The dealer's commitment to him was such that, when her gallery moved to a new Los Angeles location in 1963, she designed the space to accommodate his nine-foot verticals (she did not yet realize that his new works were limited to the five-foot-square format), and installed a narrow platform of white marble along the baseboard to keep visitors at a distance from the extremely fragile paintings, whose inscrutability seemed especially capable of provoking the public.¹⁰

Through her interest in Reinhardt, Dwan developed an appreciation of Minimalism, a movement with which she would become identified. In 1966, a year after she opened her New York gallery, she invited Reinhardt to assist her in curating an exhibition of the new art. Reinhardt asked Robert Morris and Dwan asked Robert Smithson to help with the effort. The mix of strong and contentious personalities resulted in an exhibition that was simply titled "10," and a catalogue without text.¹¹

Sol LeWitt confirms Dwan's sense of Reinhardt's importance in certain circles, recalling a keen interest in Reinhardt's art among LeWitt's friends and associates of the early 1960s. (LeWitt's circle at the time included Robert Smithson, Eva Hesse, Dan Flavin, Michael Kirby, Robert Ryman, and Lucy Lippard.)¹² For LeWitt, Reinhardt was in no sense marginal; on the contrary, he saw the older artist as "*the* important figure of the time," because he was making "the most radical art."¹³

Reinhardt's paintings were clearly important to LeWitt's artistic development. Affinities between the work of the two men were evident early in LeWitt's career in his use of a square support for his reliefs, as well as a nine-square grid for such works as *Red Square, White Letters* of 1962 (fig. 2). As LeWitt's art evolved, the cube assumed primary importance. *Cubic-Modular Wall Structure, Black* of 1966 (fig. 3), an open latticework wall relief, maintains its relation to Reinhardt's square paintings not only in its square format, its use of the grid (now expanded and in three dimensions), and the fact that it hangs on the wall, but also in its black color. Of course, the LeWitt differs from Reinhardt's paintings in essential ways which indicate important philosophical distinctions. *Cubic-Modular Wall Structure, Black* blurs the distinction between the art object, traditionally given paramount importance, and its more mundane surroundings, since the supporting wall, visible through

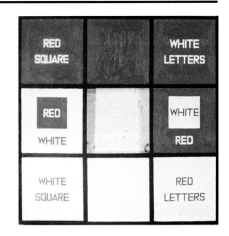

2. Sol LeWitt. *Red Square, White Letters*. 1962. Oil on canvas, 36 x 36″ (91.4 x 91.4 cm). Collection the artist

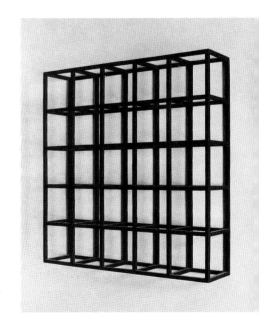

3. Sol LeWitt. *Cubic-Modular Wall Structure, Black*. 1966. Painted wood relief, 43 1/2 x 43 1/2 x 9 3/8″ (110.3 x 110.2 x 23.7 cm). The Museum of Modern Art, New York. Gift of Alicia Legg

every module, is in this way integrated into the relief. It seems reflective of a desire to "democratize" art.[14] In contrast, Reinhardt's black frames, which served to protect the paintings as the artist worked on them and afterwards,[15] isolate his art from its environment, an effect that speaks of his desire to retain art's traditionally separate, elevated position.[16]

Despite such differences, or perhaps as an expression of them, the use of the grid by both Reinhardt and LeWitt reflects a contradiction between the material and the intangible that is at the heart of their respective works. As Rosalind Krauss points out, the grid "maps the surface of the painting itself" and so is determinedly materialistic. Yet it is also meditative in its purity, in its suggestion of the infinite — it has the potential to extend unendingly in all directions — and in the possibility it poses for an almost maddening repetition of forms; for artists like Mondrian and Malevich, it is "a staircase to the universal." It embodies an ambivalence about its own "connection to matter on the one hand or spirit on the other."[17] While the message of those of Reinhardt's writings called "Art-as-Art Dogmas" is emphatically materialistic, insisting that all content be reduced to that which is contained in the physical properties of the object, paradoxically, the actual appearance of his dark paintings is highly suggestive, even quasi-mystical. For LeWitt, the conflict lies in the notion of art as pure concept, as opposed to the need to actualize the physical art work.[18] In addition, there is a further ambiguity, for the grid, which has associations with rationality and mathematical logic, also helps create an iconic, timeless, mystical presence in Reinhardt's paintings and imparts an obsessiveness to LeWitt's structures, even though both mysticism and obsessiveness connote the irrational.[19]

For both Reinhardt and LeWitt, the preplanning of an art work aided the effort to create "nonrelational" art,[20] and limit the parts played by subjectivity and chance. The notion of mental planning was important enough to both artists that each wrote in support of it: Reinhardt's dictum, "Everything, where to begin and where to end, should be worked out in the mind beforehand,"[21] is paralleled by LeWitt's statement, "Once the idea of the piece is established in the artist's mind and the final form is decided, the process is carried out blindly."[22]

Both artists have sometimes used schematic diagrams to record what was in significant part a conceptual plan. Reinhardt's sketches for his paintings existed only in his mind until after a canvas was completed. The relatively few diagrams he created appear to have been made after the art as a means of cataloguing his paintings, or of jogging his memory and assisting the restoration process, should conservation become necessary. LeWitt's plans made for his wall drawings, the first of which was realized in October 1968, evolved out of "after-the-fact" drawings of his three-dimensional structures, and at the same time as his drawings on paper, printed drawings, and books.[23] Although, like Reinhardt, he had made sketches based on already existent work, for the

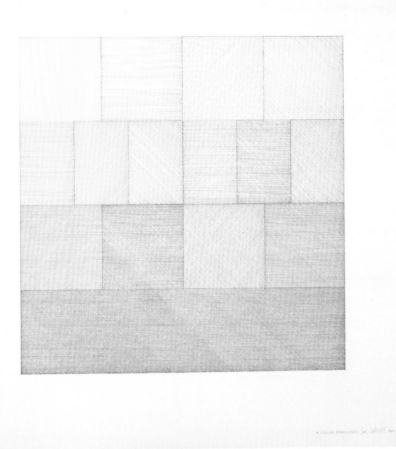

4. **Sol LeWitt.** *Four Color Drawing.* 1970. Ink on paper, 17 7/8 x 17 1/2" (45.4 x 44.5 cm). Private collection, Sweden

5. **Sol LeWitt.** *Four Color Drawing* (detail of fig. 4)

wall drawings LeWitt created diagrams in advance, as instructions to the team that would realize these large, two-dimensional, environmental pieces. Despite this difference in procedure, the artists' schematic designs are quite similar. Compare the sketch for LeWitt's *Four Color Drawing* of 1970 (figs. 4, 5) with a diagram appearing on the verso of one of Reinhardt's black square paintings (fig. 6).

Like the grid, with its associations with mathematical precision, the schematic plan, which systemized the creation of a work, was an excellent aid in the attempt to create what artists and critics in the 1960s often called an "absolute."[24] This intention was fundamental not only to Reinhardt's endeavor, but also to that of LeWitt and a number of his colleagues. LeWitt believes that, more than any other artist of his generation, Reinhardt's art embodied this ideal, which, though frequently mentioned by artists and writers during the period, seems generally to have remained undefined.[25] Clearly it suggests an art that is pure, unconditional, and self-contained, combining notions of completeness, perfection, and universality with an Eastern concept of the cosmic "void."[26] LeWitt's intention to create an "absolute," a universal, ideal art, is evidenced in the simple elegance of his modular geometric structures; in the "impersonal" execution of his early wall drawings, which could be realized in the absence of the artist; and in the elusive materiality of his skeletal lattice

6. **Detail of the verso of Ad Reinhardt's** *Abstract Painting, No. 5, 1962* (Tate Gallery, London) showing label with the artist's penciled diagram

structures, which seem to exist on an elevated, timeless plane, separate from quotidian concerns, like diagrams in the air. For Reinhardt, it was not only the uncompromising program of repeating the same motif over and over, or his ideological insistence on the primacy of the "art content" of art, that lent themselves to the concept of an "absolute"; it was his unremitting will to find and define, in the work itself, what he considered to be painting's essential components.

As Reinhardt tells us himself, the late square paintings, stripped down to eliminate all but the medium's most fundamental characteristics, are meant to be perfect in their neutrality:

A square (neutral, shapeless) canvas, five feet wide, five feet high, as high as a man, as wide as a man's outstretched arms (not large, not small, sizeless), trisected (no composition), one horizontal form negating one vertical form (formless, no top, no bottom, directionless), three (more or less) dark (lightless) no-contrasting (colorless) colors, brushwork brushed out to remove brushwork, a matte, flat, free-hand painted surface (glossless, textureless, non-linear, no hard-edge, no soft-edge) which does not reflect its surroundings — a pure, abstract, non-objective, timeless, spaceless, changeless, relationless, disinterested painting — an object that is self-conscious (no unconsciousness), ideal, transcendent, aware of no thing but art (absolutely no anti-art).[27]

Abstract Painting of 1963 (fig. 7), one of Reinhardt's 60-by-60-inch black squares, exemplifies the qualities the artist describes: its generalized blackness yields the image of a Greek cross only over time, as it gradually becomes possible to see that the painting's four corner squares are reddish-black, in contrast to the cross's bluish-black vertical and greenish-black horizontal bars.[28] The work's darkness barely admits the existence of an inner luminosity, which can be discerned at the edges of the cross, near the painting's center. The symmetrical format dispenses with the need for "composition" and reduces conventional pictorial space to almost nothing. Even at moments when the cross's vertical bar appears to be behind its horizontal bar, the distance between the two is no thicker than a paint layer. The surface is so unremittingly matte that, viewed from an angle, a thin layer of powder appears to cover the painting. Reinhardt leached most of the oil from his paint with turpentine, leaving only enough to bind the pigment, and then applied it in thin, even layers that camouflaged the individual brushstroke; the paint was as close as he could make it to pure pigment.[29] And, as noted before, the simple black frame on a work like *Abstract Painting*, which is slightly deeper than the canvas, renders it self-contained, sealed off from its environment. But perhaps the uncompromising nature of these works is best evidenced in the seemingly insurmountable challenge of reproducing them. Their subtleties are so extreme that, when the works are photographed, their distinguishing characteristics are almost always invisible, and they tend to read as uninfl-

ected black surfaces. Painting at its most essential, these works must be experienced directly, as they defy even the most rudimentary representation in any other visual medium.

In his published statements, lectures, and interviews, Reinhardt often exaggerated the characteristics of his painting, partly for satirical effect, since he was generally commenting on prevalent ideas about his art and art in general, but also in order to emphasize the radical nature of his goals. In so doing, he implicitly underscored the paradoxical nature of his enterprise, for his writings tended to present as absolute and unmitigated those very characteristics that remain most equivocal in his art. Indeed, the most dominant characteristic of the paintings is how they defy definition. Contrary to what Reinhardt wrote about the black squares, they were not "ultimate," since he in fact continued painting them; they are not really "black"; they are not "lightless" or "colorless"; they are not "formless"; and they are not "timeless," since they can be located at a specific moment within the development of a given tradition. In addition, in the passage quoted above, Reinhardt's use of metaphorical language, especially personification, for a work that is supposed to be "neutral" and without worldly associations, is particularly paradoxical. But contradiction and inconsistency stress the impossibility of perfection even as the artist strives for it, deepening rather than lessening the impact of the work.

Reinhardt was careful not to claim any sort of historical precedence in relation to Minimalism,[30] but he must have known that, in striving toward a reductionist kind of perfection (an "absolute"), he had struck a chord with the next generation. He was aware as well that, for many younger artists, the physical or optical effort required to actually "see" his paintings, as well as the effort necessary to draw meaning from them, were significant factors. Reinhardt said of the Minimalists, "They may be making large paintings, too large for museums. My making a painting that can't be seen may be like making a work too large to move in and out of places."[31] He was acknowledging a shared "resistance" to established and expected practice, accessibility, and acceptability. Like their art, his was "difficult," and carried with it a built-in test of the commitment of the audience.[32]

LeWitt says that, either consciously or unconsciously (he is unsure which), the idea of making the lines quite faint in his wall drawings originated with Reinhardt's difficult-to-see black squares. Tired of the bombast associated with Abstract Expressionism, even with work he respected — "You could see a Franz Kline painting from a half a mile away"[33] — he was searching for another model. In truth, a Reinhardt black square can be identified from the same distance as a Kline, and Abstract Expressionist paintings generally need to be approached and studied to be fully appreciated. Nevertheless, the extreme subtlety that is the essence of Reinhardt's art requires that viewers inspect his paintings especially closely in order even to discern their configu-

7. Ad Reinhardt. *Abstract Painting.* 1963.
Oil on canvas, 60 x 60" (152.4 x 152.4 cm).
The Museum of Modern Art, New York.
Gift of Mrs. Morton J. Hornick

rations. LeWitt took this idea a step further: from far away, a wall drawing like *Straight Lines in Four Directions Superimposed* of 1969 (fig. 8) does not even appear to be art. As with his first lattice sculptures, LeWitt's earliest wall drawings were monochrome black. This one is to be executed in graphite. Viewed from a distance, the light pencil marks meld with their environment, blending together to resemble a plain gray wall.

Like Reinhardt's *Abstract Painting*, LeWitt's *Straight Lines in Four Directions Superimposed* has a kind of reticence,[34] an immateriality, an almost phantom imagery. (The drawing is phantom-like in more ways than one, since it exists only as a set of instructions, except when it is installed, and is of varying dimensions, depending on the size of the wall used as a support.) It also makes use of an important aspect of Reinhardt's legacy, the idea of built-in "duration," born of the fact that it takes some minutes for the eye to attune itself to the blackness of one of the square paintings, to be able to actually "see" into it. As with the Reinhardt, one must not only physically approach *Straight Lines in Four Directions Superimposed,* but also spend time with it, in order to perceive its subtle geometry.

8. Sol LeWitt. *Straight Lines in Four Directions Superimposed.* 1969. (Vertical, horizontal, 45° diagonal left and right lines drawn as close together as possible, approximately 1/16" apart.) Graphite on white wall, size variable. The Museum of Modern Art, New York. Anonymous fund in honor of Mr. and Mrs. Alfred H. Barr, Jr. In foreground: Richard Serra, *Cutting Device: Base Plate Measure,* 1969 (The Museum of Modern Art, New York)

Like LeWitt, Carl Andre was intrigued by the outright effort required to perceive and understand Reinhardt's black paintings. In 1960, Andre lived with a black Reinhardt that was owned by Frank Stella, an experience that left its mark: "It was while trying to see Ad's black paintings that I fully realized that it requires work to see any work of art."[35] Andre states that Reinhardt was "quite an influence," and that it was through Reinhardt's black paintings that the idea came about of having the spectator work to "recover the nature of painting."[36]

Andre transformed Reinhardt's idea, making sculptures that are difficult to see not because they are almost imperceptible, but because they do not announce themselves as art: "I don't want to make works that hit you over the head or smash you in the eye. I like works that you can be in a room with and ignore when you want to ignore them."[37] The small sculpture *Timber Spindle Exercise* of 1964 (fig. 9), a simple form made of uncarved wood, which stands less than three feet high, is prosaic-looking and unobtrusive enough to be easily overlooked, not "seen" as art.

It is with the almost flat, metal floor pieces that Andre's extrapolation from Reinhardt's black squares can be most clearly understood. A work like *144 Lead Square* of 1969 (fig. 10) shares the predominance of the grid. It is intended, in its own way, to be as difficult to see as Reinhardt's *Abstract Painting*. Based on a square module, it contains 144 lead plates, each measuring approximately one foot square and three-eighths of an inch thick. The sculpture is meant to be walked on, and Andre has asserted that a spectator who traverses such a work might not even see it: "You can stand in the middle of it and you can look straight out and you can't see that piece of sculpture at all because the limit of your peripheral downward vision is beyond the edge of the sculpture."[38]

Andre's *144 Lead Square* also shares with Reinhardt's *Abstract Painting* a simple title, descriptive of the work's most basic characteristics. Reinhardt usually titled his works on the verso, often placing the year of the painting's execution, and even its size, within quotation marks as part of the title; for example, *Abstract Painting, 60 x 60", 1964.*[39] This kind of titling underscores the artist's resistance to metaphorical interpretation — to finding in the work non-art concepts conjured up through the personal associations of the viewer. It was adopted by a number of the artists of the sixties and seventies, Andre and LeWitt among them — think not only of *144 Lead Square,* but also of *Straight Lines in Four Directions Superimposed,* and *Cubic-Modular Wall Structure, Black.*

Reinhardt's Writings

Artists of the 1960s were often as affected by Reinhardt's writing as by his painting. Throughout his career, he published cartoon satires of the art world, art-historical meditations, and polemical statements on art. He saw his

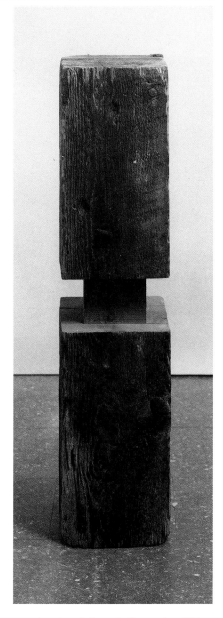

9. Carl Andre. *Timber Spindle Exercise.* **1964. Wood, 33 x 8 x 8" (84 x 20.3 x 20.3 cm). The Museum of Modern Art, New York. Gift of Mr. and Mrs. Michael Chapman**

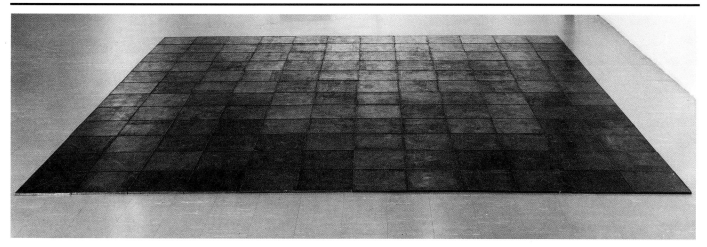

10. Carl Andre. *144 Lead Square*. 1969. 144 lead plates, each approximately 3/8 x 12 x 12" (.9 x 30.5 x 30.5 cm); overall, 3/8 x 12'7/8" x 12'1 1/2" (.9 x 368 x 369.2 cm). The Museum of Modern Art, New York. Advisory Committee Fund

writing and painting as utterly distinct activities — painting belonged to the realm of art, writing and cartooning belonged to the realm of life, and he abhorred any mixing of the two.[40] But the following generation did not necessarily view Reinhardt's writing as a wholly separate occupation. For example, it seems likely that, through his statements, he unwittingly served as an inspiration for Conceptual art. This is quite paradoxical, as he certainly never advocated the notion of the supremacy of the idea — just the reverse.[41] Nevertheless, the manifestos of the movement's two most prominent advocates, LeWitt and Joseph Kosuth, have been strongly influenced by Reinhardt's writings.[42]

LeWitt acknowledges these statements' importance for him, saying that Reinhardt was the only one who took on critically, and with polemical force, what LeWitt considers the emotional excesses of Abstract Expressionism.[43] Lawrence Alloway has suggested that Reinhardt's writings may have provided a source for LeWitt's notion of Conceptual art, noting the strong similarities between Reinhardt's "Twelve Rules for a New Academy" and LeWitt's "Sentences on Conceptual Art."[44] At the very least, it seems likely that "Twelve Rules" provided the model for LeWitt's piece, which includes thirty-five brief statements that constitute guidelines for making contemporary art. Resemblances to Reinhardt's ideas and writing style are also evident in LeWitt's "Paragraphs on Conceptual Art." His comment, "New materials are one of the great afflictions of contemporary art. Some artists confuse new materials with new ideas. There is nothing worse than seeing art that wallows in gaudy baubles,"[45] closely parallels Reinhardt's, "No texture. Texture is naturalistic or mechanical and is a vulgar quality, especially pigment texture or impasto. Palette knifing, canvas-stabbing, paint scumbling and other action techniques are unintelligible and to be avoided."[46] Both artists adopt a moralizing tone that becomes comical when applied to painting techniques and sculptural materials. Each exaggerates for effect what he sees as the problem: "New materials are one of the great afflictions of contemporary art" and "action techniques are unintelligible and to be avoided." Like Reinhardt who,

with tongue-in-cheek snootiness, tells us that texture is a "vulgar quality," LeWitt characterizes new materials as "gaudy baubles." Reinhardt does not shrink from metaphor in his writing; with terms like "palette knifing" and "canvas-stabbing," he hilariously equates texture in painting with a violent crime.

Joseph Kosuth's treatises on Conceptual art also relate closely to Reinhardt's writings. In "Art after Philosophy, Parts 1, 2, and 3,"[47] Kosuth set forth his theory of art, in each installment acknowledging his debt to Reinhardt. (In Part 1 he states, "Reinhardt had a very clear idea about the nature of art, and his importance is far from recognized.")[48] Kosuth writes of subtitling all his works "Art as Idea as Idea," which mirrors Reinhardt's "Art-as-Art" in sound, though not in sentiment. Kosuth's tautological statement, "Art's only claim is for art. Art is the definition of art,"[49] is (in meaning as well as style) a simplified variation of Reinhardt's, "The one thing to say about art is that it is one thing. Art is art-as-art and everything else is everything else. Art-is-Art is nothing but art. Art is not what is not art."[50]

Reinhardt's importance for Conceptualism is ironic, given the artist's continued commitment to painting, his belief in artistic tradition as a carrier of meaning, and his disavowal of the "idea" as an essential component in art. LeWitt, who, unlike other Conceptualists, never dispenses with the art object, probably understands Reinhardt quite well and accepts their differences: "An artist may misperceive (understand it differently than the artist) a work of art but still be set off in his own chain of thought by that misconstrual."[51]

Kosuth provides a good example of this kind of "creative misunderstanding." He seems to almost willfully misinterpret Reinhardt, literalizing Reinhardt's claim that he was making the "ultimate painting," the last kind of painting that could be made, and using it as justification for the abandonment of the art object.[52] But he misunderstood Reinhardt no more than did Harold Rosenberg, who wrote, "The black monk of the anti–Abstract Expressionist crusade, Reinhardt represents to the most extreme degree the ideal of an art dominated by ideology. He calls for a type of painting utterly ruled by concept and executed according to recipe."[53] The idea that Reinhardt painted according to a recipe is belied by the fact that, within their common framework, the black squares vary greatly from work to work, the result of the artist's using different "blacks" in each canvas, his painting the cruciform shapes freehand, and the fact that he was able to reduce the element of chance in the paint's drying process only in the last year or so of his life.[54] Like Kosuth, Rosenberg does not seem to have recognized the discrepancies between Reinhardt's paintings and the artist's proclamations about them; and as a critic rather than an artist, his mistake is less easily justified.

If Kosuth misinterprets the intended relationship between Reinhardt's writing and his art, he is perceptive in his claim that the writings created a framework for the reception of the paintings:

. . . artists must take responsibility for the meaning of their work . . . it can't really be trusted to art critics and historians whose own careers make their relationship with art similarly creative. In the late sixties, the Greenberg regime might have succeeded in depicting Reinhardt as a minor color painter, but Reinhardt's own framing, which was as much a part of his activity as an artist as the painting of his paintings, stood in the way.[55]

By "Reinhardt's own framing," Kosuth means the older artist's writings and other public, extra-artistic activities.[56] And although Kosuth is correct to a point, by the late sixties, Greenberg notwithstanding, it seems the ground-work had been laid that would allow for an increasing appreciation of Reinhardt's contribution. Though there is no question that Reinhardt's writings affected (and continue to affect) the understanding of his art, no evidence exists to support Kosuth's implication that the artist intended them to play this role. Thus, Kosuth goes too far when he claims to have learned from Reinhardt's example that "artists make meaning and that is really where our activity is located, and all the things we do are part of our activity as an artist."[57] This is a lesson Reinhardt never meant to teach.

Misconstruing Reinhardt's motivations allows Kosuth to make his own art-critical point, which concerns the integration of art and life. Kosuth clearly believes the effect of Reinhardt's writings on the reception of his painting proves that an artist's life and art are necessarily intertwined — that all one's activities count. But even granting that his premise may be correct — that it may be impossible to achieve the kind of total separation of art and life Reinhardt sought — Kosuth's position distorts Reinhardt's intention. It reshapes it to resemble that of Marcel Duchamp, another of Kosuth's heroes, but an artist with whom Reinhardt felt no affinity at all.[58]

Robert Smithson also reinterprets concepts found in Reinhardt's painting and writing in a manner that diverges significantly from Reinhardt's intentions. In "Quasi-Infinities and the Waning of Space," Smithson actually misquotes Reinhardt from "Twelve Rules for a New Academy," to this effect: "The present is the future of the past and the past of the future." The sentence should actually read: "The present is the future of the past, *not* the past of the future." Reinhardt meant it to underscore the relationship to tradition.[59] Smithson goes on: "The dim surface sections within the confines of Reinhardt's standard (60" x 60") 'paintings' disclose faint squares of time. Time, as a colorless intersection, is absorbed almost imperceptibly into one's consciousness."[60] (Presumably Smithson placed quotation marks around the word "paintings" to indicate that, appearances to the contrary, the black squares should not be identified with this "obsolete" form; certainly Reinhardt would not have chosen to put them there.) Smithson is addressing the issue of duration, the time it takes to discern the subtle configuration of a

black Reinhardt. However, in Smithson's own art, the pervading notion of time is that of a fleeting moment, a present which is an instant caught between past and future. It is expressed in the ephemerality of such works as *Incidents of Mirror Travel in the Yucatán* (fig. 11), in which clusters of rectangular mirrors were configured at nine different sites on the Yucatán peninsula. Smithson wrote of the piece, "If you visit the sites (a doubtful probability), you will find nothing but memory traces, for the mirrors were dismantled right after they were photographed."[61] This emphasis on the ephemeral runs absolutely contrary to the importance Reinhardt placed on the physical art object and on artistic tradition.

11. Robert Smithson. *Incidents of Mirror Travel in the Yucatán* (one of nine configurations). 1968. No longer extant

Robert Morris, who studied the history of Oriental art under Reinhardt at Hunter College, also explores the notion of duration, the idea that it should take time for a viewer to fully perceive and comprehend an art work. If Morris gleaned this notion from Reinhardt's paintings, he uses it in a manner entirely different from the older artist's. His claim that "the experience of the work necessarily exists in time" rests on the idea that the new sculpture is defined, in part, by the "particular space and light and [changing] physical viewpoint of the spectator."[62] Morris's project is concerned with the circumstances in which the viewer encounters the work.[63] For him, the situation in which art is shown affects and even determines the nature and quality of an object's presence.[64] This kind of melding of art and environment is antithetical to the aims of Reinhardt's paintings, which are conceived without consideration for such variables, and are meant to remain as aloof as possible from them.

Reinhardt as Model

LeWitt has commented that Reinhardt was "the most cerebral of the painters of the fifties, and the one ideologically best-suited to the sixties,"[65] alluding to Reinhardt's role as a model of the artist-intellectual for that first generation of American artists mostly educated in universities, rather than in the studios of older artists. For certain members of the sixties generation, this aspect of Reinhardt's persona had an impact in addition to or apart from the formal and conceptual approaches offered in his painting and writing. Reinhardt's repetitive, polemical writing style, which mirrored the reduced aesthetic of his paintings, his outspokenness, his activist politics, his education at Columbia University and New York University's Institute of Fine Arts, and his career as a teacher of art history made him a figure especially consonant with the interests of this new breed of artist.

For Robert Morris, Reinhardt provided an example of how an artist might conduct his life. This involved pragmatic issues like the way artists earn a living and the part they might choose to play within the community, as well as intellectual concerns involving the nature of art. Morris attributes Reinhardt's interest in "negation,"[66] what he terms his "anti-humanism," to non-Western

influences: "He had seen enough 'primitive' and Neolithic art to understand that art was really about death and perhaps commemoration, and not about life."[67] Similarly, Richard Serra emphasizes Reinhardt's role as a model of "dispassionate articulation and sustained concentration"[68] who demonstrated how it was possible to have a voice without "becoming a movie star."[69]

It is significant that Reinhardt was the only member of his generation included in "A Museum of Language in the Vicinity of Art," Robert Smithson's far-ranging essay on, among other topics, artists' use of language.[70] Smithson begins the article with a quote from Reinhardt: "The Four Museums are the Four Mirrors," explaining that the article that follows is "a mirror structure built of macro and micro orders, reflections, critical laputas, and dangerous stairways of words, a shaky edifice of fictions that hangs over inverse syntactical arrangements." Smithson (like LeWitt, Morris, and Kosuth) then reinterprets Reinhardt's often-voiced advocacy of the "uselessness" of art: "Here language 'closes' rather than 'discloses' doors to utilitarian interpretations and explanations."[71] In the first part of the article, Smithson describes the writings of Dan Flavin, Andre, Morris, Judd, LeWitt, Reinhardt, Peter Hutchinson, Dan Graham, Andy Warhol, and Ed Ruscha. Following that, his musings involve the nature of the museum, history, and time, and a meditation on Reinhardt's satirical cartoon *A Portend of the Artist as a Yhung Mandala* (fig. 12). Smithson sees the center of the cartoon as the "void," bordered by an art world populated by monsters, "a tumultuous circle of teeming memories of the past."[72]

Ad Reinhardt's importance for the artists of the sixties took many forms. If it is sometimes difficult to define, this is because his is an art cloaked in a series of paradoxes: his painting represents a closure, the end of something, and yet, for him, art drew its meaning from its connection with an ongoing tradition; his paintings are material objects, yet they seem to deny their physicality; he insisted on the complete separation of his art work from his writing (as he did of art from life), yet during the sixties and after, the writings evidently informed the reception of his painting; and, perhaps most paradoxical of all, the work of the artists most influenced by him generally bears little overt resemblance to his.

Despite such apparent contradictions, it is his delicate, seemingly ephemeral and almost immaterial black squares that carried the point. Aggressive in their very reticence, their resistance to yielding up their secrets, they imposed themselves forcefully and with great insistence. These paintings remain difficult to perceive optically, and difficult to comprehend intellectually; they must be viewed on their own terms, and over an extended period of time. In New York at the beginning of the sixties, there was a small audience of younger artists ready and willing to do just that.

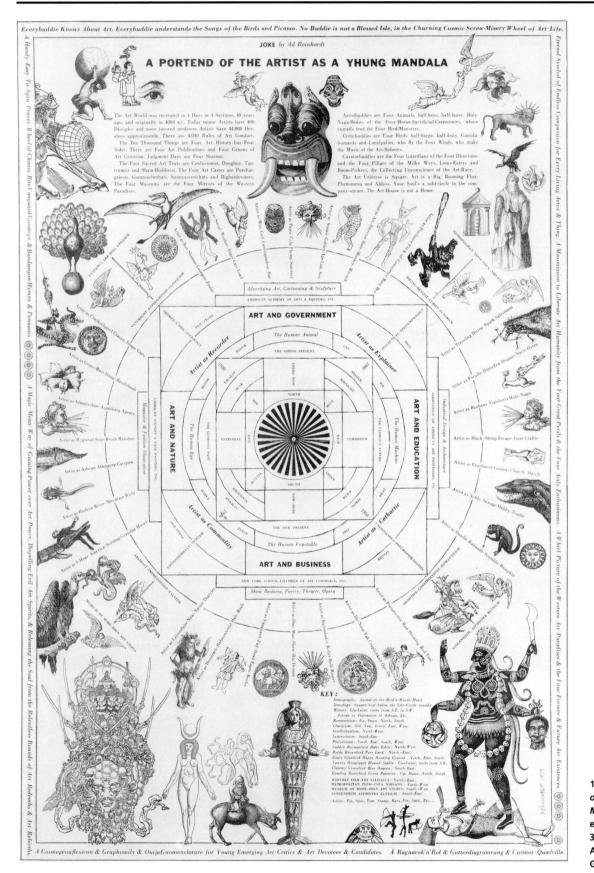

12. Ad Reinhardt. *A Portend of the Artist as a Yhung Mandala*. 1956. Cut and pasted paper, 20 1/4 x 13 1/2" (51.4 x 34.5 cm). Whitney Museum of American Art, New York. Gift of an anonymous donor

Notes

1. Irving Sandler claims that, in the 1950s, Reinhardt's "geometric abstractions were widely put down as a throwback to the thirties," and that The Museum of Modern Art reflected this attitude when it excluded him from the 1958 exhibition "New American Painting" (Sandler, "Reinhardt: The Purist Backlash," *Artforum,* 5 [December 1966], p. 46). If this was the case, there is little evidence of it in print. Although Reinhardt was not an "art star," even by early-sixties standards, he was an established figure and his shows were reviewed regularly. Most reviewers gave his paintings respectful consideration. One notable exception was Fairfield Porter, whose often-quoted statement that Reinhardt's "drug-store bright colors of almost the same value . . . make your eyes rock" was not meant as a compliment. Porter went on: "He is not the first artist to do this, nor does he do it with enough precision to make it clear whether it is intended." Porter also complained of what he termed the paintings' "lack of scale" (Porter, "Ad Reinhardt," *Art News,* 50 [February 1952], p. 41).

2. "In my opinion, Reinhardt is the intellectual pivot of the new art offered as a replacement for Abstract Expressionism" (Harold Rosenberg, "Black and Pistachio" [1963], in *The Anxious Object* [Chicago: University of Chicago Press, 1964], p. 52).

3. In 1965 Lucy Lippard wrote, "Reinhardt is now recognized as a rebel and a prophet and is widely admired, but he was a precedent for, rather than an influence on, recent trends" ("New York Letter," *Art International,* 9 [May 1965], p. 52).

　In 1966, Kynaston McShine concurred: "It has been suggested that Reinhardt is the forerunner and major influence on the younger group of artists who have been described as 'rejective,' 'minimal,' 'systemic,' 'structural,' and even 'boring.' I would prefer to think that his work along with that of a few others provided the viable climate. It is inconceivable that Reinhardt, who has always asserted the autonomy of both art and the artist, should at this point assume the role of sole dean to what one hopes will not become a New Academy" ("More than Black: The Positive of Negative Art," *Arts Magazine,* 41 [December 1966–January 1967], p. 50).

4. See Robert Morris, "Notes on Sculpture," in Gregory Battcock, ed., *Minimal Art: A Critical Anthology* (New York: E. P. Dutton, 1968), p. 223: "Sculpture . . . never having been involved with illusionism could not possibly have based the efforts of fifty years upon the rather pious, if somewhat contradictory, act of giving up this illusionism and approaching the object . . . the sculptural facts of space, light, and materials have always functioned concretely and literally." See also Donald Judd, "Specific Objects," in *Donald Judd: Complete Writings, 1959–1975* (Halifax: Press of the Nova Scotia College of Art and Design; New York: New York University Press, 1975), p. 189: "George Brecht and Robert Morris use real objects and depend on the viewer's knowledge of these objects."

5. For more on Smithson's interest in crystals, see Robert Hobbs, *Robert Smithson: Sculpture* (Ithaca and London: Cornell University Press, 1981), p. 12.

6. "In part my work was congruent with the sculptors', especially in their focus on objecthood, then a primary and timely concern. . . . But paintings, while objects, are not sculptures. . . . There can be no mark within a painting's format which does not deceive. . . . I painted my straight edges curved to make them look straight (entasis) preferring an open dialogue of illusion/physicality to simplistic, one-dimensional fiat" (Jo Baer, quoted in *Abstraction, Geometry, Painting: Selected Geometric Painting in America Since 1945* [New York: Harry N. Abrams, 1989], p. 178).

7. Robert Mangold, quoted in *Abstraction, Geometry, Painting,* p. 172.

8. In his writings, Reinhardt often plays with the idea of the "ultimate," but typically leaves his meaning ambiguous. In an unpublished statement, Reinhardt writes, "I made the ultimate painting first, that's all . . . What's more, this is the end of the beginning, that's all" ("What's More, That's All," undated, unpublished notes, Archives of American Art, N69-103). In another statement, he questions, "End of Painting as Art? Working in form nearing end of its time? Shot its bolt from the blue." But he ends the piece with, "Last word must always be secretly the first" ("End," in *Art-as-Art: The Selected Writings of Ad Reinhardt,* ed. Barbara Rose [New York: Viking Press, 1975], pp. 113–14).

9. Virginia Dwan, taped interview with the author, November 9, 1990. The characterization of Reinhardt as an "underground" figure, accurate as it may be, is more than a little ironic, considering his many years as a highly vocal and visible member of the art community.

10. Reinhardt believed that his black paintings had a marked ability to antagonize the public. The artist told Bruce Glaser: "When The Museum of Modern Art had its last fifteen or sixteen Americans show in nineteen sixty-three they had to rope off my room, and the public got angry only with that room. They accepted everything else in the show — the pop art, the plaster hamburgers and everything else"

(Glaser, "An Interview with Ad Reinhardt [1966–67]," in *Art-as-Art*, p. 15). In "The Black Square Painting Shows, 1963, 1964, 1965," Reinhardt writes of how barriers had to be erected for exhibitions of his work in various international locations (*Art-as-Art*, p. 85). There is certainly truth in Reinhardt's claim for the works' ability to arouse hostility, but it is also the case that the black paintings are extremely fragile, and even the slightest contact with people or things, that would not injure other canvases, can do lasting damage to a late Reinhardt.

11. The exhibition was held October 4–29, 1966, and included Carl Andre, Jo Baer, Dan Flavin, Donald Judd, Sol LeWitt, Agnes Martin, Robert Morris, Reinhardt, Robert Smithson, and Michael Steiner. A meeting of the artists sparked heated debate; it was impossible for them to agree on a catalogue text. Dwan had wanted an essay that would illuminate their commonalities. Smithson had proposed a text "full of galactic, frozen imagery, but it was met with icy silence. And so the catalogue remained mute, with no more description than [the brief title]" (Dwan, interview with the author). Reinhardt, who had admired Martin's work for some time, had recommended her to Dwan. It was during the organization of this exhibition that he had his only personal contact with Andre and LeWitt.

12. Sol LeWitt, interview with the author, November 9, 1990.

13. Ibid.

14. LeWitt most effectively "democratizes" art in his books. Lucy Lippard notes that, far from being "minor" works, these are among his most developed, "their implicit portability, inexpensiveness, and seriality being among their strongest points"; they "offer more art for less" (Lippard, "The Structures, The Structures and the Wall Drawings, The Structures and the Wall Drawings and the Books," in Alicia Legg, ed., *Sol LeWitt* [New York: The Museum of Modern Art, 1978], pp. 27–28).

15. Reinhardt usually framed his canvases before he began working on them. He laid the canvases flat to paint them and stood them up when he needed to examine his efforts. Until the last year of his life, he worked alone, without the aid of assistants, and the frames offered protection for the paintings as he lifted them and moved them around the studio (Rita Reinhardt, conversation with the author, March 4, 1991).

16. "The one object of fifty years of abstract art is to present art-as-art and as nothing else, to make it the one thing it is only, separating and defining it more and more, making it purer and emptier, more absolute and more exclusive. . ." (Ad Reinhardt, "Art-as-Art," in *Art-as-Art*, p. 53).

17. Rosalind Krauss, "Grids" (1978), in *The Originality of the Avant-Garde and Other Modernist Myths* (Cambridge, Mass., and London: MIT Press, 1985), pp. 12–13.

18. "The idea itself, even if not made visible, is as much a work of art as any finished product" (Sol LeWitt, "Paragraphs on Conceptual Art," *Artforum*, 5 [Summer 1967], p. 83).

19. For an explication of the obsessive nature of LeWitt's work, see Rosalind Krauss, "LeWitt in Progress" (1978), in *The Originality of the Avant-Garde and Other Modernist Myths*, pp. 251–53.

20. Frank Stella describes "relational" and "nonrelational" art as follows: ". . . European geometric painters really strive for what I call relational painting. The basis of their whole idea is balance. You do something in one corner and you balance it with something in the other corner. Now the new painting is being characterized as symmetrical . . . but we use symmetry in a different way. It's nonrelational. . . . The balance factor isn't important" (Bruce Glaser, "Questions to Stella and Judd," in Battcock, ed., *Minimal Art*, p. 149).

21. Ad Reinhardt, "Twelve Rules for a New Academy," in *Art-as-Art*, p. 205.

22. Sol LeWitt, "Sentences on Conceptual Art," *Art-Language,* 1 (May 1969), p. 12.

23. See Bernice Rose, "Sol LeWitt and Drawing," in Legg, ed., *Sol LeWitt*, p. 31.

24. For example, Donald Kuspit writes, "The key to these paradoxes [in LeWitt's art] . . . is the absolute intention that brought LeWitt's objects into being but that cannot rest comfortably with them once they exist. The paradoxes express this conflict, inherent to an intention that is always outreaching its physical embodiments, for they never quite bespeak its true purpose, viz., the intuition of an ideal art" (Kuspit, "Sol LeWitt: The Look of Thought," *Art in America,* 63 [September–October 1975], p. 46).

25. Sol LeWitt, interview with the author, December 17, 1990. Reinhardt used the term "absolute" in relation to his own work. He characterized his ideas as "an absolute aesthetic point of view," stating that he believed that in art there were certain pure and absolute standards, and equating this notion with "purism," in the sense of both a lack of corruption and a classical style of painting (see Glaser, "An

Interview with Ad Reinhardt," pp. 18–20).

26. See David J. Clarke, *The Influence of Oriental Thought on Postwar American Painting and Sculpture* (New York and London: Garland Publishing, 1988), p. 147.

 Lucy Lippard refers to Reinhardt's "desire for a quasi-Oriental absolute" (Lippard, "The Structures, The Structures and the Wall Drawings, The Structures and the Wall Drawings and the Books," p. 26).

27. Ad Reinhardt, "[The Black Square Paintings]," in *Art-as-Art,* pp. 82–83.

28. Reinhardt's cruciform shapes are Greek crosses in that their horizontal and vertical bars intersect at the midpoint of each and are of equal length and width. However, the horizontal and vertical bars of the crosses in Reinhardt's paintings are not wholly equal: they are almost always of different hues, and one is often more prominent than the other.

29. Reinhardt mixed paint from tubes in jars, adding turpentine to facilitate the process of separating the pigment from its medium, which was oil. The procedure required constant stirring to ensure evenness in the distribution of pigment as well as oil. Over time, the turpentine would evaporate, and the oil would separate from the pigment and could be poured off. The resulting mixture was dense rather than transparent, because it contained a high proportion of pigment, but it was thin enough to do away with the ridges that normally result from the brushing on of oil paint. Reinhardt applied many layers of these mixtures to create his black paintings (Rita Reinhardt, conversation with the author, February 4, 1991).

30. See Glaser, "An Interview with Ad Reinhardt," p. 22.

31. Ibid., pp. 22–23.

32. Ibid. Glaser notes that "resistant" was a word with currency among younger artists at the time, who talked of "the resistant canvas or difficult paintings." Reinhardt approved of the idea of testing the audience.

33. Sol LeWitt, interview with the author, December 17, 1990.

34. "Reticence" is another term that has been used often in relation to Minimal art. See, for example, Andrea Miller-Keller, "Excerpts from a Correspondence, 1981–1983" in *Sol LeWitt: Wall Drawings, 1968–1984* (Amsterdam: Stedelijk Museum, 1984), p. 19.

35. Carl Andre, letter to the author, December 1, 1990.

36. Quoted in Jeanne Siegel, "Carl Andre: Artworker," *Studio International,* 180 (November 1970), p. 179.

37. Carl Andre, "Quotations from the Artist," in *Carl Andre* (The Hague: Haags Gemeentemuseum, 1969), p. 5.

38. Quoted in David Bourdon, *Carl Andre: Sculpture, 1959–1977* (New York: Jaap Rietman, 1978), p. 31.

39. Reinhardt's practice of titling and dating his works on the verso presents certain problems in establishing a chronology for pictures. He generally inscribed them just before they left his studio, usually for an exhibition. Often paintings must have been dated months or even years after work on them was completed. When unsold pictures returned to his studio, he frequently repainted the canvases in the manner in which he was then working. It is possible that the versos of some canvases bear the dates of earlier paintings. In the case of the fragile black pictures, Reinhardt often had to restore them long after they had left his studio; his method was generally simply to repaint them. A number of these works have dates that indicate that they were worked on in two campaigns, but it is likely that others that were also repainted have dates that do not reflect that fact. See *Ad Reinhardt* (Los Angeles: The Museum of Contemporary Art; New York: The Museum of Modern Art and Rizzoli International Publications, 1991), p. 101.

40. This is the fundamental message of Reinhardt's "Art-as-Art Dogmas." For example: "The one nature of art fixes a boundary that separates it from every other nature and thing. . . . The one reality of art is just the reality of art, not the reality of reality, just the life of art not the life of life . . ." (Reinhardt, "Art-as-Art," p. 57).

41. "No good ideas in art" (Ad Reinhardt, ["Art-as-Art"], in *Art-as-Art,* p. 75).

42. See LeWitt, "Paragraphs on Conceptual Art" and "Sentences on Conceptual Art"; and Joseph Kosuth, "Art after Philosophy [Part 1]," *Studio International,* 178 (October 1969), pp. 134–37; "Art after Philosophy, Part 2," *Studio International,* 178 (November 1969), pp. 160–61; "Art after Philosophy, Part

3," *Studio International,* 178 (December 1969), pp. 212–13.

43. LeWitt, conversation with the author, November 9, 1990.

44. Lawrence Alloway, "Sol LeWitt: Modules, Walls, Books," *Artforum,* 13 (April 1975), p. 40.

45. LeWitt, "Paragraphs on Conceptual Art," p. 83.

46. Reinhardt, "Twelve Rules for a New Academy," p. 205.

47. See note 42, above.

48. Kosuth, "Art after Philosophy," p. 136.

49. Ibid., p. 137.

50. Reinhardt, "Art-as-Art," p. 53. Kosuth actually quotes this Reinhardt passage in "Art after Philosophy," p. 134.

51. LeWitt, "Sentences on Conceptual Art," p. 12.

52. "[Reinhardt's] painting of 'the last paintings anyone can make,' like the circularity of his writing, began . . . that self-reflexive spiral which was also painting's self-erasure in its very act of completion" (Joseph Kosuth, statement at a panel discussion held at the Solomon R. Guggenheim Museum, New York, in conjunction with the exhibition "Ad Reinhardt and Color," 1980; audiotape on deposit at the Guggenheim).

53. Rosenberg, "Black and Pistachio," p. 53.

54. Reinhardt's process of leaching the oil out of his paint caused certain difficulties. If the remaining oil was not evenly distributed throughout the paint mixture, streaks that could only be detected after the canvas was dry would appear on the surface. A great deal of stirring of the paint and turpentine mixture was required to avoid this problem (Rita Reinhardt, conversation with the author, February 4, 1991).

55. Kosuth, Guggenheim Museum panel discussion.

56. "Ad Reinhardt made black paintings, yes. But he also wrote texts, made cartoons, did diagrams, taught art, participated in panel discussions, gave public lectures, and so on. He did *all* of these things as an artist and thereby created a meaning context which affected our understanding — and perception — of those black paintings" (Joseph Kosuth, letter to the author, May 20, 1991).

57. Joseph Kosuth, taped interview with the author, October 1, 1990.

58. In a lecture at the Skowhegan School in the summer of 1967, Reinhardt stated that he "never liked or approved of anything about Duchamp," and that he had always felt one had to make a choice between Duchamp and Mondrian; there is no question as to where his allegiances lay (audiotape on deposit with the Skowhegan School of Painting and Sculpture, Skowhegan, Maine).

59. Reinhardt, "Twelve Rules for a New Academy," p. 206.

60. See Robert Smithson, "Quasi-Infinities and the Waning of Space," *Arts Magazine,* 41 (November 1966), pp. 28–31.

61. *The Writings of Robert Smithson,* ed. Nancy Holt (New York: New York University Press, 1979), p. 103.

62. Robert Morris, "Notes on Sculpture, Part 2," in Battcock, ed., *Minimal Art,* p. 234.

63. See Michael Fried, "Art and Objecthood," in Battcock, ed., *Minimal Art,* p. 125.

64. Ibid., p. 127. Fried states that, for Morris, "Everything counts — not as part of the object, but as part of the situation in which objecthood is established and on which it depends."

65. LeWitt, interview with the author, December 17, 1990.

66. In his black paintings, Reinhardt was always "painting out," "destroying"; he termed these works "negative presences" (Glaser, "An Interview with Ad Reinhardt," p. 17). In the same interview Reinhardt explained, "The painting, which is a negative thing, is the statement, and the words I've used about it have all been negative to keep it free" (p. 14).

67. Robert Morris, taped interview with the author, November 9, 1990.

68. Richard Serra, interview with the author, January 23, 1991.

69. Richard Serra, Guggenheim Museum panel discussion.

70. Robert Smithson, "A Museum of Language in the Vicinity of Art," *Art International,* 12 (March 20, 1968), pp. 21–27.

71. Ibid., p. 21.

72. Ibid., p. 24.

Jasper Johns: Ale Cans and Art

Wendy Weitman

One thing made of another.
One thing used as another.
An arrogant object.[1]

The ideas in this short entry in Jasper Johns's "Sketchbook Notes" underlie much of his early work. These few words also reveal Johns as a chameleon, a master of metamorphosis. In the fifties, as he first revealed his roster of images of flags, targets, and numbers, "one thing made of another" referred to the tension between illusion and reality and to the perceptual puzzles that resulted. Over the course of his thirty-five-year career, however, the game has evolved into a complex interplay of self-reference as well; Johns has habitually reinterpreted his images using different mediums, remaking them in sculpture, paintings, drawings, and prints, each transformation with its own, and often strikingly different, visual effects.

Johns's extensive printed oeuvre offers an ideal opportunity to study the subtleties of these transformations. He has not only often tried images in both lithography and etching, but in several cases has returned to a print some years later and reworked the plate or stone, altering his original vision. This paper follows the course of Johns's various manipulations of one image, looking at the way he used different mediums and pictorial devices to reinterpret and reinvent this image over two decades. Along the way, Johns's depictions of ale cans became particularly interesting examples of his central theme of perceptual ambiguity and of the hermetic, self-referential style that characterized his early work. Beginning with the sculpture *Painted Bronze* and continuing through numerous prints and drawings, Johns reused this image to explore the fundamentals of the ways we see.

Painted Bronze, 1960

Johns has depicted Ballantine ale cans in two sculptures, two paintings, ten drawings, twelve editioned prints, and a number of augmented proofs. The sculpture *Painted Bronze* of 1960 (fig. 1) was the first. The subsequent works based on the sculpture are Johns's creative interpretations of a three-dimensional object on a two-dimensional surface that transcend a mere rendering. The often-quoted quip of Willem de Kooning's that the dealer Leo Castelli

Opposite:
1. Jasper Johns. *Painted Bronze.* 1960. (2/2, cast and painted 1964). Painted bronze, 5 1/2 x 8 x 4 3/4" (14 x 20.3 x 12.1 cm). Collection the artist

could sell even two beer cans is the accepted inspiration behind the celebrated sculpture. Johns himself has said that after hearing the remark he felt the idea of making two beer cans fit perfectly into his work. When asked to comment on why this "fit" was so ideal, he responded with formal concerns, saying that after the flashlight and light-bulb sculptures which preceded them, the beer cans were two cylinders, two small, discrete shapes.[2]

Although at first perceived as an unconventional subject for art, the ale cans may be seen as a successor to still-life images of the wine bottle. Cubist still-life paintings of the early 1910s immediately come to mind as precedents with their numerous depictions of the wine bottle. Picasso, in particular, stands out as a source of comparison. His *Glass of Absinth* of 1914 is not only a sculpture of an alcohol vessel but is made of painted bronze.[3]

Painted Bronze was cast from a hand-made construction that Johns built up out of an assortment of found and molded objects. All of the bronze sculptures were cast in 1960,[4] in preparation for a show of drawings and sculpture held at the Leo Castelli Gallery early in 1961.[5] The subject of the Ballantine ale can, like that of the American flag, has a predetermined form, color, and design, freeing Johns from those compositional decisions. The previous sculptures, the flashlights and light bulbs, were all monotone, predominantly the gray of sculp-metal, but *Painted Bronze,* Johns's first sculpture painted in color, incorporates the red, green, and ocher colors of the can's trademark. The change from gray to colored sculpture parallels Johns's transition from his preferred gray encaustic in paintings of 1957–58 to the brightly colored palette in works such as *Device Circle* and *False Start* of 1959.

Painted Bronze, however, represents an anomaly within Johns's sculpted work in another way: it is the only doubled image in his sculpture.[6] The beer cans' nature as containers, and moreover, as containers of drink, implies they may be full or empty, which Johns makes explicit by puncturing the top of one, leaving the other closed. Johns has often worked through a process of negation, making an inquiry and then seeing if the opposite is possible. This thesis/antithesis approach is united in one work in *Painted Bronze* by including two cans exemplifying the empty/full contrast.

The idea of doubling is also to be seen in the work of Robert Rauschenberg. In two works of 1957, *Factum I* and *Factum II,*[7] Rauschenberg attempted to make two "identical" paintings and contrasted the precise duplication quality of mechanical photo-collage elements with the inevitable variations inherent in hand-painted strokes. They anticipate a similar but ironic idea in Johns's *Painted Bronze,* a double image of a mass-produced object that has, however, been constructed, cast, and painted by hand. On closer inspection, as with the Rauschenberg pair, we notice that Johns's two cans are not entirely alike; not only is one punctured and the other not, but one is slightly smaller and painted with the three-ring logo and the word FLORIDA on the top.

Marcel Duchamp's notes in *The Green Box* may have suggested the idea

of doubling, while altering, an object.[8] In a review of *The Green Box,* Johns quoted these lines from Duchamp's notes:

> *identifying*
> *To lose possibility of recognizing*
> *2 similar objects*
> *2 colors, 2 laces*
> *2 hats, 2 forms whatsoever*
> *to reach the Impossibility of*
> *sufficient visual memory*
> *to transfer from one*
> *like object to another*
> *the memory imprint* [9]

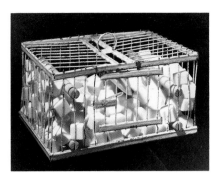

2. Marcel Duchamp. *Why Not Sneeze Rose Sélavy?* 1921. Assisted Readymade of painted metal birdcage, marble cubes, thermometer, and cuttlebone, 4 7/8 x 8 3/4 x 6 3/8" (12.4 x 22.2 x 16.2 cm). Philadelphia Museum of Art. The Louise and Walter Arensberg Collection

The essence of Johns's feelings about Duchamp is expressed in a short piece he wrote in memoriam after Duchamp's death. "[Duchamp] seems never to have exaggerated any of the conditions of art, attacking the ideas of object, artist and spectator with equal force and observing their interaction with detachment."[10] The integral role of the viewer in completing the work of art is a major concern in *Painted Bronze,* for unless someone picked up the individual cans, which are not attached to the base, the fact that the "open" can is light and the "closed" can is solid bronze and therefore heavy would never be communicated.[11]

Duchamp's influence can also be seen in the context of this unforseen weight of *Painted Bronze.* In an explanation of *Why Not Sneeze Rose Sélavy?* of 1921 (fig. 2), his assisted Readymade of a painted metal birdcage filled with marble and objects, Duchamp wrote, "The little birdcage is filled with sugar cubes. But the sugar lumps are made of marble and when you lift it, you are surprised by the unexpected weight."[12]

Referring to Johns's 1954 *Construction with Toy Piano,* Leo Steinberg wrote, "[it] has a romantic melancholy about it, even a hint of self-pity."[13] In a discussion of *Untitled Construction* of 1954, Roberta Bernstein points to the work's "disturbing, surrealistic aura, characteristic of Johns's 1955 *Target with Plaster Casts*";[14] she adds, however, that Johns repressed these tendencies with the Flag paintings. I would like to suggest that Johns's sculpture retained a Romantic sensibility and a conceptual link with Surrealist ideas, even if he eliminated them from his painting. Compare René Magritte's series of altered beer and wine bottles; his glass *Bière de Porc* of 1937 (fig. 3) bears a label of the animal's head and the hand-painted brand name of the beer.

With the exception of the sardonic *The Critic Smiles* and *The Critic Sees,* all of the 1958–60 sculptures retain a certain melancholy, but disguised by their mundane and often all-American subject matter. For example, in the unpainted sculptures of flashlights and light bulbs, all in the gray of sculp-

3. René Magritte. *Bière de Porc.* (1937). Glass bottle with painted label, 12 3/16 x 3 1/8" (31 x 8 cm). Collection Christine Brachot, Brussels

metal or the brown of papier-mâché, the object is denied its function; its electric "juice" is missing. In contrast with the horizontal orientation of these mechanical objects, *Painted Bronze* consists of two vertical cans generously poised on their pedestal and painted in color. There is an implied monumentality in this verticality and pose, yet here too any such implication is thwarted by their modest scale and the weathered look of the muted color labels. Moreover, the puncture holes of the open can indicate its "used," or in this case "used up," condition; paired with the full can, there is a feeling of an action interrupted or a partner left waiting. Instead of elevating the commonplace, the sculpture exudes a kind of pathos, a failed attempt at heroic stature.

Ale Cans, 1964

I'm always interested in the physical form of whatever I'm doing and often repeat an image in another physical form just to see what happens, what the difference is, to see what it is that connects them and what it is that separates them. . . . The experience of one is related to the experience of the other. For me it is.[15]

Seeing things with different focuses or changing orientations has been one of the artist's consistent preoccupations throughout his career. The ale-can image, like so many others, goes through a series of metamorphoses after the sculpture, many of which refer back to that earlier art object, others to the original object's function in life, and others to the can's role as a studio tool. In the cases where the sculpted image was depicted in two dimensions, this metamorphosis embodies Johns's complex perceptual games about the nature of illusion on a flat surface.

In the early sixties, individual Ballantine cans, which the artist used as paint cans, were physically attached to the canvas in several works based on the theme of the artist's studio. In these paintings, such as *Field Painting* (1963–64) and *Studio* (1964), the actual ale can is a piece of studio equipment, a token of the artistic process. In fact, with rare exceptions until the early 1980s, Johns has either physically included three-dimensional objects in his works or else cast, photographed, traced, or imprinted them, as opposed to drawing or painting them.[16] He has said, "I think the object itself is perhaps in greater doubt than the illusion of an object."[17] In his 1955 drawing *Target with Four Faces,* Johns replaced the four cast heads with the word HEAD, repeated in each niche, instead of with a drawn head. In the conté crayon drawing *Coat Hanger,* which preceded the painting, he traced the outline of the hanger. (In the painting, a real hanger is suspended from a knob.) In this context, the earliest prints depicting *Painted Bronze* can be considered anomalies — Johns's initial efforts to convey an ambivalent illusionism on a two-dimensional surface, first through autographic and then through photographic means.

No drawings immediately precede or follow the first cast of *Painted*

Bronze. The first graphic work based on the sculpture is the celebrated 1964 lithograph *Ale Cans* (fig. 4), printed at Universal Limited Art Editions in West Islip, Long Island. Johns began working on this print while completing the second cast of the sculpture,[18] and it is his first print to depict one of his sculptures.[19] Casting and painting the second *Painted Bronze* may have provided the inspiration to try the image on paper. (Similarly, Johns had made his first prints in 1960, the same year he executed his bronze sculptures.)[20] The materiality of printmaking — the transference from stone to paper, the reversal of the image — is not unlike the process of molding, casting, and painting bronze. In both mediums, the artist builds up his image in one material, and the final art work is made of another. There is also a collabora-

4. Jasper Johns. *Ale Cans*. West Islip, Universal Limited Art Editions, 1964. Lithograph, printed in color, 22 7/8 x 17 3/4" (58.1 x 45.1 cm). The Museum of Modern Art, New York. Gift of the Celeste and Armand Bartos Foundation

tive nature to both mediums, the artist's talents combining with the skills of the printer or foundry worker. His facility as a lithographer notwithstanding, the working similarities of both mediums may suggest why Johns chose lithography when making this first two-dimensional version of his famous sculpture.

Although this print is often considered Johns's most illusionistic to date, it is not the first print in which he uses illusionistic devices, as Riva Castleman has pointed out.[21] In his first color lithograph, *Painting with Two Balls* of 1962 (ULAE 8), two small round balls appear to intrude between the upper and middle horizontal bands.[22] But while that print is an overall composition of flat texture interrupted by subtle objects, *Ale Cans* is just the opposite: its objects dominate, challenging Johns to avoid a mere realistic representation.

The importance of the sculpture's base is particularly relevant here. Johns alternatively made sculptures with or without a base, as in *Light Bulb I* and *Light Bulb II* of 1958. This distinction makes a striking difference in the perception of these works. Posed on a base, the ale cans read more clearly as art object, a work of sculpture resting on its bronze support. Johns's thumbprint, the autographic mark that certifies the piece as hand-made, is imprinted on the base. The base also serves to unite the two cans into one sculpture and reinforce their reading as a still life, creating a context for the individual ale cans. When compared to the other sculpture titled *Painted Bronze* — the Savarin can, which has no base — the ale-can bronze is perceived as art object, while the paintbrush can seems almost a Duchampian Readymade, devoid of aesthetic context.

In *Ale Cans,* Johns depicts the base in perspective, foreshortened as it recedes into the background. This is the first case where he has used this kind of perspective in his printmaking. The cans appear to be positioned in a black setting, whose dimensions have been determined by the olive base. Johns has created an environment in which to view his sculpture, a context that will be emphasized in later prints.

Ale Cans stands on its own as a compelling and convincing work of art. But knowledge of *Painted Bronze* alerts the viewer to the subtle layers of perceptual investigation in the lithograph. As Richard Field has written, the print of a recognizable Johnsian image "serves to underscore that which remains constant: the process of seeing itself."[23] The visual game is no longer one of object-replication. Ale-can prints could not become objects the same way that Flag paintings did. The printed image clearly sits on a piece of paper, its white margins reinforcing its "paperness" and two-dimensionality. Johns exploited this opportunity, inherent in printmaking, by playing the illusionistic image of the sculpture against the flatness of the paper, to enhance his perceptual puzzle.

Working Proofs for *Ale Cans*, 1964

Johns donated five working proofs for *Ale Cans* to The Museum of Modern Art in memory of Tatyana Grosman, the founder of Universal Limited Art Editions, in 1985, at the time of the dedication of the Museum's Tatyana Grosman Gallery. Tatyana Grosman had been the driving force behind Johns's printmaking career, persuading him to make his first print, in 1960. The proofs he donated, which reveal the creative process behind one of his landmark printed images, seem a fitting tribute. This is in keeping with the way that Johns's repetitions of imagery often evoke a sense of remembrance, a reference back to a progenitor. *Ale Cans,* made as a memorial to a sculpture, becomes a memorial to a friend.

The working proofs leading up to the print are invaluable to understanding Johns's process of translating a sculpture into a lithograph. When making a lithograph, each color is drawn on a separate stone. Proofs can be pulled at any stage in the print's development, allowing the artist to return to the stone and modify what he has drawn; these preliminary stages are known as trial proofs. Johns often draws by hand on trial proofs to experiment with and resolve the next stage of the print, and it is these overdrawn proofs that he refers to as working proofs. He has often made extended series of working proofs for prints.[24] Their drawn revisions allow him to reevaluate an image without reworking the plate or stone. Since there are no preliminary drawings for the print, the set of working proofs for *Ale Cans* provides the only clues to the progressive development of the graphic image. He is also very interested in the different surfaces attainable with different mediums, as well as the contrast between printed and hand-applied textures, and has explored numerous such variations within this series of *Ale Cans* proofs.[25] Each working proof stands on its own as a finished and unique work of art, and Johns has allowed them to be shown as such. But when considered as a series of investigations of a particular image, they offer insight into the working habits of an artist to whom process is often the most important motivation.

Johns annotates each proof with exactness, indicating which are trial proofs, which are working proofs, and what mediums are added by hand. Although a precise order of the proofs is difficult to determine, progressions of details help to establish their sequence.

The first working proof (fig. 5), printed on newsprint, reveals that the black background was an early decision. The background is the only printed element in this proof; the areas for the cans and base are left blank, with crayon additions loosely defining their form. Johns has said that the dark background was important as a means to flatten out the spatial depth.[26] It is interesting to note that a typical Johnsian scribble, which becomes very important as a further element reinforcing the idea of two-dimensionality, is already evident in the crayon drawing over the outline of the left can.

Duchamp's *Chocolate Grinder* of 1913 could serve as a source for an

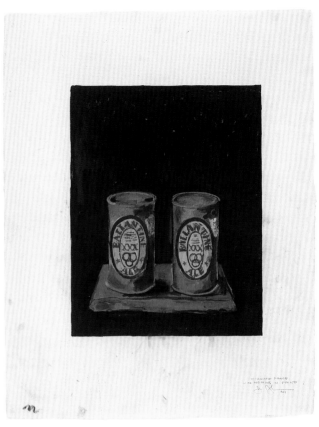

image starkly portrayed against a somber, dark background.[27] It is a strictly illusionistic image of a manufactured metal object, sitting on a base, with its title printed in gold lettering. It has also been suggested that the source for the background may have been the cover of Leo Steinberg's 1963 monograph on Johns, which illustrates *Painted Bronze* against shiny black.[28] Whatever the inspiration, the effect of the black is not only spatial ambiguity but an intensified sense of the melancholic spirit evident in the sculpture.

The second working proof (fig. 6), hand-painted with gouache and acrylic paints mixed with metallic powders, is the most illusionistic of the proofs. It is the black background alone that flattens the space of this beautiful perspectival rendering of *Painted Bronze*. As in the first proof, only the background is printed, indicating an early stage in the progression of proofs. There is a certain density to the image because of the texture of the painting, with large areas of the lithographed background covered with gray and black gouache. This stylistic heaviness adds to the emotional heaviness of the piece, while simultaneously conveying a sense of the bronze material of the sculpture through the use of shimmering, reflective gold paint. The labels are delicately painted in green, red, and ocher, creating the initial sense of realism.

Left:
5. Jasper Johns. *Ale Cans,* working proof. 1964. Lithograph with crayon additions, 26 9/16 x 20 5/8" (67.5 x 52.4 cm). The Museum of Modern Art, New York. Gift of the artist in honor of Tatyana Grosman

Right:
6. Jasper Johns. *Ale Cans,* working proof. 1964. Lithograph with paint additions, 22 9/16 x 17 5/8" (57.4 x 44.8 cm). The Museum of Modern Art, New York. Gift of the artist in honor of Tatyana Grosman

More important, however, Johns has painted shadows on the right sides of the cans and the base, conveying depth as though the image were lit from the left. The puncture holes are clearly visible on the top of the left can, adding a further illusionistic detail to this most realistic depiction of the sculpture. There is also a fingerprint in the gray gouache on the lower right of the base, very close to where Johns imprinted his thumb on the sculpture to indicate its hand-made status. All of these elements contribute to making this proof the most specific tribute to *Painted Bronze.*

With the next two working proofs, Johns abandons the realistic depiction of the sculpture in favor of more abstract renderings. The black background and olive cans and base are now printed, with a metallic ink used for the cans to simulate the bronze of the sculpture. The shadows added to the second proof, however, are not re-created here. The labels in both pieces are merely sketched in, with no words discernible.

On the third proof (fig. 7), the ocher label has been applied with crayon, as has the red and black scribbling. These black crayon lines suggest the rounded volume of the cans. As first mentioned by Castleman, such markings are evident in the earlier lithograph *Painting with Two Balls.* These energetic black lines, printed along the left half of the image, however, act as pictorial rather than spatial devices.[29] In the fourth proof (fig. 8), the label back-

Left:
7. Jasper Johns. *Ale Cans,* working proof. 1964. Lithograph, printed in color with chalk and crayon additions, 22 13/16 x 17 3/4″ (58 x 45.1 cm). The Museum of Modern Art, New York. Gift of the artist in honor of Tatyana Grosman

Right:
8. Jasper Johns. *Ale Cans,* working proof. 1964. Lithograph, printed in color with ink and crayon additions, 22 5/8 x 17 5/8″ (57.5 x 44.8 cm). The Museum of Modern Art, New York. Gift of the artist in honor of Tatyana Grosman

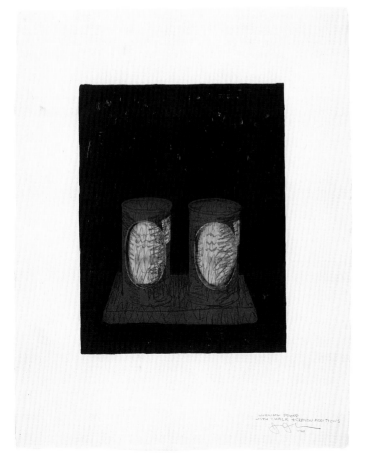

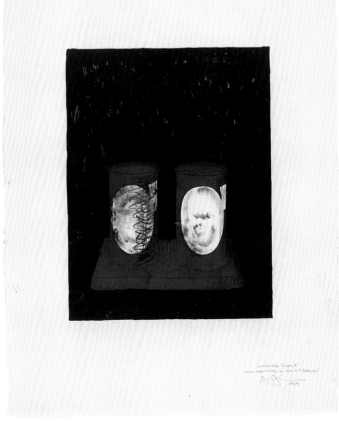

grounds are left blank, allowing the white of the paper to show through. The cans are thereby dramatically flattened out against the picture plane. The black crayon lines are on the left can only, with its heavily colored label, contrasting with the starker, flatter, mirror-like look of the label on the right. In the third proof there is an overall pattern of black lines on the cans and base which enhances a feeling of depth; in the fourth, however, Johns has omitted these lines, which further pushes the image up against the picture plane. The color markings in the labels of the fourth proof are predominantly made out of the artist's fingerprints, which generate an exceptionally beautiful texture and contrast with the printed surfaces of the background and the cans.

In the making of a print, an artist often finds himself waiting for extended periods of time while the printers are proofing, adjusting, or making corrections. Johns frequently used this time in the printshop for further experimentation with his images. During such a period, while working on *Ale Cans,* he transformed one of the numerous proofs with collage elements and hand-drawn additions in ink and crayon (fig. 9). Always meticulous about the titles, mediums, and dating of his work, Johns originally annotated this piece "Working proof with collage, ink and crayon additions."[30] But in the early eighties, he erased that notation, deciding that the work had not been conceived in the development of the final print, but as a distinct, individual project.

The collage elements are two roughly cut pieces of tracing paper, one placed over each can's label. Found in the workshop, the tracing paper was the stencil being used for the lettering BALLANTINE ALE that appears in red on the final print. The black and olive colors in the background, cans, and base are already printed, but Johns has added white, gray, and black crayon over and under the collage. The complexity of the composition is again evidenced by the fact that Johns decided to print the stone with the black outline partly in white, most noticeable in the white lines that run off the right side of the right can. He explores the visual effects of overlaying printed and hand-drawn textures in this piece more than in any of the other proofs. There are various fingerprints on the base and right can; the black outlining rectangle has been drawn in crayon.

The overall effect of this captivating, essentially monochromatic collage is one of hidden mystery. The density caused by the numerous layers — drawing over collage over drawing over print — by seeing through one layer to the masked one beneath, makes this the most distinctive interpretation of the printed image. It reaches a level of abstraction from the sculpture exceeding that of the third and fourth working proofs. Here, two-dimensionality is established not merely by the density of the dark background and the outlining black rectangle, but through the flattening effect of the collaged paper. By partially obliterating the labels yet leaving traces in gray, and tempting the viewer to read beneath the surface, Johns has created an afterimage on paper, a ghost-like souvenir of his *Painted Bronze.*

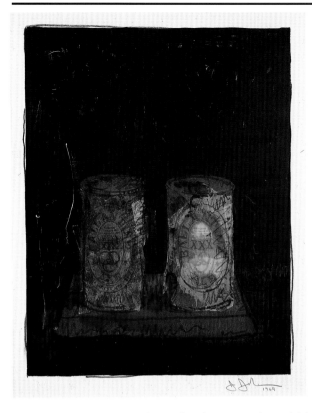

9. Jasper Johns. *Ale Cans*. 1964. Lithograph, printed in color with ink, crayon, and collage additions, 22 13/16 x 17 13/16" (57.9 x 45.2 cm). Collection Nelson Blitz, Jr., and Catherine Woodard, New York

The final proof in the series (fig. 10) is completely printed, with the exception of the black crayon lines that loosely outline the image. Most noticeably, Johns has returned in large part to the dimensional effects of the second proof (fig. 6). The printed labels closely resemble the painted versions of the earlier stage. Here, however, instead of shadows painted in gouache on the right sides of the cans, Johns has used black lithographic crayon lines to suggest volume, now vertical in movement as opposed to the horizontal scribblings seen on the third and fourth proofs. He seems to be adding further illusionistic elements at this late stage in the print's development. But the freely drawn black outline, which becomes the final stone in the editioned print, now contradicts all these devices as it reinforces the two-dimensionality of the paper, confounding our reading of the cans as volumetric.[31] The effect is much subtler than in the third and fourth proofs. There, obvious distortions of the sculpture confirmed two-dimensionality. Here, by reverting to a more illusionistic depiction, yet contradicting it with devices that deny spatial perspective, Johns creates the perceptual ambiguity characteristic of his best work.

The differences apparent between this final proof and the editioned *Ale Cans* print (fig. 4) are twofold: the color of the cans and base is a darker, richer olive, and the network of black lines on the cans and base is intensified in the print. A proof (fig. 11), printed from the two stones with the black crayon lines depicting the sculpture and the final black outline, offers a closer look at some of these alterations. As the cans are only lightly shaded on the left while heavily worked on the right, they have the appearance of being lit from the left. There are shadows on the base again, executed in heavily scratched black lines. Both these effects recall the second

10. Jasper Johns. *Ale Cans,* working proof. 1964. Lithograph, printed in color with crayon additions, 22 11/16 x 17 11/16" (57.6 x 44.9 cm). The Museum of Modern Art, New York. Gift of the artist in honor of Tatyana Grosman

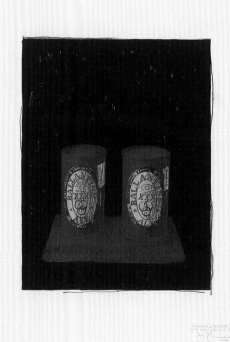

painted proof. The drawing on the base and background areas creates a sense of depth and activates the surface texture of the final print. Seen without the color, and in particular without the labels, the image is a reference to, not a depiction of, the sculpture. With the addition of the black rectangular outlines, Johns reminds us that this is exactly what it is, a mere representation on a sheet of paper, not to be confused with the sculpted object. Johns printed this image, at least once, on thick oatmeal-colored Jeff Goodman paper which was made especially for him and includes the stenciled JJ watermark. Other proofs of this image are annotated "trial proof." The proof on Goodman paper, however, is annotated "artist's proof" and includes the ULAE (Universal Limited Art Editions) chopmark as well, implying that Johns felt that this proof was a finished work in itself, not a preliminary stage to another. The beauty of his draftsmanship and the energy of his layered scribbling are most evident in this black rendering. The rough texture of the paper appears to frame the image and the oatmeal color evokes a warmth, a poignancy, not seen in any of the other proofs. By leaving the surrounding black rectangle unfinished, with upper left and lower right corners open, Johns prevents closure of the image; this seeming detail creates further spatial tension, reiterating the flatness of the paper as the background now runs into the margin.

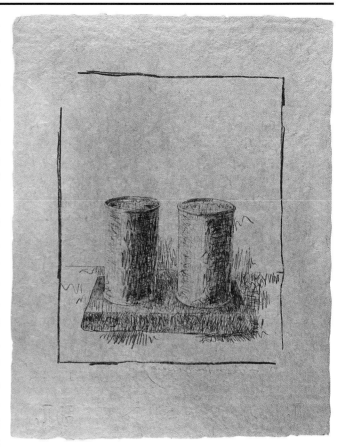

11. Jasper Johns. *Ale Cans*, trial proof. 1964. Lithograph, 25 7/8 x 20 1/16" (65.8 x 50.9 cm). Collection the artist

Like the print itself, the title Johns gave to *Ale Cans* is a kind of reinterpretation of the sculpture; it plays against the sculpture's title. The title of the *Painted Bronze* sculpture differed from the titles of the previous sculptures, which had coincided with the identity of their subjects: flashlights and light bulbs. With *Painted Bronze,* however, the most realistic of the sculptures to date, he chose to title not the subject but the process, the mediums involved in the art-making, emphasizing the sculpture as art object. The irony of its highly realistic representation of actual Ballantine cans was heightened by this change in the nature of the title. But even more ironically, Johns titled the lithograph — which is a depiction of the sculpture, not of the actual cans — *Ale Cans*.[32] He forced the viewer back beyond the sculpture to its source. The sculpture had had to be distinguished from its model, thus the paradoxical title *Painted Bronze* — depicting the real object, but titling it as the sculpted object. A work on paper, however, does not run the risk of being taken for the real object. Therefore the print's irony is produced by, in a sense, reversing the paradox — by depicting the sculpted object, but titling it as the real object. Johns used the title *Ale Cans* for all but one of the subsequent prints and drawings that portray *Painted Bronze*.[33]

Ale Cans from *1st Etchings*, 1968

In 1967 Johns embarked on his first portfolio of etchings, and titled it by process, *1st Etchings*. The suite consists of seven prints based on his sculptures. A photo-engraving of the respective sculpture is also printed on each sheet. *Painted Bronze* is alluded to five times in the *1st Etchings* portfolio — on the cover, title page, and colophon, as well as in etched and photo-engraved renderings — reinterpreting the image in five different physical forms within one work.

Johns alerts the viewer that this suite is devoted to his sculpted work by affixing an actual unsoldered Ballantine can to the wooden portfolio cover (fig. 12). An early work by Rauschenberg titled *Paint Cans* of 1954 (fig. 13), which is in Johns's collection, bears mentioning with respect to the portfolio cover. The right side of the Rauschenberg assemblage consists of a stack of four metal cans of varying sizes. The left side has two unsoldered and flattened cans, one above the other, with visible labels, indicating the brand of paint. In this piece, one of his first titled works, Rauschenberg makes the title a play on the objects themselves and the artistic process. A link to *Painted Bronze* is obvious, since Johns used Ballantine cans as his own paint cans in the studio. But instead of taking the paint can and making it a Duchampian Readymade or a Rauschenberg assemblage, Johns replicated two of them in

Left:
12. Jasper Johns. Cover from the portfolio *1st Etchings*. 1967. West Islip, Universal Limited Art Editions, 1968. Pre-soldered ale can on wood, 28 1/8 x 22 1/16" (71.4 x 56 cm). The Museum of Modern Art, New York. Gift of the Celeste and Armand Bartos Foundation

Right:
13. Robert Rauschenberg. *Paint Cans*. 1954. Relief with paint, paper, and fabric on metal cans, wood, and objects, 15 1/4 x 16 1/4 x 4 1/4" (38.8 x 41.3 x 10.8 cm). Collection Jasper Johns

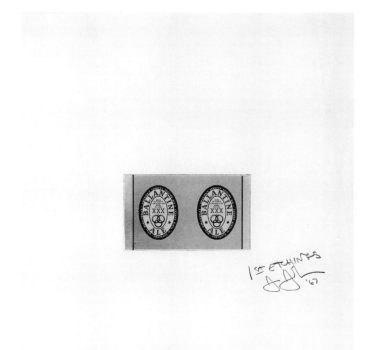

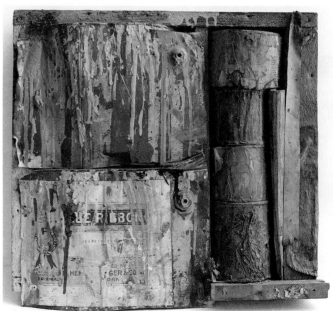

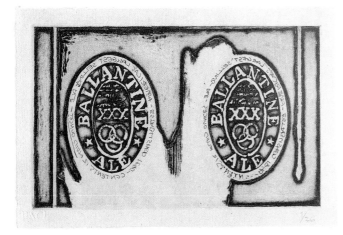

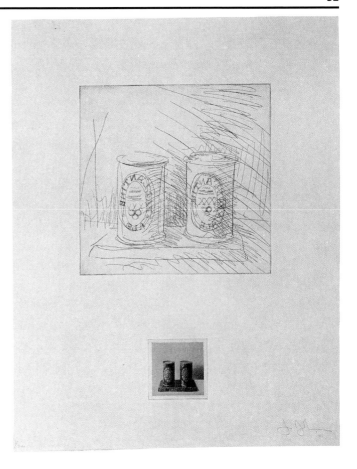

bronze and painted the labels. Nonetheless, the idea of using an actual "pre-soldered" Ballantine can and attaching it to the cover of *1st Etchings* may have been suggested by Rauschenberg's early construction.

Thus, for the first appearance of *Painted Bronze* in the portfolio, Johns incorporated a real object but cleverly came up with a two-dimensional version of it. Then, on the title page (fig. 14), he etched the front and back labels of a can, simulating the motif on the cover. On the colophon page, the final time the ale cans appear, they are printed in relief from the same plate, making this closing page a negative echo of the opening. These two etchings are images of the can itself, not the sculpture. In all three of these versions, however, the double image of the sculpture is subtly preserved through the inclusion of two labels. This is another example of Johns's ambiguity of objects, alternating images of the sculpture with ones of its model in life.

To the etched version of *Painted Bronze* Johns added a photographic depiction of the sculpture itself and succinctly posed some of his recurring questions about perception (fig. 15). This is the first of several examples where he doubles the double image. The contrast between autographic and mechanically reproduced renderings is contained within a single work. Johns asks the viewer to consider what is different between the two representations of the sculpture. Is the photographic version more "authentic" than the hand-drawn etching? Is it more illusionistic, or more real? It is not surprising that he chose his sculptures as the basis for this investigation.[34] Just as in his painting Johns rarely depicted three-dimensional objects by hand, preferring to incorporate the actual objects or casts of them, so in prints and other works on paper he preferred to trace an object, stencil the word for the object, or, by the mid-sixties, photograph the object. Indeed photography also resolved the problems of illusionism, for the photograph became an object itself, which was then incorporated into the work like any other object.

Left:
14. Jasper Johns. Title page from the portfolio *1st Etchings*. 1967. West Islip, Universal Limited Art Editions, 1968. Etching, 6 x 9 5/16" (15.2 x 23.7 cm). The Museum of Modern Art, New York. Gift of the Celeste and Armand Bartos Foundation

Right:
15. Jasper Johns. *Ale Cans* from the portfolio *1st Etchings*. 1967. West Islip, Universal Limited Art Editions, 1968. Etching and photo-engraving, 25 3/8 x 19 11/16" (64.5 x 50 cm). The Museum of Modern Art, New York. Gift of the Celeste and Armand Bartos Foundation

In the etching, Johns has quickly sketched the outlines of the cans and base and the broader details of the labels. The image is reversed, however, with the open can appearing on the right and the labels' lettering now backwards. The reversal of an image is the norm in printmaking, and Johns had worked against this in the 1964 lithograph (fig. 4) by drawing backwards on the stone so that the final print would read correctly. In this etching, however, he used the reversal to emphasize the "printedness" of the image, reinforcing its status as art object, not real object, and stressing the two-dimensionality of the print. The photo-engraved image below reproduces the sculpture and offers a striking visual contrast with the loosely rendered and "reversed" etching. (The photo-engraved version would receive the title *Painted Bronze,* the same as the sculpture, when it appeared on its own in a second portfolio; but the title page and etching are titled *Ale Cans,* since the photographic image is a "true" reproduction of the sculpture, whereas the others are independent of it.) In addition, the photo-engraved rendering was given a realistic setting. The sculpture was set on a table and then photographed, putting it in a context denied to any of the other depictions of the sculpture, which is usually posed against a flat background with no spatial indications.

In his typical fashion, Johns returned to the plates for these prints two years later in creating the portfolio *1st Etchings, 2nd State* (1967–69). Printmaking offered Johns the possibilities to easily rework his images, and he often took advantage of this flexibility, experimenting with additional mediums to alter the mood and context. He added rich layers of aquatint and open-bite etching to each of his old plates. In addition, he disassociated the photo-engravings from their etchings, printing them on individual sheets of paper. Wiry lines now scrawled over the labels on the title page; heavily etched strokes now surrounded the photo-engraving, effectively framing the sculpture and partially denying the illusionistic setting. In *Ale Cans* (ULAE 58), Johns transformed the sketchy etching into a Romantic, somber vision with a luxuriant surface. Exploiting the possibilities of aquatint, he gave the cans a weighty, more volumetric appearance.

Decoy, 1971

1st Etchings, 2nd State was an important component in Johns's next manipulation of his *Painted Bronze:* the prints and paintings titled *Decoy,* works which show the increasing role of photography in his art of the late sixties and early seventies.[35] The *Decoy* lithograph (fig. 16), which preceded the two painted versions, is an amalgam of earlier imagery, now repositioned and reworked to form a new composition. As Johns has said:

It interests me that a part can function as a whole or that a whole can be thrown into a situation in which it is only a part. It interests me that what one takes to be a whole subject can suddenly be miniaturized, or something, and then be inserted into another world, as it were.[36]

The cast of the leg and lettering originated in the painting *Passage II* (1966). A photograph of a section of the painting was transferred to a lithographic plate used in a print of the same year, *Passage I* (ULAE 29). Johns reused one of the plates from this print to make *Decoy*. Along the bottom of *Decoy* is a frieze of his sculptures, taken from the cancelled copperplates of the photo-engravings in *1st Etchings, 2nd State,* here printed in reverse and negative. The centerpiece of the print is a single ale can, printed lithographically from a photograph taken of an actual Ballantine can.

All of these reappearances from earlier works are photographically rendered. There are several levels of reproduction included in *Decoy,* each at a greater distance from reality: a photograph of an object (the ale can), a photograph of a previous work of art (*Passage II*) that included a cast of an object, and a manipulated set of photo-engravings of previous works of art (*1st Etchings, 2nd State*). In discussing the predella of photo-engravings, Richard Field pointed out that they are the furthest removed replications of any of Johns's work, "becom[ing] mere ghostly reminders of past evidences."[37] Johns has exploited photography not only to refer back to his personal iconography but to suggest the ambiguity of perception.

The conception of the *Decoy* lithograph began in 1967. A working proof of that year includes the central solitary ale can,[38] revealing that it was an early decision to reproduce the can alone. This is the only time Johns separated his celebrated double image, allowing "a part to function as a whole." When asked why he included only one can, Johns responded by saying that sometimes art refers to something other than art: art can also refer to life.[39] He is signaling that, although *Decoy* is filled with fragments of his previous works, and although the can initially registers as another fragment, it is actually functioning as an imposter: the implied reference is to the world of real objects, not the world of depicted objects.

The ale can appears twice in *Decoy,* both times in photographic depiction. Johns here uses photography, once again, as a means of conveying three dimensions in two. The photographs themselves have become "parts" of the "whole" composition. (The photo-engraving, which stood as a "part" in the first etching portfolio [fig. 15], became a "whole" in the second etching portfolio. However, in *Decoy* [fig. 16] it has again become a "part" of something else.) Although both representations of the cans are derived from photographs, they present differing degrees of realism. In the lithograph, the frieze of sculptures is flat and almost indecipherable. The central can, however, appears very illusionistic, with its strong shadow off to the right. Johns has added a framing rectangular border, which serves to deny this spatial depth and reinforce the two-dimensionality of the image. Posed in three-quarter view, it seems to be a portrait of one of his models. The can then takes on the role of a painting within the painting, or in this case, a print within a print. This framing device, more evident here, recalls the final black outline added to the

1964 *Ale Cans* lithograph (fig. 4) and has a similar compositional function.

The framing device becomes more pronounced in the two paintings of *Decoy* (see fig. 17), and the frieze is more illusionistically portrayed than the central can. The photograph of the can is now silkscreened onto the canvas and heavily overpainted in metallic paint. It is surrounded by expressive gray strokes, almost obliterating the shadow and flattening out the photograph's inherent perspective. The sculptures in the frieze, also silkscreened from photographs, are now more clearly defined than in the lithograph, but Johns has added gray framing marks around them as well to counter the illusion of spatial depth. Thus, unlike *1st Etchings,* where he juxtaposed the hand-drawn and the photographic depictions, Johns has combined two photographic versions in *Decoy.* Yet he still contests the veracity of the cans' representations by altering the photographs with hand-drawn compositional devices, to create his desired ambiguity.

All of the ale-can images discussed thus far have been true to scale, with two exceptions, the photo-engravings in *1st Etchings* and *1st Etching, 2nd State.* Likewise, in *Decoy* the frieze derived from these photo-engraved plates is reduced in scale. The central can, however, is life-size. Johns emphasizes this by including in the print the instructions written on the photograph REDUCE TO 4¾"(FRONT OF CAN). When Johns enlarges the print into the painted *Decoy* in the Ganz collection (fig. 17), the same words appear. The image, however, has now been enlarged to 9½", twice its original scale, rendering the inscription contradictory and the can a decoy (in a different sense). By keeping the inscription but doubling the size of the actual can, Johns points to the illusionary nature of photography in an additional way.

Similarly, the frieze of sculptures in the painting, unlike the reduced photo-engraved image in *1st Etchings* (fig. 15) and its afterimage in the *Decoy* lithograph (fig. 16), has been enlarged and is now life-scale at 4³/4". Thus in both printed and painted versions of *Decoy,* Johns keeps one of the two ale-can appearances true to scale. As in the case of *1st Etchings,* with its etched and photo-engraved depictions, it appears that Johns feels free to manipulate the scale of photographs when there is a reference point to real scale somewhere else in the work.

Johns returned to *Decoy* in 1973. The additional seven plates printed for the lithograph *Decoy II* (ULAE 125) include a rainbow roll of color over the lower frieze, which obliterates the images of the sculptures. He has also added a dark gray border around the central can, further isolating the profile within the composition. This print is the final recapitulation of this series of "parts" and "wholes" that is one of the artist's most complex investigations into the myriad levels of perception and artistic representation.

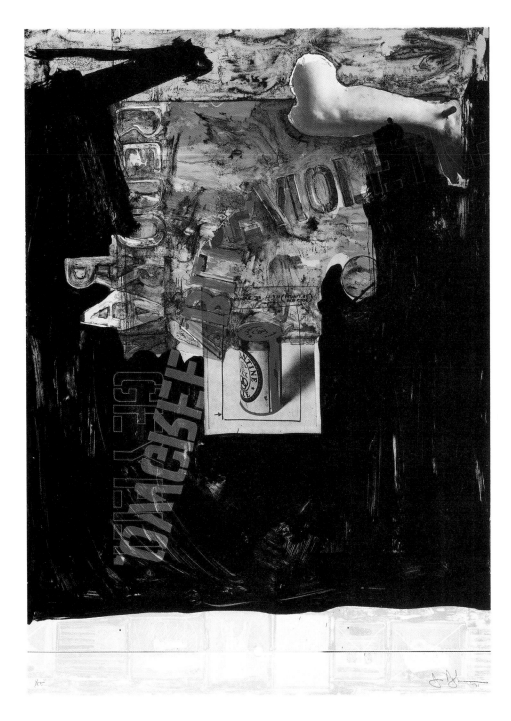

16. Jasper Johns. *Decoy*. West Islip, Universal Limited Art Editions, 1971. Lithograph, printed in color, 41 1/2 x 29 9/16" (105.4 x 75.1 cm). The Museum of Modern Art, New York. Gift of Celeste Bartos

Opposite:
17. Jasper Johns. *Decoy*. 1971. Oil on canvas with brass grommet, 72 x 50" (182.9 x 127 cm). Collection Mrs. Victor W. Ganz, New York

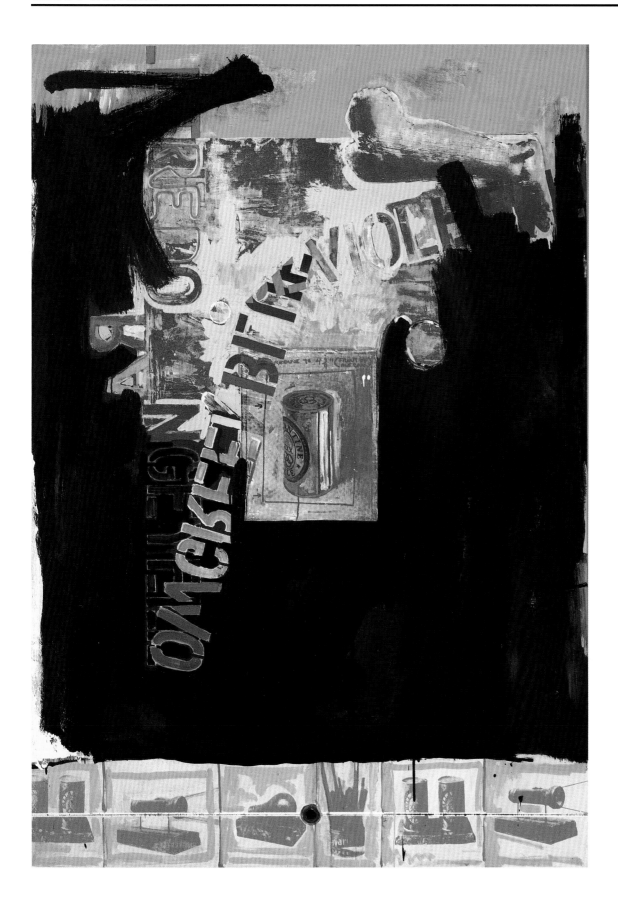

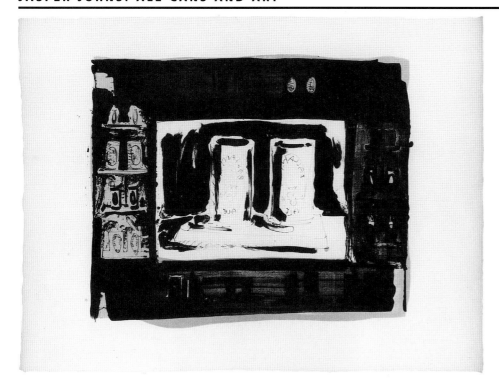

18. Jasper Johns. *Ale Cans*. Los Angeles, Gemini G.E.L., 1975. Lithograph, printed in color, 22 3/4 x 31 1/4" (57.8 x 79.4 cm). Gemini G.E.L., Los Angeles

Ale Cans, 1975

In 1974 Johns made his first drawings of the *Painted Bronze* sculpture, all ink on plastic. Each is in a different style but all keep the ale cans true to scale. All but one, *Ale Cans II,* are head-on views of the sculpture, in which the tops of the cans and base are not shown. This frontal stance deprives them of any sense of depth and in the pen line drawing *Ale Cans III* lends itself to a diagrammatic depiction.[40]

Johns was working on and off in Los Angeles at the Gemini GEL print workshop during 1974 and 1975 on an ambitious four-part print, *Four Panels from Untitled 1972* (ULAE 149). While at the studio he also made four lithographs titled *Ale Cans* (ULAE 151–154). By this time Johns was well-versed in the potential of the medium and achieved a wide range of effects with washes, scratches, and direct acid applications to the stones. The third *Ale Cans,* printed in a rich brown-black, has overall washes of ink that bear a resemblance to the velvety surface of an aquatint. In contrast, the fourth *Ale Cans* is covered with agitated scratches highlighted in white against a deep black ground. The largest and most unusual of the series is the first *Ale Cans* (fig. 18). The central motif of the cans is sketchily drawn with large, expressive brushwork roughly filling in a black background. The lettering on the cans is now backwards, evidencing Johns's quick, intuitive approach. The cans are surrounded by a ring of miniature *Painted Bronze* sculptures, printed in black against a blue ground, each drawn in a slightly different style. Johns covered this ring with a layer of broad black strokes which accentuate this embellished border and create the effect of a heavy, ornamental frame. En-

hanced by the white margin of the paper, this print is Johns's most overt attempt to frame and flatten out the sculpture.

The second *Ale Cans* (fig. 19) is an unusual example of Johns's lithographic interpretations of *Painted Bronze* in its doubled image, relating back to his ale-can print in the *1st Etchings* portfolio. The lithograph is most likely made from a transfer drawing, a drawing on thin, translucent paper that workshop printers transfer to the stone. It is printed in pale colors that only hint at the somber tonality of the sculpture and 1964 lithograph. The cans are mirror images of each other, with a visible seam running vertically through the center of the image. There are vertical and horizontal black bars that again serve to bring the image up to the picture plane. As in the 1967 etching (fig. 15), there is a second, smaller ale-can image printed below this mirror image. The lower version is a pale afterimage printed in taupe, echoing the background color of the upper cans. This ghost image is made from Johns's fingerprints, which only crudely outline the cans and base and hint at the oval shape of the labels. There are two india-ink drawings of 1975, titled *Ale Cans V* and *Ale Cans VI* (fig. 20), on folded paper, that must have served as studies for the lower cans. In them it appears that Johns composed one can in fingerprints, and by folding and blotting the paper achieved the mirror image. It is exactly during this period that Johns began his hatching paintings *Corpse and Mirror* (1974) and *Corpse and Mirror II* (1974–75), which focus on the perceptual possibilities of mirror images in his abstract work. The flatness of a mirror, implied in all of these works and in the 1975 lithograph, reinforces the two-dimensionality of this unusual depiction of *Painted Bronze*. By printing one pair of cans below the other, Johns again doubles the double, and contrasts different ways of creating and perceiving the image. With the lower mirrored image in *Ale Cans,* he reminds the viewer that the print is a flat illusion, a phantom depiction of *Painted Bronze*.

Ale Cans, 1990

Johns made three ink-on-plastic drawings of the sculpture in 1978. For twelve years he did not return to the image, but in 1990, as a wedding gift for two friends, Johns overpainted one of the trial proofs from two black stones of the 1964 lithograph *Ale Cans* with watercolor and crayon (fig. 21). The transparency of the watercolor lends an overall luminosity and lightness to the image that does not exist in any of the previous renderings. Johns places the sculpture against a black watercolor background, recalling the format of the earliest print, but its aqueous texture and subtle underlayer of blue watercolor transform melancholy into optimism; the pathos of the 1964 lithograph has been transposed into another key.

Consistent with Johns's practice in the 1980s of camouflaging imagery borrowed from art-historical sources within his backgrounds, he concealed two faces of the Mona Lisa beneath the watercolor, a whole face in the upper

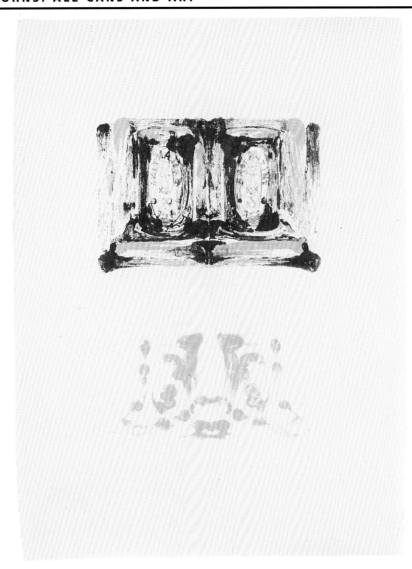

Left:
19. Jasper Johns. *Ale Cans*. Los Angeles, Gemini G.E.L., 1975. Lithograph, printed in color, 19 x 14³/₄" (48.3 x 37.5 cm). Gemini G.E.L., Los Angeles

Right:
20. Jasper Johns. *Ale Cans VI*. 1975. India ink on folded paper, 8¹/₄ x 10¹/₄" (21.0 x 26.1 cm). Private collection, London

left and a half-face at the edge of the image in the upper right. Either dissatisfied with these images or merely for the sake of concealment, he obscured them with the blue and black washes.

The cans themselves are in orange watercolor outlined in black crayon, with hints of blue radiating from the edges. Johns adds black crayon scribbles to the right side of the labels and the base, as he did in the lithograph. But the most remarkable quality of this piece remains the celebratory, even joyous mood it conveys. The depiction of these two like but dissimilar objects, united on a base, can perhaps be read as a metaphor for a marriage — a nuptial tribute — and a new discovery in the way that Johns has interpreted his *Painted Bronze*.

21. Jasper Johns. *Ale Cans.* **1990. Lithograph with watercolor and crayon additions, 16 1/2 x 12 7/8" (41.9 x 32.7 cm). Private collection, Los Angeles**

Notes

In the captions, the dimensions indicated for works on paper refer to sheet size, with height preceding width. A date given in parentheses is not inscribed on the work.

All paintings and sculptures by Jasper Johns mentioned in the text are illustrated in Michael Crichton, *Jasper Johns* (New York: Harry N. Abrams in association with the Whitney Museum of American Art, 1977). Prints mentioned in the present text but not illustrated are identified by a ULAE number, referring to *The Prints of Jasper Johns, 1960–90: A Catalogue Raisonné,* forthcoming from Universal Limited Art Editions, West Islip, New York.

1. Jasper Johns, "Sketchbook Notes" (1965), *Art and Literature,* 4 (Spring 1965), pp. 185–92.

2. Jasper Johns, interview with the author, November 6, 1990.

3. Both versions of *Glass of Absinth* are illustrated in William Rubin, *Picasso and Braque: Pioneering Cubism* (New York: The Museum of Modern Art, 1989), p. 323.

4. The bronze sculptures were cast at Modern Art Foundry, 18-70 41st Street, Long Island City. They are *Light Bulb,* four casts; *Flashlight; Painted Bronze* (ale cans), two casts; *Painted Bronze* (paintbrushes); *Flag,* four casts; and *Bronze (Light Bulb, Socket, Wire on Grid),* four casts.

From the outset, Johns intended to make two casts of *Painted Bronze* (ale cans). The second cast, however, was not completed until 1964. It differs slightly from the first in its painting but otherwise appears the same. A topic of frequent confusion, the correct identification of the second cast is: *Painted Bronze,* 1960 (2/2, cast and painted in 1964).

5. "Jasper Johns: Drawings and Sculpture," Leo Castelli Gallery, New York, January 31–February 25, 1961.

6. Johns's first doubled work appeared the previous year, 1959, with the painting *Two Flags.*

7. Illustrated in *Robert Rauschenberg* (Washington, D.C.: National Collection of Fine Arts, 1976), p. 93.

8. On the relationship with Duchamp, see Max Kozloff, "Johns and Duchamp," *Art International,* 8 (March 1964), p. 42.

9. Quoted by Johns in his review of Duchamp's *The Green Box,* in *Scrap,* no. 1 (December 23, 1960), p. 4.

10. Jasper Johns, "Thoughts on Duchamp," *Art in America,* 57 (July–August 1969), p. 31. For an analysis of Duchamp's influence on Johns's sculpture, see Roni Feinstein, "New Thoughts for Jasper Johns' Sculpture," *Arts Magazine,* 54 (April 1980), pp. 139–45.

11. The idea of viewer participation appears as early as 1955, in *Target with Plaster Casts,* in which the lid over each cast is movable, and continues in works such as *Tango,* with its inviting crank. Johns conveys this idea most clearly in *Jasper Johns and . . .* (1971), an editioned object including a simply drawn black-target lithograph with a paintbrush and three watercolor pads collaged below it, ostensibly proposing that the viewer/owner complete the piece.

12. Anne d'Harnoncourt and Kynaston McShine, eds., *Marcel Duchamp* (New York: The Museum of Modern Art; Philadelphia: Philadelphia Museum of Art, 1973), p. 295.

13. Leo Steinberg, "Jasper Johns: The First Seven Years of His Art," in *Other Criteria: Confrontations with Twentieth-Century Art* (London and New York: Oxford University Press, 1972), pp. 52–53.

14. Roberta Bernstein, *"Things the Mind Already Knows": Jasper Johns — Painting and Sculpture, 1954–1974* (Ann Arbor: UMI Research Press, 1985), p. 5.

15. Jasper Johns, in Katrina Martin, dir. and prod., *Hanafuda: Jasper Johns* (film), 1980; quoted in Riva Castleman, *Jasper Johns: A Print Retrospective* (New York: The Museum of Modern Art, 1986), p. 20.

16. There is one drawing, *Sketch for Flashlight* of 1958 (illustrated in Nan Rosenthal and Ruth E. Fine, *The Drawings of Jasper Johns* [Washington, D.C.: National Gallery of Art, 1990], p. 148), that precedes the sculpture *Flashlight I* of the same year, as well as two light-bulb drawings: one in 1957 — of a hanging light bulb for a sculpture that was not executed until 1969, as an editioned lead relief — and one in 1958 that followed *Light Bulb I.*

17. Jasper Johns, interview (1965) published in David Sylvester, *Jasper Johns Drawings* (London: Arts Council of Great Britain, 1974).

18. Bill Goldston of ULAE recalls that Johns finished the second cast of *Painted Bronze* before his trip to Japan in 1964 but did not complete the lithograph until after his return.

19. Although Johns completed over forty-five prints between 1960 and 1963, *Ale Cans* is the only published print in 1964.

20. When asked about the coincidence of his printmaking and sculpting activities, Johns denied any concrete connection.

21. Castleman, *Jasper Johns: A Print Retrospective,* p. 18.

22. There is a 1960 charcoal drawing of the same composition, made after the encaustic painting of the same year.

23. Richard Field, *Jasper Johns: Prints, 1970–1977* (Middletown, Conn.: Davison Art Center, Wesleyan University, 1978), p. 8.

24. Johns's working proofs engendered an important exhibition in 1979 titled "Jasper Johns: Working Proofs," organized by Christian Geelhaar at the Kunstmuseum Basel; see Geelhaar, *Jasper Johns: Working Proofs* (Basel: Kunstmuseum Basel; London: Petersburg Press, 1979). The working proofs for *Ale Cans* were included in that exhibition.

25. For a detailed discussion of Johns's various drawing mediums, see Ruth E. Fine's essay "Making Marks," in Rosenthal and Fine, *The Drawings of Jasper Johns.*

26. Johns, interview with the author.

27. Illustrated in d'Harnoncourt and McShine, eds., *Marcel Duchamp,* p. 272.

28. See Geelhaar, *Jasper Johns: Working Proofs,* p. 65.

29. See Riva Castleman, *Jasper Johns: Lithographs* (New York: The Museum of Modern Art, 1970).

30. This piece is illustrated with its original annotation in Geelhaar, *Jasper Johns: Working Proofs,* plate 2.8. A further indication of the importance to the artist of the accuracy of these annotations is a note from August 24, 1985, that Johns wrote to The Museum of Modern Art to check if one of these proofs was correctly marked as a "working proof" and not as a "trial proof." He wrote that he had already changed one of them.

31. The use of the rectangular framing device can be seen in some of Johns's early drawings as well, such as *Figure 1* (c. 1959); illustrated in Rosenthal and Fine, *The Drawings of Jasper Johns,* p. 123.

32. When the print was published, it was titled *Beer Cans.* By the time the first volume of Richard Field's catalogue raisonné appeared, in 1970, the title had been changed to *Ale Cans,* accurately reflecting the cans' labels.

33. See the photo-engraving in the portfolio *1st Etchings, 2nd State,* mentioned below.

34. This is not Johns's first use of photography in his printmaking. *Pinion* (1963–66), *Passage I* and *Passage II* (both 1966), and *Voice* (1967) incorporated photographic images, taken from earlier paintings, into the composition.

35. For a detailed discussion of the evolution of the prints and paintings of *Decoy,* see Roberta Bernstein, *Jasper Johns Decoy: The Print and the Painting* (Hempstead, N.Y.: Emily Lowe Gallery, Hofstra University, 1972).

36. "Interview with Jasper Johns" (1978), in Geelhaar, *Jasper Johns: Working Proofs.*

37. Field, *Jasper Johns: Prints, 1970–1977,* p. 42.

38. Illustrated in Bernstein, *Jasper Johns Decoy,* n.p.

39. Johns, interview with the author.

40. For a detailed description of the *Ale Cans* drawings of the 1970s, see Rosenthal and Fine, *The Drawings of Jasper Johns,* pp. 154–57.

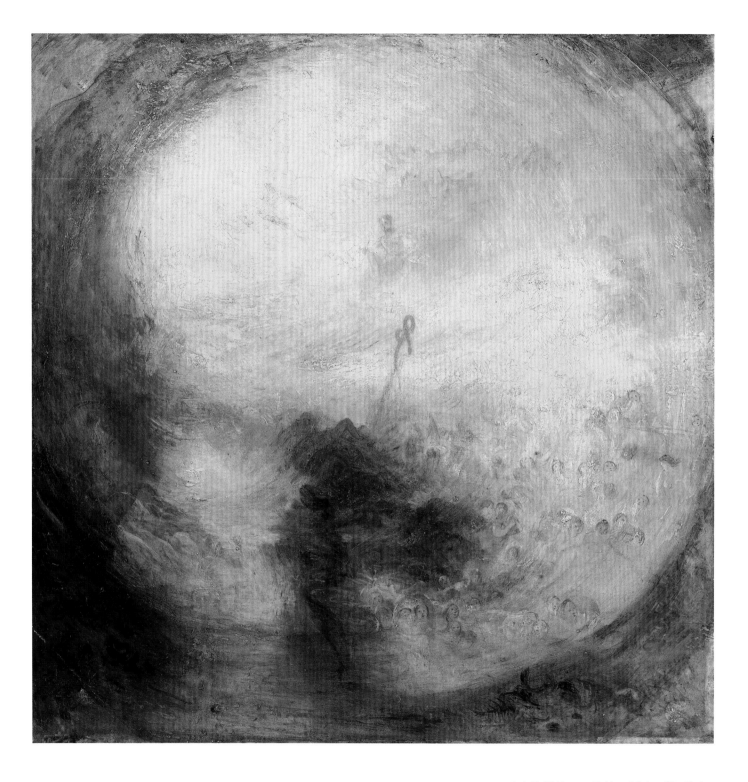

1. J. M. W. Turner. *Light and Colour (Goethe's Theory) — The Morning after the Deluge — Moses Writing the Book of Genesis.* exh. 1843. Oil on canvas, 31 x 31" (78.5 x 78.5 cm). Tate Gallery, London. The Turner Collection

The Precursor

John Elderfield

The meanings are our own —
It is a text that we shall be needing. . . .
 Wallace Stevens[1]

In 1966 — the Minimalist year, which saw "Primary Structures" at The Jewish Museum and "Systemic Painting" at the Guggenheim[2] — The Museum of Modern Art held an exhibition that proved to be the most popular in its then thirty-seven-year history. The subject of the exhibition was the paintings and watercolors of Joseph Mallord William Turner, 1775–1851.[3]

In the catalogue for "Turner: Imagination and Reality" — explicitly in the foreword by Monroe Wheeler and implicitly in the critical essay by Lawrence Gowing — Turner was offered as a precursor of contemporary abstract painters, in particular those "whose principal means of expression is light and color."[4] Earlier, the Museum very exceptionally had devoted exhibitions to "other periods of art history in which the modern spirit happened to be foreshadowed or by which modern artists have been influenced."[5] But there was "no precedent for a one-man show of an artist who died more than a century ago." So, why Turner?

Precursors of modern art have worn a surprising variety of guises and have preached many creeds. Always, however, they have served two interrelated functions: first, to contemporize the historical and, second, to historicize the contemporary.

First: "Turner died a hundred and fifteen years ago, but some of his pictures look as if they were painted yesterday," the Museum's press office asserted.[6] His art "astounded and bewildered his contemporaries," said Gowing, "and is still not altogether comprehensible today."[7] If these two claims are true, the work of Turner is continuous with today's incomprehensible art. Thus, Turner becomes a contemporary painter, at one with the painters who derive from him; one of that group. For the historical and the contemporary are thereby equal in the present, equally ahistorical: a Turner (fig. 1) looks as much in imitation of a Pollock (fig. 2), let us say, as a Pollock looks in imitation of a Turner.[8]

Contemporization of the historical can be achieved by purely conceptual

2. Jackson Pollock. *The Deep*. 1953. Oil and enamel on canvas, 7' 2³/₄" x 59¹/₈" (220.3 x 150.2 cm). Musée National d'Art Moderne, Centre Georges Pompidou, Paris. Given in memory of John de Menil by his children and the Menil Foundation

recontextualization; that is to say, purely by arguing (or by asserting) that Turner is in effect a contemporary. In the case of the Turner exhibition, however, the effect was reinforced by *literal* recontextualization: not only by moving historical pictures into a modern museum but also by removing them from behind glass and from their elaborate historical frames into more modern moldings,[9] and by displaying them on severely bare walls with a sleek, Plexiglas-topped barrier in front (fig. 3). The Turner shown at The Museum of Modern Art in 1966 is therefore presented as if he were a contemporary

3. Installation view of the exhibition "Turner: Imagination and Reality," The Museum of Modern Art, New York, 1966

artist; that is to say, in imitation of a contemporary artist. So we now have another question to answer: What is the real identity of this contemporary artist called Turner?

The second function of a precursor, I said, is to historicize the contemporary: "These pictures, from the last twenty years of Turner's life, revealed potentialities in painting that did not reappear until our time," claimed Gowing and Wheeler.[10] But is it not true also to say that our painting revealed potentialities in these pictures that did not appear in Turner's time? Of course, the novelty of Turner's late pictures was noticed when they were made. Nevertheless, to choose to exhibit in 1966 at The Museum of Modern Art thirty-seven late oils and only two early oils is unquestionably a critical judgment of Turner influenced by contemporary art.[11] Not any Turner will do. It must be a particular Turner.

This is most easily demonstrated, in fact, with reference to the two early oils that were chosen. The early Turner had to be represented in some form because "one cannot separate an artist's late work from the rest; its meaning unfolds throughout his life."[12] Not to include early Turner would be to disrupt the idea of continuity between early and late, between past and present: the whole idea of the exhibition. It need only be a token representation, and preferably should be, lest attention be drawn away from the late work. It does, however, have to make the right point. And here, the wrong point very nearly was made.

The original proposal was to have just one early work, the highly the-atrical *Fifth Plague of Egypt* (fig. 4). However, as Gowing eventually realized, this picture alone would give "quite a false idea of Turner's starting point. It emphasizes the aspect of the Sublime but doesn't give the opposite point of view which is equally important."[13] In other words, it overemphasizes the dra-matic and rhetorical in Turner. So a second early work was added, the more lyrical *Buttermere Lake* (fig. 5), where "the paint itself" was as real to the artist, claimed Gowing, as what it represented.[14] Thus early anticipates late which anticipates still later, namely the contemporary:

Now we find that a kind of painting, which is of vital concern to us, was anticipated by Turner. And by Turner alone. . . . Turner showed that a certain potentiality was inherent in the nature of painting. The latent possibility has emerged again.[15]

The contemporary is thus historicized, returned to the moment of Turner's death to pick up where Turner left off. (Gowing's catalogue essay appropriately concludes with a lengthy description of a posthumous invento-ry of Turner's studio.)[16] So, a Pollock, let us say, is really an extremely late Turner. Simultaneously, the continuity of past and present is confirmed — and with it the idea of artistic progress as unfolding within, not against, tradi-tion — and the antagonism of the avant-garde is ameliorated as it gains a respectable paternity. A wonderful premise for a successful exhibition. But still: Why Turner? And what is his real identity?

In 1966, nobody could agree. The arrival of the loans from London on the S.S. *United States* on March 4 was announced in the *New York Times* with the explanation that Turner's "revolutionary works . . . are regarded by many art historians as precursors of French impressionism."[17] But that, surely, would not bring them to The Museum of Modern Art. The organizers of the exhibi-tion said that the Turners "tell us something about the inner nature of a

Left:
4. J. M. W. Turner. *The Fifth Plague of Egypt.* exh. 1800. Oil on canvas, 49 x 72" (124 x 183 cm). The Indianapolis Museum of Art. Gift in memory of Evan F. Lilly

Right:
5. J. M. W. Turner. *Buttermere Lake, with part of Cromackwater, Cumberland, a Shower.* exh. 1798. Oil on canvas, 36 1/8 x 48" (91.5 x 122 cm). Tate Gallery, London. The Turner Collection

whole pictorial tradition, of which recent American painting is an integral part."[18] But they did not say, precisely, which pictorial tradition and which examples of recent American painting they had in mind. It was clear, nonetheless, that there were associations to be found between Turner and contemporary painters; also that these associations came as a revelation to many visitors to the show. Even at the preview, reported the *Herald Tribune,* "guests, numbering in the thousands, walked through the Museum as if in a daze."[19] When the exhibition opened, the Museum's (then much smaller) galleries were thronged with some 5,200 visitors a day and opening hours had to be extended. In its twelve-week run, it was seen by nearly 400,000 people and over 68,000 catalogues were taken home (extraordinary figures even for today).[20] And the press was almost unanimous in its ecstatic praise. Turner, it was clear, was "our contemporary."[21] But still, nobody could agree why.

"In the rampant confusion besetting the world of art, the Turner exhibition at the Museum of Modern Art proved to be the source of still more confusion," wrote Dore Ashton in her "New York Commentary" for *Studio International,* summarizing reactions to the exhibition for the benefit of the artist's countrymen:

It loosed a deluge of speculative commentary which alternated between a beard-stroking pontificating about Turner's revolutionary role in the history of modern art and frantic appeals for "re-evaluation." Of course, Americans have always vacillated, now rejecting the past with fervor, now annexing it indiscriminately to justify the present. But the Turner show seemed to have roused them beyond all previous exhibitions of so-called precursors, and they have filled the press with resounding essays.[22]

Ashton went on to quote from conflicting *New York Times* reviews of the exhibition by John Canaday and Hilton Kramer. Canaday, in fine curmudgeonly form, said it would be easy to "string along with the thesis of the Museum's show, which seems to be that Turner could not have been such a bad painter after all, if in his grandeur more than a hundred years ago he could anticipate the anemia of experimental painting in the 1960s." He was "weary of the parasitism . . . [of] *avant-garde* abstract painters in this country today . . . [who,] busily celebrating the ABC's of art under a camouflage of aesthetic gibberish, suck support from artists of the past for whom these ABC's were merely ABC's."

This seems, to say the least, a somewhat heated reaction to an exhibition of Romantic landscape painting. Until we learn two things Ashton neglected to explain: First, the ABC's that so incensed Canaday refer to an article by Barbara Rose published in *Art in America* in October–November 1965, a few months before the opening of the Turner exhibition.[23] The article was called "ABC Art" and was one of the first extended discussions of Minimalism, which Rose described as an art of "blank, neutral, mechanical impersonality"

6. J. M. W. Turner. *Reflecting Metallic Spheroids* (detail). c. 1820–28. Oil on paper, 25 x 38 1/2" (63.5 x 97.8 cm). Tate Gallery, London. The Turner Collection

reacting against "the romantic, biographical Abstract-Expressionist style which preceded it" and which she understood to derive ultimately from the work of Malevich and Duchamp. More precursors. But hardly anything to do with Turner.

Second, however, the Turner exhibition contained these oddities: an oil on paper of *Reflecting Metallic Spheroids* (fig. 6) and a pair of *Colour Diagrams* in watercolor (fig. 8).[24] The oil on paper showed the windowed interior of Turner's room reflected on the convex surfaces of three polished spheres, which also reflect each other. "Such images were demonstrably composed of light, and they were colored by the medium in which they were seen," wrote Gowing, adding: "The idea that images could possess an inherent shape, and one that was not rectangular, reappeared many years later in some of his most original pictures."[25] The watercolor comprised two diagrams, each representing three superimposed triangles of different hues surrounded by a circular rainbow. "These are the first diagrams of their kind by any artist of standing that we know . . . ," wrote Gowing. For Turner "the theory of color held a profound imaginative richness. . . . Turner looked at the intrinsic visual character of painting with a directness that anticipated the studies of modern painters."[26]

So there we have it. The *Reflecting Metallic Spheroids* look as if they could have been in the Modern's 1965 "The Responsive Eye" exhibition (fig. 7);[27] the *Colour Diagrams* in the Guggenheim's "Systemic Painting." (fig. 9).[28] These curiosities of Turner's certainly were noticed. But they were greeted with some skepticism. "Possibly the current exhibition aims at the establishment of new kinships," wrote Robert Pincus-Witten in *Artforum,* kinships between Turner and "artists working in the vast Duchampian legacy, notably a whole school of Diagramists" and "color-field painters of purely retinal and surface appeals."[29] He did not sound convinced. Dore Ashton asked some painters what they thought: "They tend to laugh at the attempts of the critics to make Turner's color notations in his watercolor book prototypes of modern abstract experimentalism. Any artist with a box of colors might have done the same thing, they feel."[30]

7. Enzo Mari. *Dynamic Optical Deformation of a Cube in a Sphere.* 1958–63. Transparent polyester resin, 4" (10.2 cm) diameter. The Museum of Modern Art, New York. Larry Aldrich Foundation Fund

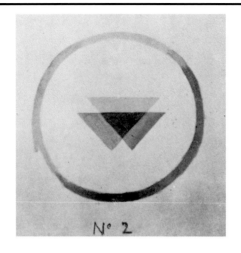

8. J. M. W. Turner. *Colour Diagrams* (details).
after 1824. Watercolor on paper, 21 1/2 x 29 1/2"
(54.6 x 74.9 cm). Tate Gallery, London.
The Turner Collection

Canaday was right: Turner's ABC's were merely ABC's. But the exhibition also included a generous selection of extremely freely conceived late pictures, and it was in these that Canaday's colleague, Hilton Kramer, found the mark of Turner's contemporaneity in its most pronounced form. In these pictures, he observed, "Turner comes to us at the present moment as an inspired precursor of the attempt to create a pictorial style out of the materials of color alone." He continued:

It is precisely this priority of color upon which an increasing number of contemporary American painters (including two of the four who will represent the United States in Venice next summer; Helen Frankenthaler and Julius [sic] Olitski) have lately been concerned to build their entire pictorial vision. It is color liberated from the form-making authority of drawing — color conceived and executed as the sheer embodiment of light.[31]

9. Al Brunelle. *Jayne*. 1965. Metalized cellulose
acetate butyrate on wood with acrylic and
crystals; six panels, each 21 x 21 x 3" (53.3 x
53.3 x 7.6 cm). Whereabouts unknown

This seemed far more plausible. The Museum of Modern Art was showing Turner because he was a Color Field painter. But which one? Frankenthaler? Olitski? "During a television discussion the names of Noland and Louis were also mentioned," reported Dore Ashton.[32] "I can remember a time when Rothko and others of the Abstract Expressionist generation were used as examples of the Turner influence, relayed somehow from England." The problem, she concluded, was this:

The resurrection of fathers is a frequent occurrence here, although their moments of worship are brief. Who, these days, talks about Monet? Yet he, too, was honored by a Museum of Modern Art show not too long ago, and he too was busily worked upon so that he would satisfy a peculiar American craving for history.[33]

So each generation creates its own paternity for itself — or, as a contemporary of Turner's put it rather more eloquently, the child is father of the man.

But still, "paternity" while a selective term is not a voluntary one; just like "modernism." It is selective because it is limiting but it is not voluntary because it cannot be chosen. In the organic, developmental model of art presented by this metaphor, each artist and each work of art grows from, indeed is inconceivable without, its predecessors, which assert their immortality in the new artist and new work, even in what seems most new and most individual there.[34] The same must be true for the paternities claimed by new artists and new work. Each artistic father is, finally, the child of the father who preceded him. Turner, finally, is not created in Olitski's image, or Noland's, or Pollock's. Turner, the precursor, is created in the image of another precursor, the one whose role he supplants. The modern artists whom Turner anticipates will seem to have developed from the artists influenced by that supplanted precursor. Likewise, Turner's own art (viewed with this telescoped hindsight) will seem to comprise a development beyond that other precursor's art, regardless of their chronological places in history. Ashton, in fact, had stumbled upon the truth of the matter. Turner is modeled after Monet.

We know that he is modeled after Monet when we learn that the Turner exhibition of 1966 was originally proposed as a sequel to the Monet exhibition of 1960 by the curator of the Monet exhibition, William C. Seitz, shortly after that exhibition had opened.[35] This institutional succession, however, is but a reflection (as well as, in part, a cause) of something much broader, namely a succession of taste that brought Turner in Monet's footsteps to contemporary artistic attention as a candidate for precursor in the mid-1960s. As will soon become apparent, to consider how Turner is modeled after Monet is also, in effect, to consider what remained in the mid-1960s of Abstract Expressionism and how it was interpreted. Turner will therefore become our guide into the sensibility of the sixties; his eventual dismissal will tell us when we have arrived.

Transparent Things

Turner is modeled after and succeeds Monet, and is worthy of consideration as a precursor of contemporary painting, in these four ways. First, "he reached out into the borderline between representation and the abstract"[36] and thereby engaged the issue of making paintings that while abstracted nevertheless had subjects. Second, he overcame the contradiction of representation and abstraction by making representational paintings of what seemed to be abstract subjects; therefore, "someone said of his landscapes that they were *pictures of nothing and very like.*"[37] Third, the effect of this was to make his paintings, at their most extreme, seem not mimetic but symbolic in their representation of the external world; therefore, records of imagination rather than of reality. And fourth, all this was achieved by Turner's having "confidence in the element in painting that is involuntary and unrehearsed,"[38] that is to say, in the very act of painting itself. Let me take these points in turn.

First: Even — especially — at its most abstract, Abstract Expressionism was preoccupied with subject matter. However, its preoccupation with the border-line between representation and abstraction is associable with its admitting elements suggestive of the non-abstract.[39] That is to say, it is a phenomenon of the mid-1950s, motivated in part by the exhibition of de Kooning's six large Woman-series pictures in 1953. Thereafter, a large range of, especially, so-called second-generation artists (from Frankenthaler and Joan Mitchell to Larry Rivers and Milton Resnick) seemed to find greater freedom on the abstraction-representation borderline than in either abstraction or representa-tion: a greater freedom of action in the improvisatory creation of art and a greater freedom of potential meaning in the ambiguity of the result.

Many painterly, *malerisch,* artists of the past could be — and were — admired for having embraced an equivalent freedom. But Monet was of par-ticular interest. The Monet vogue had begun earlier, in the late 1940s, and originally served to validate abstract, not abstract-representational art: the all-overness of the Impressionist field and its composition, in Monet's late works (fig. 10), from close-valued and broadly drawn areas of paint spread out over a large surface area seemed to anticipate Pollock and Color Field painters like Still and Rothko.[40] However, Monet became particularly interesting to the 1950s because abstraction and representation thus seem to be mutually re-inforcing across the entire pictorial surface as in the figuratively enriched Abstract Expressionism of that decade.

This interpretation of Monet in the context of contemporary painting was codified with the introduction of the term "Abstract Impressionist" in 1954 to refer both to the Color Field wing of Abstract Expressionism and to those second-generation artists whose work afforded associations with land-scape, to a greater or lesser degree.[41] It can be said to have culminated in the Whitney Museum's 1958 exhibition "Nature in Abstraction,"[42] and with The Museum of Modern Art's Monet exhibition in 1960. For Monet, wrote Seitz in the concluding paragraph of his catalogue essay for that exhibition, "nature had always appeared mysterious, infinite and unpredictable as well as visible and lawful. He was concerned with 'unknown' as well as apparent realities."[43] Gowing's Turner, in his catalogue essay, begins at this very point, where Seitz's

10. Claude Monet. *Water Lilies.* c. 1925.
Oil on canvas, 6′6 1/2″ x 18′4 3/4″ (199.4 x 560.7 cm). The Museum of Modern Art, New York. Mrs. Simon Guggenheim Fund. Destroyed April 15, 1958

Monet had left off. Thus, "the kind of reality and the order of imagination that painting had traditionally offered were changing in Turner's time. Since his time such transformations have reoccurred with increasing frequency. We are now familiar with the disturbances that they make."[44] Turner succeeds Monet because, even more than Monet, he reached the precise borderline of the abstract and the representational. As Pincus-Witten put it, in his review of the 1966 exhibition:

Turner, long before 1850, came to grips with the 20th century's most critical question, namely, how great is the role of natural representation? Turner replied by bringing a dissolution of reality in threaded pools of tissue-thin paint as near to atomization as any figure of modern painting since.[45]

But abstraction-representation was hardly a gripping issue in New York in 1966. Even in the early years of the decade, art occupying that borderline was looking outmoded. Pop art and the new cooler abstract painting were both against what now looked like evasive ambiguity.[46] Thus, the Monet–Turner succession viewed as a continuing investigation of the abstraction-representation borderline was hardly credible in 1966. To exhibit Turner for that reason was not really to exhibit an artist of fully contemporary relevance but rather of relevance to art that had been contemporary a decade before. (This may help to explain the extraordinary popularity of the Turner exhibition; it was familiarly new.)

So what is Pincus-Witten talking about? The clue is his "threaded pools of tissue-thin paint . . . near to atomization." He is discussing Pollock, or possibly Louis; fully abstract painters. This takes me to my second point: Turner succeeds Monet in 1966 by succeeding Monet's original function as precursor of *abstract,* not abstract-representational, art. Monet had become important to abstract painting in the late 1940s for his dissolution of the sculptural in reality. In his Nymphéas pictures especially, "appearance becomes apparition";[47] and "now the unity and integrity of the visual continuum, as a continuum, supplants tactile nature as the model of the unity and integrity of pictorial space."[48] What is represented, that is to say, is not tactile appearance but something incorporeal, like a mirage. Here Turner's "pictures of nothing" could offer an even better model than Monet's pictures of water; they suggested some "primal flux which denies the separate identity of things."[49]

And, of course, Turner had chronological precedence over Monet. "Turner, really, was the one who made the first significant break with the conventions of light and dark," wrote Clement Greenberg in "'American-Type' Painting," his influential account of the anti-sculptural, optical principles he inferred from what he considered to be the most advanced of Abstract Expressionism. "In [Turner's] last period he bunched value intervals together at the light end of the color scale" and thereby anticipated both "Monet's close-valued painting" and the "volume-muffling" color in the paintings of

Newman, Rothko, and Still.[50] And yet, what made Monet rather than Turner the ideal model for the 1950s was the warmth and darkened quality of his close-valued color, which was closer to that of Abstract Expressionist painting than the coolness and lightness of Turner's watercolor-influenced late style. Additionally, Monet was an early modern School of Paris painter whose paternity could be documented. His late *Nymphéas* paintings of the 1920s seemed "to belong to our age"[51] and as such could be seen hanging at The Museum of Modern Art (fig. 10).[52]

However, Monet's example eventually faded. In 1966, we heard earlier, Ashton was saying that he had been forgotten, and that Turner was proposed to replace him. Monet's example had faded, we must presume, because so had the art supported by Monet's example. We know that art on the abstraction-representation borderline did fade at the end of the 1950s. But what about abstract painting?

Here, Turner's appearance in 1966 is of much greater interest, for abstraction had flourished to produce a new generation of Color Field painters, among them Louis, Noland, and Olitski, whose art was being avidly discussed at mid-decade. Was Turner's relationship to these new painters what Monet's had been to their Abstract Expressionist predecessors? So it would seem from reviews of the Turner exhibition.

Before considering Turner's relationship with these new abstract painters, however, we need to know more about his relationship with their predecessors. This brings me to my third point about the Monet–Turner succession.

Monet, as Seitz observed, "was concerned with 'unknown' as well as apparent realities."[53] In this respect, he could be seen as anticipating not only the morphology of Abstract Expressionist Color Field painting but its purported symbolic content as well. Here, however, Turner's Romanticism could serve even better than Monet's Symbolism. And in February 1961, as the Monet vogue faded, there appeared in *Art News* an article of which the reception afforded the Turner exhibition can reasonably be said to be a consequence. By Robert Rosenblum and called "The Abstract Sublime," it bore the editorial subtitle "How Some of the Most Heretical Concepts of Modern American Abstract Painting Relate to the Visionary Nature-Painting of a Century Ago."[54] Here, Rosenblum suggested "affinities of vision and feeling" between, on the one hand, Turner and other nineteenth-century artists concerned with the Sublime, such as James Ward or Caspar David Friedrich, and on the other, Still, Rothko, Newman, and Pollock.

Turner was especially important because he revealed the two opposite ways the Sublime could be attained: "by saturating . . . limitless expanses with a luminous, hushed silence" and "by filling this void with a teeming, unleashed power."[55] An example of the former approach was his *Evening Star* (fig. 11), which Rosenblum compared to a Rothko (fig. 12). An example of the

Left:
11. J. M. W. Turner. *The Evening Star.* c. 1830. Oil on canvas, 36 1/4 x 48 1/4" (92.5 x 123 cm). The National Gallery, London

Right:
12. Mark Rothko. *Yellow and Gold.* 1956. Oil on canvas, 67 1/8 x 62 3/4" (170.5 x 159.4 cm) The Museum of Modern Art, New York. Gift of Philip Johnson

Left:
13. J. M. W. Turner. *Snowstorm — Steam-boat off a harbour's mouth making signals in shallow water, and going by the lead. The author was in this storm on the night the Ariel left Harwich.* exh. 1842. Oil on canvas, 36 x 48" (91.5 x 121.9 cm). Tate Gallery, London. The Turner Collection

Right:
14. Jackson Pollock. *Number 1, 1948.* 1948. Oil and enamel on unprimed canvas, 68" x 8'8" (172.7 x 264.2 cm). The Museum of Modern Art, New York. Purchase

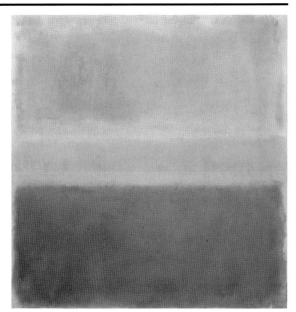

latter was his *Snowstorm* (fig. 13), which Rosenblum compared to a Pollock (fig. 14).[56] What is meant by the Sublime here, be it quiet or noisy, is not the same thing that Gowing referred to when questioning the proposed representation of Turner's early work in the 1966 exhibition; it does not carry the same explicitly rhetorical associations. Nevertheless, association of the Abstract Expressionists with what Rosenblum calls the Northern Romantic tradition does impute to their work an illustrational meaning; their art is seen as issuing from, and symbolizing, an "heroic search for a private myth to embody the sublime power of the supernatural."[57]

Certain later Color Field painters could also be viewed as heirs of Romanticism. In 1963, Rosenblum wrote of Morris Louis in these terms.[58] But by the mid-1960s, the illustrational in Romanticism, and the symbolic in Abstract Expressionism, seemed as outmoded as art on the abstraction-representation borderline. And yet, there was something in Romanticism, and

therefore in Turner, that continued to seem relevant. "The works of Pollock, Louis, Noland and Olitski," wrote Stanley Cavell at the end of the 1960s, "achieve in unforeseen paths an old wish of romanticism — to imitate not the look of nature, but its conditions, the possibility of knowing nature at all and of locating ourselves in a world."[59]

15. Cham. *Nouvelle École — Peinture indépendante*. 1870s

My fourth and final comment on Turner's succession to Monet as an Abstract Expressionist will take us to the new Romanticism of which Cavell speaks.

The Monet admired by the Abstract Expressionists was a painter of spontaneous, unrehearsed pictures; that is to say, a fictional Monet — not quite the dauber some of his contemporaries thought he was (fig. 15) but enough of an improvisor to anticipate Pollock (fig. 16).[60] In one section of Gowing's catalogue essay on Turner, a comparable artist appears (fig. 17); one who while

more secretive than anyone . . . had evidently an even stronger instinct for the nature of painting as a performance. His absorption in the intrinsic character of paint seems to have extended to the act of painting. It was as if he needed to exhibit an action as well as a picture. He gave a perennial demonstration of a quality in painting that he must have been determined should be recognized. It was like an anticipation of the recent controversy in New York about whether it is possible to hang an action on the wall. . . .[61]

16. Jackson Pollock in his studio, 1951. Photograph by Hans Namuth

The anachronism of Turner as American Action Painter is startling enough. But what makes this passage even stranger is that Harold Rosenberg's article which provoked the controversy Gowing refers to was published in 1952, some fourteen years before Gowing's essay.[62] This is yet additional evidence that part (a large part) of the appeal of a Turner exhibition in 1966 was that his pictures looked as if they were painted not, in fact, yesterday but far enough in the past to look *familiarly* contemporary.

Still, even if the exhibition recalled and reinforced the familiar, it did make fresh discoveries there — as it did not in its few obvious appeals to contemporary relevance, the systemic color studies and the images of globes shaped by their subjects' form. (There may be a lesson here for other polemical shows.) For Turner's Action Painting as presented in the exhibition and in Gowing's essay differs from Rosenberg's model of 1950s Abstract Expressionism in one very crucial respect: in the stress placed on watercolor as the liberating medium for Turner's late style. By virtue of this emphasis, Turner seems to have a great deal to do with Louis and Noland and other post–Abstract Expressionist Color Field painters who used the so-called soak-stain technique and who arrived on the contemporary New York scene around the same time that he did (figs. 18, 19).[63]

We have heard how critics of the 1966 exhibition described Turner as a precursor of soak-stain Color Field painting. But what I want to stress now is not how a Turner may look like a Color Field painting, or vice versa; nor

17. *Turner Painting One of His Pictures*, from *The Almanack of the Month*, June 1846

even how both may be perceived to have similar aims, for example "color liberated from the form-making authority of drawing," as Kramer reasonably suggested.[64] Rather, I want to stress how both may be perceived as issuing from similar working methods, how both may be perceived as purely products of their procedures, deriving their meaning explicitly from how they are made. I also want to stress how Gowing's interpretation of Turner as a kind of

Action Watercolorist, exploiting the liquidity of his thinned medium and the optical vividness of its white ground, merges Rosenberg's view of Abstract Expressionism as physical enactment with Greenberg's view of it as visual disembodiment. Turner is an Action Painter who makes Modernist Painting.

As such, his relevance to the mid-1960s has to be judged in the context of Pollock's relevance to the Color Field painting of that period. For Pollock was celebrated for his technique by Rosenberg and claimed purely for its result by Greenberg. But because Turner's technique derives from watercolor, like Louis's most notably, he seems to be almost as much a follower of Pollock as Louis was; not a precursor of Pollock but a disciple. And yet, a precursor by definition anticipates. Turner must be a bridge from Pollock to what was possible.

By the early to mid-1960s, a consensus was forming that Pollock's all-over drip paintings of 1948–50 were the most important products of Abstract Expressionism and that crucial to their importance was the improvisatory means, the "automatism," of their creation and the expressive but non-symbolic, non-illustrative abstractness their automatism produced.[65] A consensus was also forming (deriving even more explicitly from Greenberg than the first) that the abstractness of these pictures was a consequence of the effect of disembodiment produced by the spread and the superimposition of their dripped skeins or lines of paint; in other words, a consequence of their revi-

Left:
18. J. M. W. Turner. *A Wreck, with Fishing Boats.* c. 1840–45. Oil on canvas, 36 x 48 1/4" (91.5 x 122 cm). Tate Gallery, London. The Turner Collection

Right:
19. Morris Louis. *Iris.* 1954. Acrylic resin on canvas, 6'8 3/4" x 8'10" (205.1 x 269.2 cm). Collection Mr. and Mrs. Eugene M. Schwartz, New York

sion of contour drawing, the traditional way of evoking figures, or more pre-
cisely bodies. To critics interested in new abstraction, especially to critics who
had learned from Greenberg, these pictures seemed to be nothing less than
"the fountainhead of an entire tradition of modernist painting";[66] and the
automatisms of the 1960s deriving from them — be they based also on con-
trolling the behavior of paint (Louis) or on controlling the format or shape it
occupied (Stella) — tended also to be viewed as preoccupied with disembodi-
ment. Louis's eschewing the tactility of the painting medium and Stella's
internalization of the contoured framing edge could equally be seen as ways
of disembodying or dematerializing the physical object of painting without
recourse to traditional illusionism.[67]

The late work of Turner — incorporeal, atomized, and clinging like
mist to the picture surface — was surely the most convincing antecedent for
all of this. Monet's late paintings had dissolved the substance of things in
depictions of water and its reflections. But surely, paintings that did not, or
did not only, *depict* water but were actually *composed* from water offered even
greater disembodiment — and comprised automatism in the Pollock tradi-
tion. The progress of Turner's career thus took him from the old, illustra-
tional Romanticism to the threshold of the new, where "instead of the
illusion of things, we are now offered the illusion of modalities: namely, that
matter is incorporeal, weightless and exists only optically like a mirage."[68]

So why, then, did Turner never quite take? Once the crowds had dis-
persed and discussion surrounding the 1966 exhibition had subsided, he is lit-
tle mentioned in the context of contemporary painting. It would be the late
watercolors of Cézanne, rather than of Turner, and especially the thinly paint-
ed pictures of Matisse that became the most frequently cited precursors for
1960s Color Field painting. Turner, it seems, was simply the bridge from
Monet to what was possible.

After Abstract Expressionism
So, why not Turner? It is a question worth asking not merely for the sake of
the record. For there are some broad lessons to be learned here — about the
role and function of precursors and about the interpretation of Abstract
Expressionist and post–Abstract Expressionist art — which pertain to the
critical experience of modernism as well as to its historiography.[69]

Among these lessons is that the extent to which precursors figure in the criti-
cism of the 1960s is a reflection of the extent of artistic change in that decade,
or at least of the anxieties such change produced, including the anxiety of
wanting a known identity for the new. All novelty tends to produce a similar
reaction, but to call Stella an Abstract Dadaist, as Max Kozloff did,[70] is quite
different from calling a car a horseless carriage. It implies not only historical
progress but a particular version of history. Stella stands at the end of a partic-

ular version of art history which imputes to him a particular artistic identity. Michael Fried finds that identity to be "sheer fantasy" and places Stella at the end of a history in which Dada has no part. Thus each critic's "conception of the enterprise of painting in our time simultaneously depends on and entails a particular interpretation of the history of painting since Pollock or Cubism or Manet or David."[71]

Among the consequences of this position are that a critic's experience of new art will "deeply and irreversibly" alter his experience of past art, observed Michael Fried in 1966 — "so deeply and irreversibly, in fact, that his conviction is that not merely his *experience* of the older work, but, so to speak, the *work itself,* has been changed."[72] The following year, William Rubin chose as epigraph for his "Jackson Pollock and the Modern Tradition" a famous passage from T. S. Eliot's "Tradition and the Individual Talent" where Eliot tells of how "the new (the really new) work" modifies the preexisting order into which it is introduced.[73] Rubin's long essay was explicitly a reordering of the historical past on the basis of his understanding of Pollock's importance; as such, it provoked complaints that it was art-historical and not critical.[74] In 1969, Fried published his equally lengthy "Manet's Sources," in which he argued that Manet aligned himself with the past in order to consolidate then continue tradition.[75] It provoked the complaint that it was critical and not art-historical.[76] Both essays, and their receptions, exemplify the erosion in the 1960s of the distinction between criticism and art history insofar as art of the modern tradition, at least, is concerned.[77] If old and new art mutually exchange meaning, their discussion cannot be segregated; hence "the modern tradition" or, avoiding the oxymoron, the mainstream.

The continuity of the mainstream is the product of meaningful borrowing; thus the past is caused to flow into the present, even into the most individual part of a new artist's work. From Eliot's insistence in 1919 that tradition "cannot be inherited . . . you must obtain it by great labour,"[78] down to Greenberg's assertion in 1966 that "the superior artist is the one who knows how to be influenced,"[79] the past is never passively received but is chosen, and becomes part of a new work as part of its intention.[80] The mainstream (the modern tradition) therefore includes two intertwined currents: the one (modern) that joins, say, Pollock to Louis; and the other (tradition) that simultaneously joins, say, Monet to Turner. And the traditional current in the mainstream is chosen by and reinforces the momentum of the modern current. The mainstream, of course, is an organic metaphor: tradition is culture which encourages growth (not necessarily progress but irreversible succession produced by continuing improvisation). And while its traditional current, which joins its precursors, is as free from chronology as its modern current is tied to it (Turner being free to succeed Monet whereas Louis is not really free to succeed Noland),[81] the traditional current nevertheless depends as much as the modern one does upon those artists whose mission may be perceived

chronologically; that is to say, artists whose mission is to go beyond.

Thus, it used to be said that Monet had outlived himself, but in fact he went further than his contemporaries.[82] Thus, many of Turner's pictures after 1840 are balanced on a central axis in defiance of the picturesque.[83] Here lies the attraction, within modernism (and significantly, I think, within late modernism), to precursors who have identifiably late styles which do not seem as much endings as beginnings. Thus, late Monet, late Turner, late Cézanne, late Matisse, all may be perceived as paradigmatic of the wish to go beyond the established modernist past and thereby to open up a new modernist future.

It is in this context that the importance to the mid-1960s of the work of Morris Louis should be viewed. Louis's late work (he died in 1962), like the late work of the aforementioned artists, did not "seem to mark a close"; but additionally it comprised Louis's *earliest* work — "the first paintings in Louis's career" — to engage with developments that opened "to the concerns at work in the most important painting of the past several years."[84] Thus, he was at once precursor and contemporary; at once old and new. "Louis is the really interesting case," observed Frank Stella in an interview published in 1966. "In every sense his instincts were Abstract Expressionist, and he was terribly involved with all of that, but he felt he had to move, too." Stella's "all of that" was "the old values in painting" persisting in Abstract Expressionism, mainly the idea "that there is something there besides the paint on the canvas." The new idea, in contrast, can be summed up in Stella's slogan, "What you see is what you see."[85]

To move after Abstract Expressionism and to do so by shunning illustrational content: these mid-1960s aims that made Louis important made Turner unimportant. Whereas Louis's early Veils (fig. 19) seemed continuous with Abstract Expressionism, and with Turner, his late Stripes (fig. 20) began to move on beyond these old values, as did the work of Noland, Olitski, even Frankenthaler in the 1960s. The surface itself, not transparent depth, was the source of their meaning.

It was precisely the strain of transcendentalism in Abstract Expressionism that now seemed anathema. Rubin's 1967 essay on Pollock is thus symptomatic of its moment in setting out to correct overemphasis on the artist's "Romantic" side by showing that Pollock was also, and more importantly, a "Classical" artist.[86] And Pollock's growing importance was attributable in part, and possibly in large part, to the fact that, increasingly, his art seemed simply unavailable to serious discussion in Romantic terms, in terms of symbolic or illustrational content. (In contrast, Newman's importance eventually declined because it attracted such discussion.)[87] Pollock had overcome the Romanticism of his early work. Louis, in his own way, had done the same. And so, of course, had Cézanne.[88] While Matisse, best of all, had been "cold, undistracted, and full of arrogant purpose" from virtually the start.[89]

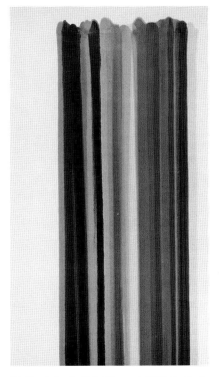

20. Morris Louis. *Third Element*. 1961. Synthetic polymer paint on unprimed canvas, 7′ 1³/4″ x 51″ (207.5 x 129.5 cm). The Museum of Modern Art, New York. Blanchette Rockefeller Fund

He, especially, became an important model; was applauded as a present-day neoclassicist (such had the climate changed);[90] and showed why Turner could no longer serve: without coolness of emotion behind it, a cool palette was of no interest at all. What is more, Turner epitomized the inherent danger of painting in a watercolorist technique: that it simply would be too transparent to its meaning; like a pane of Gothic stained glass, a source of now anachronistic spiritual light.[91]

The extent to which New York painters who used a watercolorist technique seemed to avoid effects of transparency had a great deal to do with their critical reputations in the 1960s. Using a watercolorist technique in a free, painterly manner, as Turner did, tends to produce effects of transparency because tonal (and therefore spatial) layering is a natural attribute of painterliness. Consequently, painterly watercolor-influenced artists like Sam Francis, Paul Jenkins, and Helen Frankenthaler, who were highly regarded at the beginning of the 1960s, were seen either to be problematical or simply less important as the decade advanced.[92] Of course, that may have been as much because of their painterliness itself, which alone associated them with outmoded Abstract Expressionism, as because of the transparency their painterliness produced. Nonetheless, it is true that critical writing on watercolorist-influenced painting in general tended increasingly to rate its surface materiality either above its transparency or as a necessary corrective to it. Thus, for example, in a discussion mainly of Olitski's work, Rosalind Krauss posited an opposition between "the assertion of flatness, which calls attention to the painting as an opaque object, and the declaration of frontality, which guarantees its transparent depth."[93] And she left her readers in no doubt that opaque things were preferable to transparent things. The opaque surface was the surface that French modernism bequeathed to American modernism. The transparent surface was the surface of painters like Kandinsky and Malevich, who sought to destroy the material plane of the canvas in order to create effects of unlimited depth that could produce sensations of headiness and awe. Krauss is, effectively, associating Kandinsky and Malevich with the Northern Romantic tradition and with the Sublime; and opposing that tradition to French and American modernism.

More explicitly, Sidney Tillim saw painters like Olitski and Noland as actually revising or reinventing the Gothic stained-glass tradition by combining it with a Mediterranean, decorative one which (mural-based, he might have argued)[94] gave it greater substance.[95] He too could thereby argue a continuity between French and American modernism, a continuity that succeeded the Gothic-Sublime tradition and was characterized by far greater materiality. (By this point, it must be very clear that Turner's not being French placed him at an enormous disadvantage as a precursor.) Additionally, however, Tillim argued that earlier American artists using watercolor had been noticeably more

materialist than their European counterparts: "Their provincial loyalty to real-
ism ultimately guaranteed their rigor."[96] Thus, American modernism was not
to be viewed merely as an imported version of French modernism; rather,
imported French modernism uncovered something indigenous to American
art, a sort of Yankee matter-of-factness that was suspicious of the insubstantial
and imaginary.

For modernism as a whole, Clement Greenberg insisted, was a reaction
against the "eventual tendency of Romanticism . . . to take medium and arti-
sanry too much for granted and to consider them as more or less transparent
or routine."[97] Moreover, the best American art had always been artisanal, even
in the intrinsically less substantial medium of watercolor. Thus, Winslow
Homer, "like a good American . . . loved *facts* above all things."[98] Even
American painters of the imagination were considered honest realists at heart:
"The visionary overtones of [Eakins's] art move us all the more because they
echo *facts*," Greenberg asserted.[99] The new American art of the 1960s was also
an art of facts, of tangible, opaque surfaces, not elusive transparencies. Even
when it used watercolorist methods, it was still held to be an "Art of the
Real."[100] In light of this developing view of what was intrinsically "American"
in such art, we must wonder whether Turner's greatest liability as a precursor
was not so much his effects of transparency as simply the fact that he was not
American.[101]

Indeed, what eventually told against him was that his art belonged to an
old European order. When American art had to be justified against European
standards, the validation of a renowned British artist was extremely useful.
The Museum of Modern Art's sending new American pictures to Europe and
then bringing back from Europe old European pictures resembling them was
perhaps the cultural-exchange equivalent of a newly successful immigrant
going back to the old country and returning with an elderly, cultured parent.
But very soon Turner seemed old-fashioned. And the only Europeans who
would be made welcome were anti-traditional ones, such as the Russian
Constructivists whose toughness and whose belief in a new order could be
easily assimilated into the hard new world of the 1960s in New York.[102]

Outside New York, however, things were different. And it remains to be told
how the tradition of luminous spiritual illusionism, rejected by New York
abstract artists of the mid-1960s, was picked up, nurtured, and transformed in
California at the same time.[103] As early as 1967, Sidney Tillim observed that
Robert Irwin's work comprised "spirituality as style," a subversion of the
Gothic tradition where form becomes "the *temptation* of the senses."[104] But
the whole California light-and-space school, so-called, deserves reconsidera-
tion in this context, if only to reseparate the artists of this school from
Minimalism, to which they have become attached for spurious reasons of for-
mal similarity. The light that lines the inside of Judd's boxes or that glares

from Flavin's neons is far harsher and harder, more emitted than released light. As such, it is light that, far from connoting symbolic release from materiality, affirms materiality; that fills its containers as if with corporeal presence.

I began this essay by remarking that The Museum of Modern Art's Turner exhibition took place in the same year, 1966, as the exhibitions "Primary Structures" and "Systemic Painting." And, of course, the emergence of Minimal art institutionalized by these two exhibitions and the foreclosure of Romanticist interpretations of contemporary art such as motivated the Turner exhibition are but two aspects of the same phenomenon. Not only did the corporeal emphasis of Minimalism reject the very possibility of optical disembodiment, but its urban-industrial connotations made a landscape paradigm for abstraction no longer relevant.

Thus, Minimalism opposed Romanticism and those artists associable with the Romantic tradition; therefore, it would seek to separate itself from contemporaneous Color Field painting to the extent such painting seemed to prolong that tradition.[105] More than that, for anyone open to Minimalism, Abstract Expressionism itself became suddenly problematical because of its transcendental associations. Minimalism could be seen as *overthrowing* Abstract Expressionism; dismissing it as Romantic, as Stella implicitly did with his talk of "old values."[106] But if Minimalism was instead to be seen as *succeeding* Abstract Expressionism, then Romantic interpretation of Abstract Expressionism must be dismissed; hence Rubin's "Classical" Pollock, which effectively reattaches Abstract Expressionism to mid-1960s Minimalist sensibilities.[107] And hence, too, the reinterpretation of Abstract Expressionism that discovered within it sources of the corporeal emphasis and urban-industrial connotations of Minimalism.

Early interpretation of Abstract Expressionist painting, notably Harold Rosenberg's, had stressed its corporeality.[108] It was an art descriptive of the body because a record of the body's gestures. It therefore welcomed chance which allowed spontaneous, uninhibited expression of the body; each dripped line in a Pollock could "establish the actual movement of the artist's body as an esthetic statement."[109] This highly Romantic view of Action Painting was discredited in the mid-1960s. So was the notion that chance had any more significant role in the making of Abstract Expressionist paintings, and those derivative of them, than chance did (it was even suggested) in Rubens's oil sketches.[110] Except in some, Minimalist quarters, chance was de-Romanticized and with it corporeality. Bruce Glaser asked Judd: "You've written about the predominance of chance in Robert Morris's work. Is this element in your work too?" Judd replied:

Yes. Pollock and those people represent actual chance; by now it's better to make that a foregone conclusion — you don't have to mimic chance. You use a simple

form that doesn't look like either order or disorder. We recognize that the world is ninety percent chance and accident. [111]

Judd thus builds on Pollock in taking for granted the accidentality of the world; the visible world does not express a prior order. For that very reason, he does not use chance as a Romantic, as a route to self-expression, but rather in the way that Duchamp chose a Readymade, to close out self-expression. By denying the illusionism of anything internal or prior, he can discover the corporeality of the literal: the corporeality of the literal, non-illusionistic surfaces of literal objects.[112]

To this extent, the corporeality of Minimalism could back-project into Abstract Expressionism; to a small extent, that is to say. Rejection of the old, Romantic corporeality in Abstract Expressionism seemed to have hindered any new discussion of its corporeality — except discussion of the absence of corporeality in the optical disembodiment of Pollock's art in particular.

In contrast, the urban-industrial connotations of mid-1960s art in general more readily affected interpretations of its parent source. Even in 1960, when many reviews of Helen Frankenthaler's exhibition at The Jewish Museum noted the continuousness of her landscape-associative paintings with Pollock's, one reviewer objected that Pollock's art was actually "cool, tough and rigorous" and had "implications of objectivity" that Frankenthaler's did not. But the reviewer was Judd and his questioning of the landscape paradigm not an entirely explicit one.[113] Very explicit, however, is Rubin's treatment of the Pollock–Impressionism connection in his 1967 study. Whereas earlier, that connection had associated Pollock with landscape painting, it now served an almost opposite purpose, showing

. . . their common confrontation of the flux, rhythm and complexities of modern life, especially in great urban centers. While the Impressionists and Pollock had great interest in landscape, the world of nature was shared by them with the artists of the past. Only modern painters can have confronted the metropolis; none have better understood it than the Impressionists and Pollock.[114]

Rubin does not actually reject a landscape association for Pollock; rather he subsumes it within an urban association — and sees in Pollock's doing the same his advance over the Impressionists, who had to choose between landscape and cityscape whereas Pollock could fuse them in a single image.[115] But he does give precedence to the urban: Pollock's landscape associations are a matter of the atmospheric tonalities and large size of his pictures; his urban associations proceed from the very method of their making, which evokes the molecularity and *prima facie* confusion of modern life and their transcendence.[116]

To make Pollock more urban than rural is, in effect, to return Abstract Expressionism to its pre–Abstract *Impressionist* interpretation. Before it began

to be landscaped and Romanticized in the 1950s, Abstract Expressionism had seemed to be "an incarnation of the city" in its rawness and boldness (just as Minimalism did a decade later), and only as it softened in the 1950s did its rural associations grow.[117] This suggests an equation — urban is to rural as raw is to lyrical — and consequent upon it, temporal alteration between the two as critical models for new art. Thus, Minimalism neither overthrows nor succeeds Abstract Expressionism; it renews it. It goes back to its beginnings as a raw, urban art. (And it replays it: Minimalism too will be landscaped and Romanticized in its turn.)[118]

But it goes back only iconographically. What stands immovably between Abstract Expressionism and Minimalism, polarizing them, is the issue of corporeality. Minimalism, as the art of the bodied, corporeal subject, must oppose Abstract Expressionism as outmoded because the latter entails either a debased model of corporeality (Rosenberg's Action Painting) or an irrelevant model of opticality (Greenberg's Modernist Painting). But are these the only options? Of course they are not. And this returns me to Turner. For Turner appeared in this arena as both Action Painter and Modernist Painter although clearly unsuited to either role.

In fact, Turner fails as an Action Painter only because he dramatizes it more even than the Rosenbergian model: he seems to have liked painting in public.[119] By overwhelming the model — going beyond Action Painter to acting painter — he thereby overthrows it. The model itself is useless as a guide to corporeality since it effectively allows all intentionally marked surfaces to convey that quality.

Turner as a Modernist Painter is more interesting (his Romanticism notwithstanding), for his later pictures do often conform to a model (Abstract Expressionist derived) of close-valued, harmonized fields of color produced in their painting and tending to effects of mirage-like dematerialization. But herein lies the problem. True comparison depends not on morphological similarity but on equation in practice. And for all that might be said on behalf of Turner's watercolorism, no equation exists. It may be plausibly argued that Abstract Expressionist paintings — and the ultimate model has to be Pollock's all-over paintings — and Turner's paintings do resemble each other in the way I have just described. It is very clear, however, that Pollock's all-over paintings are not harmonic creations like Turner's, but creations of discord, of oppositions, which include oppositions of line and color and contour and field. And while these oppositions seem to settle toward color and field (and therefore toward Turner), they do so not because they repudiate line and contour but because the traditional functions of line and contour seem momentarily to have been waived or suspended. (Therefore, they never reach Turner.)

That is, thinking of corporeality, even if line is so modified to function as a purely perceptual stimulant, some memory of its contouring functions remains. It remains, moreover, not merely as some accidental or unimportant

remnant of past usage. Rather, its reminder of what temporarily has been sur-rendered is what helps to account for the grave beauty of an art like Pollock's, whose beauty is partly that of elegy, of the glimmering persistence of things pal-pable within this apparently all-optical paradise. In this context, Minimalism is but corporeality regained.

And in *this* context, Turner is truly irrelevant. Even Monet is too har-monic. Instead, what is needed from a precursor for Pollock is a palette of both large-scale light and dark contrasts, emphasizing the sculptural, and innumerable, small steps in value that take in, say, reds and greens and grays and that climax on the upper end of the value scale in pure or nearly pure white. Also, a rough-and-ready way of painting which seems to have been dis-covered in its making and looks objective at the same time. And an interpre-tation of light and space that determinedly avoids the "poetic" harmonies of Turner while still producing a coherent, luminous space that opens to our beholding.[120]

And so, in this context, one more question — Why did not The Museum of Modern Art do a *Constable* exhibition in 1966? Constable fulfills precisely the foregoing requirements for a precursor (figs. 21, 22). However, while transcen-dentalism held sway, art had to have more than visual or material justification. Accordingly, Turner's pictures — apparently of nothing but actually of some-thing — were to be preferred to Constable's pictures — apparently of some-thing but actually of nothing except what could be felt in seeing and making.

After 1966, however, the tide that had already turned against transcen-dentalism in the making of art finally began to pull against transcendentalism in the exhibition of art as well. And as it did so, not only Turner was swept away. So was the possibility that any distant precursor could seem as relevant as Turner briefly had. The disbelief in symbolism and subject matter that characterized the changed climate of Minimalism derived from a distrust of the associative faculty and a demand for "an honest, direct, unadulterated experience in art."[121] That being the case, historical associations were seen as

Left:
21. John Constable. *On the River Stour.* c. 1834. Oil on canvas, 24 3/8 x 31 1/8" (62 x 79 cm). The Phillips Collection, Washington, D.C.

Right:
22. Jackson Pollock. *One (Number 31, 1950).* 1950. Oil and enamel on unprimed canvas, 8' 10" x 17' 5 5/8" (269.5 x 530.8 cm). The Museum of Modern Art, New York. Sidney and Harriet Janis Collection Fund (by exchange)

potentially adulterating: of interest, certainly, for critical reasons, but distant from the immediate experience of the new art. The role of the precursor was therefore changed. Contemporization of the historical would continue in specialized criticism of new art; historicization of the contemporary would not. The identity and the authority of the contemporary resided in its very modernism, and historicism was anathema to it. The validation of premodern precursors was therefore undesirable. It was also unnecessary. The broad international recognition, patronage, and institutional support of American modernist art in the late 1960s accrued to it so great an intrinsic importance that it no longer required any external justification.[122] Consequently, there would be no more exhibitions of precursors of contemporary art. The Turner exhibition was the culmination of its genre.

Of course, once modernism itself began to be questioned, all of this would change. As a new, postmodern climate of taste developed, the premodern precursor returned.[123] The blessing of the past was wanted again.

Notes

1. From "Things of August," in *The Collected Poems of Wallace Stevens* (New York: Alfred A. Knopf, 1985), p. 495.

2. See *Primary Structures: Younger American and British Sculptors* (New York: The Jewish Museum, 1966), catalogue by Kynaston McShine for an exhibition shown April 27–June 12, 1966; *Systemic Painting* (New York: Solomon R. Guggenheim Museum, 1966), catalogue by Lawrence Alloway for an exhibition shown September 24–November 27, 1966.

3. See *Turner: Imagination and Reality* (New York: The Museum of Modern Art, 1966). Foreword and Acknowledgements by Monroe Wheeler; catalogue essay by Lawrence Gowing. (Hereafter cited as: Gowing.) The exhibition, co-directed by Wheeler, Director of Exhibitions and Publications at the Museum, and Gowing, Keeper of British Paintings at the Tate Gallery, London, was shown March 23–June 19, 1966. (It was originally scheduled to close on May 22, but was extended because it was so popular.) It comprised 39 oils, 59 watercolors, and 3 sketchbooks (one, containing watercolors showing the burning of the Houses of Parliament on October 16, 1834, also shown as a continuous projection of color slides), and was installed by Gowing with Alicia Legg, Associate Curator, Painting and Sculpture Exhibitions, in galleries designed by Wilder Green, Program Coordinator. Except for 9 loans from American private and public collections, the exhibition was selected from the collections of the Tate Gallery, the National Gallery, and the British Museum in London and was funded in part by the British Foreign Office. It was originally proposed for the autumn of 1962 (William C. Seitz, The Museum of Modern Art, to Sir John Rothenstein, Tate Gallery, letter of July 11, 1961). However, the restoration and reinstallation of the Tate's pictures forced postponement of the exhibition until at least February 1963 (Rothenstein to Wheeler, letter of August 15, 1961). It was originally to have been shown in New York, Cleveland, Chicago, and Ottawa (Wheeler to Rothenstein, letter of January 19, 1962) but the Tate Gallery's reluctance to lend other than to New York caused the tour to be canceled and its wish to make the selection of its own pictures, counter to the Museum's policy for loan exhibitions,

caused the entire project to be shelved (Wheeler to John Maxon, The Art Institute of Chicago, letter of February 28, 1962). It was revived as a possible alternative to a Bonnard exhibition that was in jeopardy for the autumn of 1964 (Peter Selz, The Museum of Modern Art, to Wheeler, memorandum of July 10, 1963), but the Bonnard exhibition finally took place as scheduled. Negotiations were reopened with the Tate Gallery in the early autumn of 1965, after preliminary discussions with the British Council, and the Tate agreed in principle to support the exhibition if it provided the catalogue essay, nominating Gowing as author (Norman Reid, Tate Gallery, to Wheeler, letter of September 7, 1965). By that time, Seitz, who had originally proposed the exhibition, had resigned to become director of the Rose Art Museum, Brandeis University, and Wheeler was appointed to take over the exhibition (William A. M. Burden, The Museum of Modern Art, to M. N. F. Stewart, British Embassy, Washington, D.C., letter of September 8, 1965). Wheeler met in London with officials of the Tate Gallery, including Gowing, who proposed the exhibition be called "Turner: Pictures of Nothing" (after Hazlitt; see Gowing, p. 13), and learned that the Tate Gallery was happy to cooperate because "they want our future shows of American artists which they feel belong with them rather than with [the] Whitechapel [Gallery]" (Wheeler to René d'Harnoncourt, The Museum of Modern Art, letter from London, undated, presumably late September 1965). At this very late date, only some six months before the exhibition was due to open, it was finally on — and the selection and work on the catalogue could begin.

(Unpublished documents pertaining to the exhibition, cited here and elsewhere in these notes, are in the various archives of The Museum of Modern Art.)

4. Wheeler, in Gowing, p. 5; and for the following quotations in this paragraph.

5. Shortly after its founding in 1929, the Museum decided it should exhibit and collect art of approximately the past fifty years (see Alfred H. Barr, Jr., "Chronicle of the Collection of Painting and Sculpture," in his *Painting and Sculpture in The Museum of Modern Art, 1929–1967* [New York: The Museum of Modern Art, 1977], p. 623, citing a report to the Trustees of November 1933). Since then, the year 1880 has remained the traditional date for the beginning of the Museum's collections (excepting those of photography and film, which begin with the dates those mediums were invented) and the earliest date of works to be shown in normal Museum exhibitions (excepting the early works of artists whose mature works date after 1880). As early as 1930, however, the eighth exhibition organized by the Museum was devoted to Corot and Daumier; the former viewed as a precursor of 1920s classicism, the latter of expressionist draftsmanship (see Alfred H. Barr, Jr., Introduction to *Corot, Daumier* [New York: The Museum of Modern Art, 1930]), p. 12).

Between then and the Turner exhibition, there were some dozen important exhibitions devoted to precursors and some four or five more that included a significant proportion of historical material. The majority by far of precursor shows dealt with ancient or non-Western art. All those of the 1930s after "Corot, Daumier" did: "Persian Fresco Painting" (1932), "American Sources of Modern Art" (i.e., pre-Columbian art) (1933), "African Negro Art" (1935), "Pre-historic Rock Pictures in Europe and Africa" (1937). Fewer precursor shows were held in the 1940s but that decade was spanned by "Ancestral Sources of Modern Painting" (1941) and "Timeless Aspects of Modern Art" (1948). The 1940s also saw exhibitions of early photography, but it was only in the 1950s that Western precursors returned: "Masters of British Painting, 1800–1950" (1956) prepared the ground for Turner; "Claude Monet: Seasons and Moments" (1960) immediately anticipated Turner, as we shall see.

6. Press Release No. 32, March 23, 1966. The same statement appears in the catalogue flap copy.

7. Gowing, p. 7.

8. Concerning influence and borrowing in visual art, including the backward projection of meaning, see Norman Bryson, *Tradition and Desire: From David to Delacroix* (1984; Cambridge: Cambridge University Press, 1987), p. 172 and *passim*; Richard Wollheim, *Painting as an Art* (Princeton, N.J.: Princeton University Press, 1987), especially pp. 187–90, 231–32. (Both authors acknowledge the work of Harold Bloom.) See also notes 77 and 80 below.

9. This reframing was not a last-minute decision but was integral to the conception of the exhibition from the start. Indeed, the very first letter to the Tate Gallery, proposing the exhibition, states that "if the pictures are entirely separated from the historical context which the great old frames give them, they will have a freshness and life otherwise impossible" (Seitz to Rothenstein, letter of July 11, 1961). The transformation of Turner's pictures achieved thus was widely commented on in reviews of the exhibition. E.g.: his "colors make a much more intense impression in the rather bare, severe setting of the Museum of Modern Art than in the more traditional rooms of the Tate" (*Wall Street Journal,* April 18, 1966). "Cleaned, released from under glass, divested of heavy frames, their skirts have been shortened to catch the modern eye . . ." (*New York Newsday,* April 4, 1966).

10. See note 6, above.

11. The standard catalogue of Turner's paintings lists 204 as "Later Works, 1829–51" out of a total of 532 dated works. See Martin Butlin and Evelyn Joll, *The Paintings of J.M.W. Turner,* 2 vols. (New Haven, Conn., and London: Yale University Press, 1977).

12. Gowing, p. 7.

13. Gowing to Wheeler, letter of November 11, 1965. In *The Fifth Plague of Egypt,* Turner erroneously represented the seventh plague, which allowed him more terribly Sublime effects; the fifth plague was less dramatic. This is, in fact, an undistinguished picture (Ruskin, with reason, had judged it "a total failure"), but it was thought insufficient in 1966 for polemical not qualitative reasons. For discussion of the picture, see Butlin and Joll, cat. 13.

14. Gowing, p. 7 (cf. Butlin and Joll, cat. 7). Gowing's original choice for an additional early work was *Morning on Comston Fells* (Butlin and Joll, cat. 5), an even less rhetorical picture (Gowing to Wheeler, letter of November 11, 1965). It is not known why the substitution was made.

15. Gowing, p. 56.

16. Ibid., pp. 53–56.

17. *New York Times,* March 5, 1966.

18. See note 6, above.

19. *New York Herald Tribune,* March 23, 1966.

20. According to Press Release No. 2, November 7, 1966, the total attendance was 394,428 and the total catalogue sales, as of September 30, 1966, were 68,212. The exhibition was on view for 91 days, an average daily attendance of 4,334. The highest daily attendance (Sunday, March 27) was 8,384. By comparison, the 1989 Andy Warhol show, which ran 73 days, had a total attendance of 296,879; a daily average of 4,067. Attendance figures no longer exist for every Museum exhibition. However, it would seem that the only exhibition to clearly surpass the Turner exhibition in attendance was the 1980 Picasso retrospective, which ran 132 days with a total attendance of 1,021,404 and a daily average of 7,400.

21. *The New Leader,* April 11, 1966.

22. *Studio International,* 171 (May 1966), pp. 207–08, from which the following quotations derive. The same issue contained (pp. 262–64) an article on Turner by Jack Lindsay, author of a new biography of the artist published that year in London and New York. Lindsay's Turner is highly prescient: ". . . he burst though all existing stereotypes and in effect created modern art. He was so far ahead of his time that only in the last few years have critics realized that almost all the advanced tendencies of twentieth-century art can be found somewhere in his work." Listed recipients of Turner's influence included Cubism and Futurism, Bacon, Cézanne, Klee, Kokoschka, Redon, and Rouault.

23. Reprinted in Gregory Battcock, ed., *Minimal Art: A Critical Anthology* (New York: E. P. Dutton, 1968), pp. 274–79; the following quotations come from pp. 274–75.

24. Gowing, cats. 51–53.

25. Ibid., p. 23.

26. Ibid., pp. 23–24.

27. See William C. Seitz, *The Responsive Eye* (New York: The Museum of Modern Art, 1965), for example, pp. 27, 42, 50 (illustrated here).

28. See *Systemic Painting,* for example, pp. 41, 44 (illustrated here), 47.

29. *Artforum,* 10 (June 1966), p. 52.

30. Ashton (note 22, above), p. 208. It should be noted that while American critics happily looked for a broad range of contemporary artists whose work resembled Turner's, some European critics were dubious. The *Allgemeine Zeitung* (Frankfurt) observed, "As was the case with Monet, the relationship here to abstract art is very forced" (a reference to the Museum's 1960 Monet exhibition, discussed later in this essay). The *Guardian* (London) said that the promotion of Turner was "slightly questionable"; the exhibition "has been sold on the fortuitous resemblance between some of the late Turner paintings and abstract expressionism." And according to the *Primera Plana* (Buenos Aires), "in London, Bryan Robertson accuses Gowing of having intentionally seduced the simple-minded Americans with an erroneous interpretation of Turner." But Robertson had been director from 1955 to 1965 of the Whitechapel Gallery in London, competitor of the Tate for exhibitions of American artists from The Museum of Modern Art (see note 3, above). These reviews are quoted from Press Release No. 2, November 7, 1966.

31. Quoted in Ashton, ibid., pp. 207–08. The other two artists shown in Venice were Ellsworth Kelly and Roy Lichtenstein.

32. Ibid., p. 208. Ashton does not say who mentioned Noland and Louis. The television discussion she refers to took place on March 23, 1966, on WNDT-TV, Channel 13. It was hosted by Albert Goldman, Associate Professor of Art at Columbia University. Monroe Wheeler was the Museum's representative. Other speakers included the painter Robert Motherwell, the critic Hilton Kramer, and John McCoubrey, Professor of Art History at the University of Pennsylvania (Press Release No. 2, November 7, 1966).

33. Ibid.

34. The classic modern version of this concept is, of course, T. S. Eliot's 1919 essay "Tradition and the Individual Talent" in *The Sacred Wood* (1920; rpt., London and New York: Methuen, 1980), pp. 47–59; see p. 48 for the passage paraphrased here.

35. See note 3, above, for a brief chronology of the exhibition's organization, including Seitz's resignation from the Museum before it was realized, and note 30, above, for one critic's realization that Turner was a sequel to Monet. Despite Seitz's work on the exhibition, he was not credited for having had any part in its organization. His name was only mentioned buried in the catalogue's list of acknowledgments (Wheeler, in Gowing, p. 5). For the Monet exhibition, see William C. Seitz, *Claude Monet: Seasons and Moments* (New York: The Museum of Modern Art, 1960).

36. Wheeler, in Gowing, p. 5.

37. William Hazlitt, quoted in Gowing, p. 13. "Pictures of Nothing" was originally to have been the subtitle of the exhibition (see note 3, above).

38. Gowing, p. 16.

39. The subject matter of Abstract Expressionism is considered in relationship to its sources in E. A. Carmean et al., *American Art at Mid-Century: The Subjects of the Artist* (Washington, D.C.: National Gallery of Art, 1978). Needless to say, this is by no means the only way that subject matter might be considered; see, for example, the publications by Krauss and Harrison cited in notes 77 and 87, below, for just attacks on this approach. On the emergence of depicted subject matter in the 1950s, see Sidney Tillim, "The Figure and the Figurative in Abstract Expressionism," *Artforum,* 4 (September 1965), pp. 45–48; Clement Greenberg, "After Abstract Expressionism" (1962–69), in Henry Geldzahler, *New York Painting and Sculpture, 1940–1970* (New York: The Metropolitan Museum of Art, 1969), pp. 362–66; Irving Sandler, *The New York School: The Painters and Sculptors of the Fifties* (New York: Harper & Row, 1978), pp. 46–89.

40. See Clement Greenberg, "'American-Type' Painting" (1955–58), in his *Art and Culture: Critical Essays* (1961; Boston: Beacon Press, 1965), pp. 221–28. The Monet vogue is discussed in Sandler, *The New York School,* pp. 52–57, but its full history has yet to be written. Greenberg implies that new interest in Monet developed in the early 1940s (*Art and Culture,* pp. 44, 221). However, historians of the period suggest that it was a late 1940s phenomenon. See Sandler, *The New York School,* p. 52; Sandler, *The Triumph of American Painting: A History of Abstract Expressionism* (New York: Praeger, 1970), pp. 273–74; William S. Rubin, "Jackson Pollock and the Modern Tradition, Part 2," *Artforum,* 5 (March 1967), pp. 28, 35.

41. For the Monet vogue and Abstract Impressionism, see Sandler, *The New York School,* pp. 52–57.

42. See John I. H. Baur, *Nature in Abstraction* (New York: Whitney Museum of American Art, 1958).

43. Seitz, *Claude Monet,* p. 52.

44. Gowing, p. 7.

45. See note 29, above.

46. See Sandler, *The New York School,* p. 297.

47. Leo Steinberg, "Monet's *Water Lilies,*" *Arts,* 30 (February 1956), pp. 46–48; reprinted in his *Other Criteria: Confrontations with Twentieth-Century Art* (New York and London: Oxford University Press, 1972), p. 239.

48. Clement Greenberg, "On the Role of Nature in Modernist Painting" (1949), in his *Art and Culture,* p. 173.

49. Gowing, p. 16.

50. Greenberg, "'American-Type' Painting," in his *Art and Culture,* pp. 222, 226.

51. Clement Greenberg, "The Later Monet" (1956–59), in his *Art and Culture,* p. 45.

52. In January 1956, the Museum put on view its newly acquired Nymphéas painting in a recent-acquisitions show which also included another painting on the theme of water, Larry Rivers's *Washington Crossing the Delaware.* The acquisition generated a number of articles that discussed the contemporaneity of Monet (e.g., note 47, above). This painting was destroyed in the fire at the Museum in 1958. The large triptych and the single-panel Nymphéas now owned by the Museum were both acquired in 1959.

53. Seitz, *Claude Monet,* p. 52.

54. *Art News,* 59 (February 1961), pp. 38–41, 56–58; reprinted in Geldzahler, *New York Painting and Sculpture,* pp. 350–59.

55. Ibid., p. 353.

56. Rosenblum's illustrations are in ibid., pp. 354–55, 356–57. With the exception of the Rothko (in a private collection), the precise works he illustrated are reproduced here. When Rosenblum returned to these issues in his *Modern Painting and the Northern Romantic Tradition: Friedrich to Rothko* (New York: Harper & Row, 1975), he used Friedrich rather than Turner as his first Romantic paradigm. Nevertheless, his comparisons of Turner to Pollock and then to Rothko (pp. 205, 214) effectively recapitulate what he had published in 1961.

57. Ibid., p. 359.

58. "Morris Louis at the Guggenheim Museum," *Art International,* 7 (December 1963), p. 24. This interpretation is reviewed in John Elderfield, *Morris Louis* (New York: The Museum of Modern Art, 1986), p. 45.

59. Stanley Cavell, *The World Viewed: Reflections on the Ontology of Film* (New York: Viking Press, 1971).

60. Compare, for example, Greenberg's reference to "Monet's broad, slapped-on daubs of paint and his scribbles" ("The Later Monet," in his *Art and Culture,* p. 45) with Robert Herbert's account of Monet's calculated technique in his "Method and Meaning in Monet," *Art in America,* 67 (September 1979), pp. 90–108.

The illustrations here appeared in William Rubin's evaluation of Pollock's sources, "Jackson Pollock and the Modern Tradition," which appeared in four successive issues of *Artforum* (5, nos. 6–9 [February–May 1967]) and is discussed below. The illustrations appeared in no. 6 (February 1967), p. 14 (Pollock) and no. 7 (March 1967), p. 32 (the Impressionist). The caricature of Turner painting appeared in Gowing, p. 43.

61. Gowing, p. 43.

62. "The American Action Painters," *Art News,* 51 (September 1952); reprinted in Geldzahler, *New York Painting and Sculpture,* pp. 341–49.

63. While Louis's first mature series of pictures dates to the early 1950s, he did not fully hit his stride until the late 1950s; his reputation dates from the early to mid-1960s. See Michael Fried, *Morris Louis, 1912–1962* (Boston: Museum of Fine Arts, 1967), especially "Appendix II: Clement Greenberg on Morris Louis" (pp. 81–84), which effectively documents how Louis and Noland were first received. See also Elderfield, *Morris Louis,* for discussion of Louis's critical reception.

64. See note 31, above.

65. See, for example, Michael Fried, *Three American Painters* (Cambridge, Mass.: Fogg Art Museum, Harvard University, 1965), pp. 11–19, which develops Greenberg's interpretation of Pollock's priority (e.g., in *Art and Culture,* pp. 152–53) to make him the main Abstract Expressionist precursor for subsequent painting. Rubin's "Jackson Pollock and the Modern Tradition" develops further from Greenberg to provide for Pollock a wide historical base. Significantly, both authors begin by attacking (and the consensus developing opposes itself to) Harold Rosenberg's concept of Action Painting. See also Philip Leider's introduction (pp. 3–13) to a special issue of *Artforum* on "The New York School" (4 [September 1965]), in which it is argued that confused discussion of Abstract Expressionism was the direct result of (often misinterpretation of) Rosenberg's writings.

66. Michael Fried, "How Modernism Works: A Response to T. J. Clark," in Francis Frascina, ed., *Pollock and After: The Critical Debate* (New York: Harper & Row, 1985), p. 72.

67. See Fried, *Three American Painters,* pp. 20, 44–45. Fried's essay also introduces his idea of "deductive structure," which he will develop as an alternative to Greenberg's idea of opticality. But even in his "Art and Objecthood," where deductive structure and also now "syntactical structure" are developed, he still prominently quotes Greenberg on dematerialization (see note 68, below).

68. Clement Greenberg, "The New Sculpture" (1948–58), in his *Art and Culture,* p. 144. This, Greenberg's classic, most fluent description of "opticality," was not in the original, 1948 version of his essay (see John O'Brien, ed., *Clement Greenberg: The Collected Essays and Criticism,* vol. 2 [Chicago and London: University of Chicago Press, 1986], pp. 313–19). Its appearance in *Art and Culture* in 1961 proved to be extremely influential and therefore helped to create the climate of taste encouraging of a Turner exhibition. In 1967 (the year after that exhibition), Michael Fried quoted this passage as descriptive of the art he was defending (Anthony Caro's specifically) in opposition to Minimal art in his influential article "Art and Objecthood" (*Artforum,* June 1967; reprinted in Battcock, ed., *Minimal Art,* p. 137). That quotation represents at once the climax of the critical application of the concept of "opticality" and the moment at which alternative models for modernist abstraction began to be proposed to replace it, among them Fried's own concept of "syntax" mentioned in note 67, above. See "Theories of Art after Minimalism and Pop," in Hal Foster, ed., *Dia Art Foundation Discussions in Contemporary Culture, No. 1* (Seattle: Bay Press, 1987), especially the papers by Fried (pp. 55–58) and Rosalind Krauss (pp. 59–64) and the relevant parts of the Discussion (pp. 71–87).

69. I do not consider here the major changes of staff and organization within The Museum of Modern Art in the later 1960s that replaced the older generation of senior curators and administrators. (For this subject, see Russell Lynes, *Good Old Modern: An Intimate Portrait of The Museum of Modern Art* [New York: Atheneum, 1973], chapters 19, 20.) It is true that the new generation understandably wanted its own, new programs and therefore was unlikely to pursue older programs, including exhibitions of precursors. However, the taste of that generation has to be considered extramurally. The reasons for the decline in Turner's prestige, and that of distant precursors generally, lie outside the Museum.

70. Cited by Michael Fried, in *Art Criticism in the Sixties,* recording a May 7, 1966, symposium at Brandeis University (New York: October House, 1967), unpaginated.

71. Ibid.

72. Ibid.

73. *Artforum,* 5 (February 1967), p. 14. See notes 34, 60, above.

74. See "Letters," *Artforum,* 5 (April 1967), pp. 6–7.

75. Michael Fried, "Manet's Sources: Aspects of His Art, 1859–1865," *Artforum,* 7 (March 1969), a special issue.

76. Theodore Reff, "'Manet's Sources': A Critical Evaluation," *Artforum,* 8 (September 1969), pp. 40–48.

77. Cf. also Fried's 1966 suggestion that "disputes among [critics] will tend more and more to look like disputes among historians rather than like our traditional picture of disputes among critics" (*Art Criticism in the Sixties*) and Rosalind Krauss's 1982 insistence that "this distinction between critic and art historian would seem to be a false distinction," in part because "[a]rt history, as an academic discipline, shares its historical moment with the birth and development of modernist art" ("Reading Jackson Pollock, Abstractly," reprinted in her *The Originality of the Avant-Garde and Other Modernist Myths* [Cambridge, Mass.: MIT Press, 1985], p. 221). Some very pertinent remarks about critic-historians and obsession with genealogies will be found in David Carrier's *Artwriting* (Amherst, Mass.: University of Massachusetts Press, 1987), pp. 119–34.

78. *The Sacred Wood,* p. 49.

79. "Influences of Matisse," in *Henri Matisse* (New York: Acquavella Galleries, 1966), unpaginated.

80. For subtle discussions of past and present, see Stanley Cavell, *Must We Mean What We Say? A Book of Essays* (1969; Cambridge: Cambridge University Press, 1976), especially pp. 183–84, 201, 230–37.

81. Whereas Noland did influence Louis, Greenberg observed, Louis's art "would have evolved anyhow" in that direction (quoted in Fried, *Morris Louis,* pp. 82–83). This is a characteristic way of addressing this difficulty.

82. Greenberg, "The Later Monet," in his *Art and Culture,* p. 45.

83. Gowing, p. 27.

84. Fried, *Morris Louis,* p. 23.

85. Bruce Glaser, "Questions to Stella and Judd," *Art News* (September 1966); reprinted in Battcock, ed., *Minimal Art,* pp. 157–58. A useful summary of the broad differences between the old and the new values is chapter 1 of Irving Sandler, *American Art of the 1960s* (New York: Harper & Row, 1988). The five chapters that follow provide a fascinating account of the constitution and concerns of the New York art establishment of that decade.

86. *Artforum,* 5 (February 1967), p. 15.

87. See Charles Harrison, "Modernism and the 'Transatlantic Dialogue,'" in Frascina, ed., *Pollock and After,* pp. 225–26, referring particularly to Thomas Hess's interpretation in *Barnett Newman* (New York: The Museum of Modern Art, 1971). Cf. Michael Fried's 1965 non-illustrational Newman in his *Three American Painters,* pp. 20–23. Pollock, of course, has been first re-Romanticized and second re-symbolized since the 1960s: for the first, see Kynaston McShine, ed., *The Natural Paradise: Painting in America, 1800–1950* (New York: The Museum of Modern Art, 1976), whose introduction claims the Turner exhibition as a precedent (p. 7) and which, significantly, contains an essay by Rosenblum; for an attack on the second, see William Rubin, "Pollock as Jungian Illustrator: The Limits of Psychological Criticism," *Art in America,* 67 (November 1979), pp. 104–23.

88. See William Rubin, ed., *Cézanne: The Late Work* (New York: The Museum of Modern Art, 1977), an exhibition catalogue which included an essay by Gowing.

89. Clement Greenberg, in O'Brien, ed., *Clement Greenberg: The Collected Essays and Criticism,* vol. 2, p. xix. In 1966, Greenberg wrote of Matisse's preeminence in his "Influences of Matisse" (note 79, above). There, Matisse's influence begins and Monet's influence "comes a little later" only to be superseded by the return of Matisse's, whose "influence on American painting at its best continues after Monet's leaves off" (unpaginated).

90. See Robert Rosenblum, *Transformations in Late Eighteenth-Century Art* (1967; Princeton, N.J.: Princeton University Press, 1969), p. 191. Rosenblum's references to the scorn for oil painting of artists like Carstens and Blake, and their turn to watercolor and tempera (p. 186) are neoclassical equivalents to Gowing's references to Turner using oil in imitation of watercolor and being attacked for it by Beaumont (p. 16), and both are relevant to the 1960s. (Thomas Hess attacked Louis for the same reason that Beaumont did Turner: because he found the watercolor effect to be thin and impoverished; see Glaser, "Questions to Stella and Judd," p. 157.) But the neoclassical associations of the mid-1960s go beyond questions of technique to those of purist layouts and simple geometric structures (cf. Rosenblum, chapters 3 and 4). And graph paper (with masking tape, the indispensable material of sixties artists) was, significantly, invented around 1800. (The question of gridding is clearly a central one, for grids associate Pop art, Minimalism, and Color Field painting.)

91. Cf. Sidney Tillim, "Gothic Parallels: Watercolor and Luminism in American Art," *Artforum,* 5 (January 1967), pp. 18–19. Light in art remained a subject of contemporary critical interest through the 1960s. See, for example, Thomas B. Hess and John Ashbery, eds., *Art News Annual 35: Light — From Aten to Laser* (New York: Macmillan, 1969), which includes articles on Gothic glass and the color of divine light; however, the contemporary apogee of this development is seen to be art that literally makes use of light, usually artificial light.

92. As was often the case, Greenberg took the lead in this. See his "Louis and Noland," *Art International,* 4 (May 1960), pp. 26–29, and his introduction to *Post-Painterly Abstraction* (Los Angeles: Los Angeles County Museum of Art, 1964). In the former, Frankenthaler and Jenkins are considered to be "special cases"; in the latter, Francis and Frankenthaler are described among those artists using familiar painterly methods.

93. Rosalind Krauss, "On Frontality," *Artforum,* 6 (May 1968), p. 43.

94. Following Tillim, a combination of Gothic window and Mediterranean wall is suggested for Louis's art in Elderfield, *Morris Louis,* pp. 46–47.

95. See Tillim, "Gothic Parallels," pp. 18–19.

96. Ibid., p. 19.

97. "Necessity of 'Formalism,'" *New Literary History,* 3 (Autumn 1971), p. 172.

98. Greenberg, "Winslow Homer" (1944), in his *Art and Culture,* p. 188.

99. Greenberg, "Thomas Eakins" (1944), in his *Art and Culture,* p. 178.

100. See *The Art of the Real: U.S.A. 1948–1968* (New York: The Museum of Modern Art, 1968). In his introduction to the catalogue, Eugene C. Goossen observes, for example, that while there are "lyrical qualities" in Louis's art, "they are balanced by the physicality of the soak-stain method he used" (p. 9).

101. Certainly, when Turner's kind of Romanticism was revived later, only the American version would suffice (see McShine, ed., *The Natural Paradise* [1976]), but that admittedly was in the year of the Bicentennial. See also note 123, below, for precursor exhibitions after the Turner exhibition.

102. See, for example, Rose, "ABC Art" (note 23, above), which begins by referring to the iconoclasm of Malevich and Duchamp (pp. 274–75); and Robert Morris, "Notes on Sculpture: Part 1," *Artforum,* 4 (February 1966), pp. 43–44, which opens with references to Tatlin, Rodchenko, et al.

103. It has now been told: see Rosalind Krauss, "Overcoming the Limits of Matter: On Revising Minimalism," in the present issue of *Studies in Modern Art.*

104. "Gothic Parallels," p. 18. This phenomenon was not restricted to California, however. The same year, 1967, that Tillim wrote his article and that saw heightened debate about Minimal art with the publication of Fried's "Art and Objecthood" saw also the apotheosis of sixties spirituality as style with the release of *Sergeant Pepper.* It is in the popular culture of the later 1960s, more than anywhere else, that the anachronistic search for the Sublime continues. (See also note 117, below.)

105. Originally, the two closely interrelated and were treated by most critics as virtually one phenomenon (see Battcock, ed., *Minimal Art,* passim). As late 1960s Color Field painting reintroduced effects of painterliness and transparency, it became anathema to Minimalist artists and their supporters (and despite the fact that Minimalism too was re-Romanticized then; see note 118, below). Even before then, however, the common geometric morphology of Color Field painting and Minimalism disguised very different aims. One of the agendas of Michael Fried's writing in the 1965–67 period, and what helped to make it so influential, was his desire to separate them; and he correctly (and quickly) realized that their point of division was the work of Stella, of whom he observed later: " . . . I was claiming his paintings for a development I believe in. In a sense Carl Andre and I were fighting for his soul"; in Foster, ed., *Dia Art Foundation Discussions in Contemporary Culture, No. 1,* p. 79. See also note 117, below.

106. See note 85, above.

107. See note 86, above.

108. See note 62, above, and the discussion of Rosenberg's ideas in Rosalind Krauss's *Passages in Modern Sculpture* (1977; Cambridge, Mass.: MIT Press, 1981), pp. 256–58.

109. Rosenberg, quoted and analyzed by Rubin in *Artforum,* 5 (February 1967), p. 16, as part of a critique of Rosenberg's concept of Action Painting. (Cf. note 65, above.)

110. The reference to Rubens is Greenberg's on Louis (quoted in Fried, *Morris Louis,* p. 83), who minimizes the role of chance in works like Louis's to defend them from heated, Romantic interpretations. Greenberg's most explicit description of modernism as a reaction against Romanticism is in his "Necessity of 'Formalism,'" pp. 171–75.

111. Glaser, "Questions to Stella and Judd," p. 156.

112. See Krauss, *Passages in Modern Sculpture,* pp. 258–72.

113. Judd's statement is quoted and discussed in John Elderfield, *Frankenthaler* (New York: Harry N. Abrams, 1989), p. 140.

114. *Artforum,* 5 (March 1967), p. 29.

115. Ibid., p. 33.

116. Ibid.

117. See Elderfield, *Frankenthaler,* pp. 40–41, for discussion of the shift back to the urban from the rural around 1960. I consider there why an art of assemblage ultimately could not serve as both tough and urban. Pop art could, clearly; it was an urban-industrial alternative to landscape-connotative late Abstract Expressionism before Minimalism was. But precisely because it seemed an alternative — and a figurative, iconographical alternative — it did not affect the course of abstract art issuing from Abstract Expressionism to the extent that Minimalism did. (It could be ignored, whereas Minimalism could not.) For Minimalism could be perceived as a further, more extreme development of the abstract "purity" to which Abstract Expressionism, like all modernist painting, had tended. (Cf. Greenberg's "Modernist Painting" [1965], reprinted in Gregory Battcock, ed., *The New Art* [New York: E. P.

Dutton, 1966], pp. 101–10, where Greenberg allows but does not sanction this interpretation.) That is to say, it could be perceived as having surpassed and therefore supplanted Color Field painting in a way that Pop art could not. Additionally, it seemed to occupy a position between its two preceding alternatives — abstract but also urban-industrial — and could therefore claim a position of centrality as a consequence. Its relationship, on one side, to Pop art was noticed from virtually the beginning (see Rose, "ABC Art"), to the indifference of both parties; its relationship, on the other side, to Color Field painting was too, but soon became a matter of mutual dissatisfaction leading to separation (see note 105, above). Recently, an ingenious attempt has been made to associate Pop art and Color Field painting as commercial-industrial, thus to separate, now, Minimalism from both (see Krauss in Foster, ed., *Dia Art Foundation Discussions in Contemporary Culture, No. 1*, pp. 60–62; and Benjamin H. D. Buchloh, "Andy Warhol's One-Dimensional Art, 1956–1966," in Kynaston McShine, ed., *Andy Warhol: A Retrospective* [New York: The Museum of Modern Art, 1989], pp. 80–93). This is too large a subject for a footnote. However, it can be argued that the surface dazzle of Pop paintings reflects *back* to the beholder the paradisal mirage that previously had seemed unobtainable; in that sense, they offer what is at once a temptation and a gratification of the senses. In any event, commodification occurs. The year 1966 saw not only Turner's sunsets and pastorals but also Warhol's Silver Clouds and Cow Wallpaper.

118. I am thinking not only of the development of Minimalism into actual landscape art, or land art, but also of the development between, say, Robert Morris's *Untitled* of 1965–67 (fig. 23) and his *Untitled* of 1968 (fig. 24); both developments can be historicized as from neoclassicism to the picturesque and as paralleling the shift in Abstract Expressionism from the raw and urban to the lyrical and rural. What has been called Post-Minimalism, for the new pictorialism of its handling of materials as opposed to the severity of mid-1960s work, is thus analogously the Abstract Impressionism of the Minimalist movement if not, indeed, its Romanticism at last. Right on cue, there appeared in *Artforum*, 10 (November 1971), an article by Robert Pincus-Witten called "Eva Hesse: Post-Minimalism into Sublime."

119. See Gowing, pp. 38, 42–43. Turner would send in for exhibition paintings that had been barely prepared and would extensively work them during the so-called "varnishing days" allowed for retouching.

120. This characterization of the painting of Constable, excepting the reference to Turner, is indebted to Kermit S. Champa's *The Rise of Landscape Painting in France: Corot to Monet* (Manchester, N.H.: The Currier Gallery of Art, 1991), p. 27.

121. Eugene C. Goossen, "Two Exhibitions," essays of 1964 and 1966, in Battcock, ed., *Minimal Art*, p. 169.

122. For the recognition accorded to this art, and to its artists, see Sandler, *American Art of the 1960s*, chapters 4, 5, 16.

123. "The Natural Paradise" of 1976, the first of the new precursor exhibitions to be devoted to painting, reopened the genre precisely where it had been closed down a decade before (see notes 87, 101, above). Other such exhibitions of note at the Museum include that important harbinger of postmodernism, "The Architecture of the École des Beaux-Arts" (1976) and its footnote, "The Architecture of Sir Edwin Landseer Luytens" (1979); also "Before Photography: Painting and the Invention of Photography" (1981).

It is interesting that, after "The Natural Paradise," precursor exhibitions of paintings disappear, with one single, important exception which revises the kind of precursor exhibition held in the Museum's early years, namely "'Primitivism' in Twentieth-Century Art: Affinity of the Tribal and the Modern" (1984).

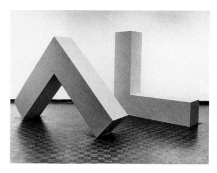

23. Robert Morris. *Untitled*. 1965–67. Fiberglass; each component, 8 x 8 x 2' (243.8 x 243.8 x 61 cm). Private collection

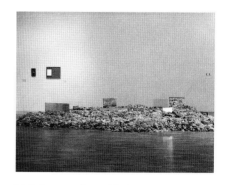

24. Robert Morris. *Untitled*. 1968. Felt, asphalt, mirrors, wood, copper tubing, steel cable, and lead, 21 1/2" x 21' 11" x 16' 9" (54.6 x 668 x 510.5 cm) variable. The Museum of Modern Art, New York. Gift of Philip Johnson

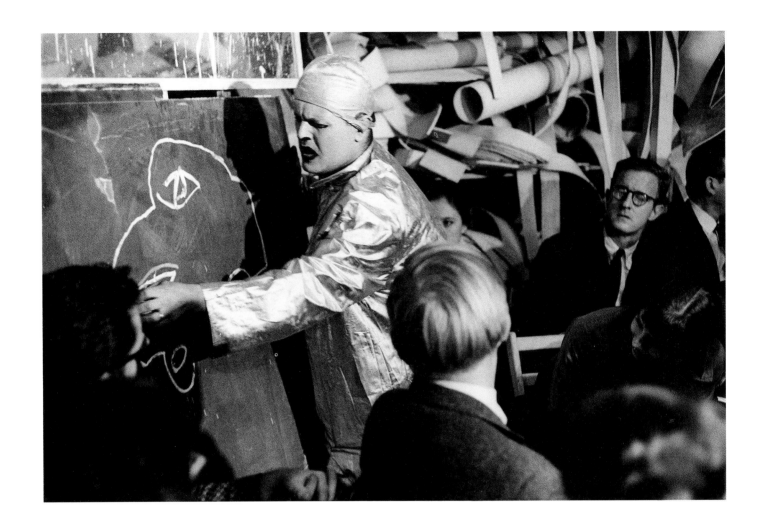

1. Jim Dine in his Happening *Car Crash*,
performed at the Reuben Gallery, New York,
November 1–6, 1960

Jim Dine and Performance

Joseph Ruzicka

During the heyday of Happenings, the young Jim Dine staged four performances in 1960, marking his first sustained engagement with the New York avant-garde. Much of his work of the ensuing decade came out of the highly energetic yet ambivalent dialogue that resulted; it was ambivalent in the sense that, while Dine was always attuned to adventurous thinking, he nonetheless remained aloof from every movement and chafed at being labeled a member of any particular group. By focusing on his work in the performing arts, from the Happenings to his stage adaptation of Oscar Wilde's *The Picture of Dorian Gray* (1967–68), we can achieve a clearer understanding of his ambiguous struggle with the avant-garde and his quest to discover his own identity as an artist.

Dine himself once noted, "I did arrive full-blown in a certain way."[1] When he came to New York in late 1958, he possessed boundless energy, manual dexterity, and, most important, the conviction that he was always meant to be an artist.[2] But, as he has also said, he was "psychologically young and emotionally immature," and had not yet developed the confidence to set out on his own.[3] In an attempt to orient himself, to establish some intellectual bearing, he undertook a decade-long conversation with various avant-garde styles, working with one, then discarding it and moving on to another. The resulting work was often brilliant and always idiosyncratic.

Since his student days in Cincinnati, Dine had keenly followed the development of avant-garde art, then Abstract Expressionist painting, by reading art magazines and making periodic trips to New York.[4] He has commented that he is by nature "an expressionist thinker," but at this stage in his life, in the late fifties, it was an unfocused — and therefore adaptable — expressionism; if he had once been interested in working in an Abstract Expressionist style, he was nonetheless later drawn into the new art of Happenings and Environments, which he discovered soon after arriving in New York: "I was aware of the fact that I was of another generation. Different things were happening then, and I got involved with them. What Kaprow was saying appealed to me, so I went along. Happenings were not all that I wanted to do, but were what I was locked into by time and events. It was expected of an energetic young man with talent."[5] Dine met Allan Kaprow and Kaprow's students through the Reuben Gallery and the Judson Gallery in late 1959 and early 1960. He was

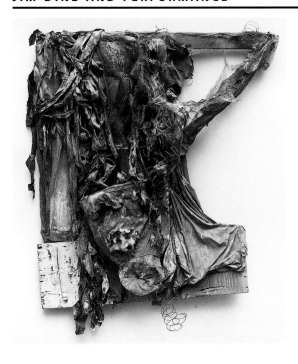

very quickly in the thick of things and in 1960 played a major role in several evenings of Happenings by Claes Oldenburg, Robert Whitman, Al Hansen, Red Grooms, and Kaprow.

But before he tackled the logistics of a Happening, Dine first learned how to deal with the problem of making a room-size work of art in his Environment *The House* — his half of a two-man installation that included Oldenburg's Environment *The Street* — which opened at the Judson Gallery in late January 1960.[6] Dine's Environment issues directly from his assemblages of the previous year, such as *Household Piece* (fig. 2), work taking both its subject matter and material from the streets of New York's Lower East Side. Two distinct expressionistic currents run through a work like *Household Piece*. First, the fact that it is made from other people's discards means the piece, when completed, already has a very rich and complex history. Previous owners inevitably impressed their own lives onto their possessions through repeated use,[7] and the assemblage becomes, therefore, a complex interweaving of many different lifetimes. Second, Dine's handling of the material clearly reflects his interest in the gestural power of Abstract Expressionist painting.[8] Moreover, by virtue of his deliberately crude handling of the material in *Household Piece*,[9] and the irregular shape of the piece, Dine made a significant break from the rigid corners and edges of the traditional rectangular format. The natural next step, then, was to transform, both spatially and emotionally, the white walls of an entire room (*The House,* fig. 3) by accumulating even greater piles of fragments from the lives of others: cloth, cardboard, household items, grocery signs, and painted cutouts of figures.

The House was a transitory work of art that could be experienced only until the end of the exhibition, when it was dismantled and destroyed. This attitude toward art as something passing and non-salable of course formed the basis of all Happenings, Dine's included. His first, *The Smiling Workman* (fig. 4), was performed the evenings of February 29 and March 1 and 2, 1960, on a makeshift stage within *The House*.[10] Wearing a floor-length smock and with a red-painted face, Dine stood behind a table that supported buckets of paint, acting out

2. Jim Dine. *Household Piece*. 1959. Assemblage: wood, canvas, cloth, iron springs, oil and bronze paint, sheet copper, brown paper bag, mattress stuffing, and plastic, 54 1/4 x 44 1/4 x 9 1/4" (137.7 x 112.4 x 23.5 cm). The Museum of Modern Art, New York. Gift of John W. Weber

3. Jim Dine in his Environment *The House,* shown at the Judson Gallery, Judson Memorial Church, New York, January–March 1960

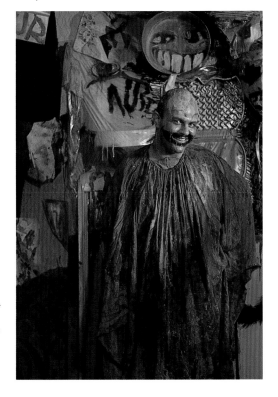

4. Jim Dine in his Happening *Smiling Workman,*
performed at the Judson Gallery, Judson
Memorial Church, New York, February 29–
March 2, 1960

the role of artist as priest, as leader in a spiritual ceremony. Behind him was a large sheet of paper — stretched to look like a canvas, its painted border imprinted with Dine's left hand (he is left-handed) — on which he very rapidly scrawled in paint, I LOVE WHAT I'M DOING; just as he finished, he drank a bucket of red paint (actually tomato juice), poured two other buckets of paint over his head, and finally jumped through the "painting."[11] When it was all over, nothing was left.

5. Jim Dine in his Happening *Vaudeville Show,*
performed at the Reuben Gallery, New York,
June 11, 1960

The subject matter of *The Smiling Workman,* like all of Dine's Happenings, was resolutely personal, originating in "bad dreams, but not directly from nightmares. They came from a life of bad dreams."[12] Translating these experiences into what he called "metaphors," he acted out facets of his private life in public. This particular piece was about "obsessions, obsessive working, about being an artist and becoming famous through the theater."[13] Covering himself with the paint of his profession, Dine projected both the exhilaration and anxiety he was then experiencing, newly caught up in the avant-garde. Much of the piece's intensity stemmed from the sense of purpose that Kaprow instilled in the young artists of the day. "Kaprow made us feel important, in a new and revolutionary way. He made us feel like brave young soldiers. We felt right out there in front, brave young soldiers being put up in the trenches, the first ones to go over the hill."[14] It also stemmed from a need, a determination, to be successful.[15]

The Vaudeville Show (fig. 5), Dine's second Happening, staged on the evening of June 11, 1960,[16] was decidedly more sophisticated than

his previous one. Sound played an important role: a tape recording of organ music with Dine talking and other sounds — what he referred to as "a collage on tape"[17] — played throughout the show, which was divided into three acts. In the first, Dine, in red suit and with yellow face, picked pieces of cotton off himself, then left the stage. He did not appear in the second act; instead, "inanimate objects became actors."[18] He set up a string of carrots, celery, cabbage, and lettuce that jumped and danced when two people behind the scenes pulled the ends.[19] When this dance ended, the act closed as red paint was poured down the walls on either side, inundating the stage with the painter's medium, much as in *The Smiling Workman*. The dance of the vegetables suggests that the way Dine saw and used objects was changing. From out of the welter of stuff in an assemblage like *Household Piece* or an Environment like *The House,* the artist began to single out certain objects, pulled them forward and emphasized them, while he smoothed out the background and made it more uniform.

In the final act, Dine, accompanied by two life-size cutouts of women, one arm through a hole in the shoulder of each, "did a freeform soft-shoe across the stage,"[20] bringing down the house.[21] As Dine recalled, "It was an incredible scene. In the sense of audience participation, I have never felt it stronger — with someone else or me. People remember it as a fantastic night."[22] Alan Solomon recalled the audience response as "electrifying. Dine on stage had a charismatic effect which depended on the intensity of his projection of himself and the activities he was involved in."[23] Dine once commented that *The Vaudeville Show* "was a crowd-pleaser and one that was quite pleasing to me to do."[24] Indeed, that was very much what this Happening was about, with Dine here assuming the persona of artist-as-entertainer, of popular performer, achieving fame and reaching an audience.

Car Crash (figs. 1, 6), staged in early November,[25] was Dine's most important Happening and marked a watershed in his career at which certain lifelong work habits were established. One was the practice of collaborating with others. While his previous Happenings had each been part of a slate of different performances, nonetheless he performed alone in them. Those evenings were something like group shows of separate, individual artists, rather than collaborative efforts. Indeed, he preferred to perform by himself because, as he explained, "I did not trust anyone else, and I did not feel that what I was doing was of a public-enough nature to even tell the people what to do."[26] In *Car Crash,* however, he was one of four actors; he needed others in order to stage the more elaborate event that he had in mind. He trusted three friends — Pat Oldenburg, Judy Tersch, and Marcus Ratliff — to understand what he wanted.[27] This Happening was still clearly based on Dine's own "life of bad dreams," although the more public nature of the piece, a tragedy on the American road, must have given him the confidence to let friends in on the action.[28] *Car Crash* was a cathartic performance for the artist, a

"metaphor" for the traumatic summer of 1958, when he and his wife Nancy survived one auto accident and a friend died in another.

When preparing for his other Happenings, Dine designed the costumes and sets in his head and simply walked through the action as his wife watched and made suggestions.[29] But with the greater complexity of *Car Crash,* he adopted a more disciplined approach, working up a script for Pat Oldenburg's monologue[30] and holding rehearsals. He also drew a number of costume and prop designs, only three of which are known to survive.[31] These were originally working documents, steps along the way as he refined his final ideas for the performance.[32] One design, *Study for the Happening "Car Crash" (Man in Woman Costume / Woman in Male Costume)* (fig. 7), is in fact composed of several separate ballpoint pen and pencil drawings (one of each figure and a red cross) on scraps of paper, designs for the costumes that Tersch and Ratliff wore in the performance. It was only after the performance, when Dine was back full-time in his studio, that he began to consider these drawings in a new light, as permanent objects rather than shopworn working documents; while he was preparing for the Happening, he thought of the studies as having the same

ephemerality as the Happening itself. This distinguishes these designs, at least in their original form, from the other works — assemblages, paintings, and prints — he made at the same time dealing with the Crash theme, but which did not pertain directly to the staging of the Happening. The latter were always thought of as permanent objects, made in the studio, and never sharing the brief life span of his Happenings.

Dine executed many works dealing with the Crash theme in a wide variety of mediums in 1959 and 1960. Working in this way became a trademark process: the prototype for all his extended series of bathrobes, tools, gates, trees, and hearts was this, his first series. The motif that ties all the Crash works together is the cross, which Dine still considers "a very strong shape."[33] In the course of two years, he executed no fewer than a dozen works on the

Left:
6. Marcus Ratliff and Judy Tersch in Dine's Happening *Car Crash,* **performed at the Reuben Gallery, New York, November 1–6, 1960**

Right:
7. Jim Dine. *Study for the Happening "Car Crash" (Man in Woman Costume / Woman in Male Costume).* **1960. Ballpoint pen, ink, chalk, watercolor, pencil, and collage on paper, 16 3/4 x 21 3/4" (42.5 x 53.3 cm). The Museum of Modern Art, New York. Gift of the artist**

theme,[34] which reached a climax late in 1960 with the Happening. All of them form a coherent group: in the small vestibule to the Reuben Gallery, where the Happening was staged, Dine lined the walls with Crash drawings and paintings.[35] And besides being thematically related, all of the Crash works are executed in a dense, expressionistic style, the last time he would work in such an unrestrained manner for several years.

Of all the work Dine has done throughout his career, the Crash series remains the most unambiguous and explicit in emotion.[36] In the 1960 *Car Crash* assemblage of tar, paint, and clothing (fig. 8), the clothes of victims hurled from cars lie engulfed in asphalt, strewn all over the road. In Crash drawings and prints, dense webs of lines entrap crosses, and the words CRASH and SMACK, conjure up the confusion and pain of the impact and its aftermath. Skeins of blood-red ink spill over the surface of the drawings, a grim reminder of human frailty; in the lithographs (fig. 9), a tangle of thick, black lines evokes "a twist of machinery left at the road's edge in a mixture of blood and machine-oil."[37] In a work like *Household Piece,* Dine had used the gestural tradition of the Abstract Expressionists and the residue of other people's private lives (through their refuse) to create a poetic and mysterious work. The Crash series, however, channeled his expressionistic energy in another direction; through an exposition of the tragedy of two specific incidents, he reached a kind of catharsis which ridded him of that pain. In this experience, the public acting-out of the horror by means of the Happening was the most important step.

Car Crash was staged alone at the Reuben Gallery, enabling Dine to take over the entire space to create an Environment that embraced both audience and actor. The props that hung from the walls and ceiling established a crash and hospital iconography: tires, tubing that eerily resembled human entrails, gloves that were surrogates for severed hands, a doctor's bag, red crosses, and silver crosses.[38] The entire ensemble was painted white, including all the performers (except Dine, who was silver), accentuating the emergency-room atmosphere.[39]

In addition to carrying meaning, the whiteness guaranteed that the Environment would envelop the actors and the audience alike.[40] When Dine had staged *The Smiling Workman* within his Environment *The House,* there was virtually no relationship between the two; he set one within the other because it was available space. And in that first Happening, he maintained the traditional separation between performer and spectator, with the two facing each other. He oriented *The Vaudeville Show* the same way. In *Car Crash,* however, to the greatest extent that he ever would, Dine broke down this physical barrier by seating the spectators on white chairs in a U-shaped configuration in the middle of the white Environment created especially for the performance, and then ran the action behind, through, and in front of them. Nonetheless, although involving the audience to a greater degree than

in any other of his performances, by having them sit in the middle of the action, he did not ask them to join in the performance (as others in their Happenings increasingly did).[41] Moreover, to his mind, the spatial organization of the Happening was based on principles familiar from theater-in-the-round (albeit a liberal adaptation). It was never his intention to revolutionize the performance space, nor to draw the spectators directly into the action.[42] He wanted to keep a clear line of demarcation between life and art.

For the first time, Dine fully exploited the formal and dramatic possibilities of stage lighting, deploying spotlights, flashlights, and overhead house lights for a variety of effects. Beginning the performance, the woman-dressed-as-a-man (Judy Tersch) and the man-dressed-as-a-woman (Marcus Ratliff) pursued the car (Dine) throughout the darkened set with flashlights, occasionally striking Dine with beams of light, reliving collisions, making Dine — the struck automobile — react in fear and pain (fig. 6). Whenever an action required special emphasis, such as Pat Oldenburg's rambling, nonsensical monologue, Dine spotlit the person, leaving the rest of the performance area in darkness. And at selected times when all four performers were interacting, the house lights came up, such as when Dine stood at a chalkboard obsessively drawing and redrawing the same automobile while the other per-

8. Jim Dine. *Car Crash*. 1960. Clothing, tar, and oil paint on two burlap panels, 60 x 63" (152.4 x 160 cm) overall. Private collection

9. Jim Dine. *The Crash, No. 3*. 1960. Lithograph; sheet, 29 7/8 x 22 1/8" (75.9 x 56.2 cm). The Museum of Modern Art, New York. The Associates Fund in honor of Riva Castleman

formers stood still and grunted (fig. 1). The complexity of the lighting effectively underscored the ambitious scope of the action.

Quite different in character was *The Shining Bed* (fig. 10), Dine's final Happening of 1960, and his last for nearly five years. In establishing the space of this performance — the stage itself was a foil-wrapped bed, surrounded by the front row of seats — Dine interpreted theater-in-the-round much more traditionally than he had in *Car Crash*. And he mounted this production much more economically, wishing "to do something more modest in scale than *Car Crash*."[43] Gone were the elaborate flats and props. In their stead, he emphasized a single object (here the bed), a development of special significance for his paintings and performances. This marked a definite shift in his thinking as he distilled and simplified his work in all mediums, reining in his expressionist tendencies for the next several years, a change visible in the work of many other artists as well.[44]

To complement the simplified set in *The Shining Bed,* Dine also simplified the lighting, by focusing one overhead light on the bed. In doing this, he created a cell in which he acted, an area of light circumscribed by the darkness that enveloped the audience. This method of defining units of space through concentrated light became a tool that Dine would use to great advantage five years later in his next and last Happening, *Natural History (The Dreams)*, of 1965, in which he spotlit different groups of people spread across an otherwise darkened stage.

In *The Shining Bed,* Dine turned away from the explicit subject matter and energetic action of *Car Crash* to a more allusive and poetic performance.[45] Dealing with the idea of transformation, he performed, dressed as a blue-faced Santa Claus, either lying on the bed under covers of brown wrapping paper or plastic, or sitting on the bed.[46] At one point, he whitened his face in

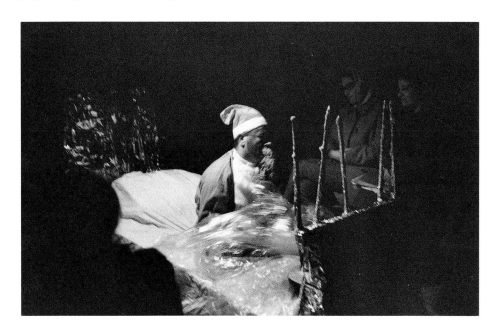

10. Jim Dine in his Happening *The Shining Bed,* performed at the Reuben Gallery, New York, December 16–18, 1960

a bowl of flour. At another, he coated foil spikes on the bed's footboard with batter, making them seem no longer like metal. For the finale, he substituted for himself on the bed a small golden doll. The entire Happening progressed through a series of physical changes that redefined Dine's appearance and restricted surroundings, and thus his identity.

Change was the most appropriate issue for Dine to grapple with in *The Shining Bed,* for after it he changed direction, leaving the stage for several years. While he certainly felt that his participation in Happenings was important for him,[47] he never thought that they would make easel painting obsolete, as Kaprow had predicted they would.[48] In fact, Dine stopped doing Happenings in large part because he wanted to devote more time to painting.[49] He never considered Happenings, his own at least, as being revolutionary. He saw them as a fusion of "painter's theater"[50] (insofar as the visual aspects accorded with what he was working on in his paintings)[51] and a "very personal psychodrama"[52] as he acted out aspects of his private life in public. This personal record of his life was enacted using the techniques and general form of traditional theater.[53] From his first engagement with the New York avant-garde, he made of its practices what he wanted, reshaping them to his own personal vision, and did not adhere to them as dogma.

If the relative simplicity and purity of *The Shining Bed* suggested that Dine was moving toward a more measured expenditure of energy, after that Happening he declared that he needed "a renunciation to get clean."[54] This change in direction was both emotional and aesthetic, and was fully evident in his Environment of early 1961, *Rainbow Thoughts,* which bore no resemblance to *The House* but rather embodied his new, economical vision. In a small room painted black, a six-inch-wide rainbow hung suspended from the ceiling, illuminated only by a single blinking light bulb. Confronted with such a stark situation, viewers had few options other than turning their attention back onto themselves.[55] In the short span of a year, Dine narrowed his focus to a select group of objects, things mostly from his own personal world, rather than things indiscriminately gathered from the world at large. The new restraint and clarity of *The Shining Bed* and *Rainbow Thoughts* set the tone for his work of the next several years. He gradually imposed a relative calm (relative because he never fully curbed his expressionist tendencies) on both his handling of materials and the heated emotions that works such as his Happenings conveyed.

One reason Dine retreated to his studio was to concentrate on his painting. Another was to remove himself from any sort of stage, to shed his identity of performer and to attend more closely to what it meant to be a serious and disciplined artist, a creator of permanent objects. This need to turn from his performance past meant that he also had to turn from his performance cronies. Many of them did not understand why he stopped performing and

felt that somehow he had sold out. After 1960, he withdrew from the society of his fellow visual artists and more and more sought the company of literary people.[56] But he nonetheless maintained a dialogue with the newest ideas of the time, over the years creating work that variously interpreted Pop art, Minimalism, and hard-edge abstraction in a very personal manner.

Dine's last Happening, *Natural History (The Dreams)* (fig. 11), opened the month-long "First Theater Rally: New York," in May 1965.[57] After being away from the stage for five years, he was persuaded to return by Alan Solomon, one of the organizers of the rally and an early champion of the artist. What ensued proved to be a most unpleasant clash of personalities. This was one of several unfortunate incidents occurring at mid-decade that drove Dine away from New York for many years.[58]

 Natural History was decidedly larger in scale and more polished in form than Dine's previous performances, and in this sense was in keeping with the

11. Bob Brown and Nancy Fish in Dine's Happening *Natural History (The Dreams)*, performed at the RKO theater at West 81st Street and Broadway, New York, May 1–3, 1965

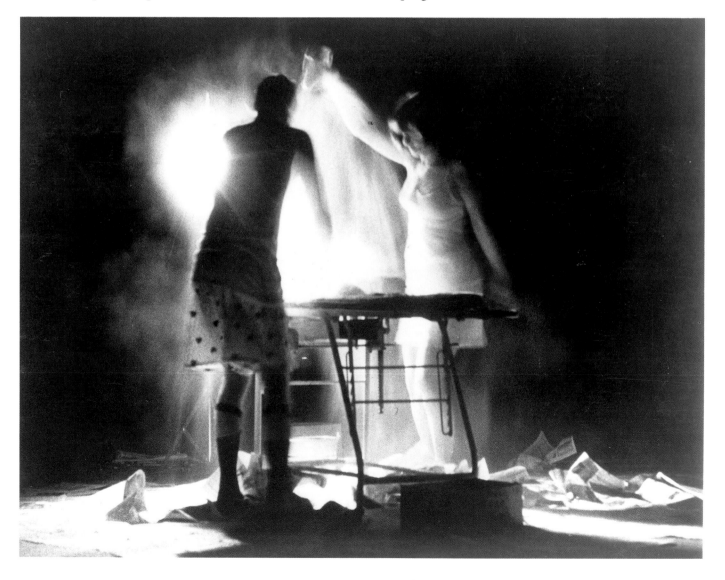

character of the other rally performances. Indeed, the ambitions behind the rally were announced by the fact that it was not staged in an alternative space on the Lower East Side, the hub of such activity earlier in the decade, but was moved uptown, to an RKO theater, complete with permanent seats and a large stage. Nonetheless, *Natural History* was markedly introspective and physically inactive when compared to both his earlier performances and the other rally pieces, most of which were exuberant physical displays making the most of the vast stage space. It was this inwardness that so disappointed the organizers of the rally, who had been anticipating something more on the order of *Car Crash,*[59] something entertaining and exciting.

Dine's last Happening was based on his dreams from the summer of 1963, a shift in subject matter from life's events to the workings of the inner mind. These were thoughts Dine mulled over for several years before acting them out, instead of performing them in skits with a minimum of preparation, and the result was a much more considered and controlled performance. Equally important, he had been in therapy since 1962, redirecting the focus of his thinking inward. One consequence of this was that the Happening dealt with insomnia, sleepless nights surrounded by a whirl of images from the semiconscious mind.

Wearing all black, slouched in a black chair in the middle of the stage, in his cell of light, Dine was flanked by four groups of performers (two on each side) simultaneously acting out his dreams, each group's cell defined by a blinking light: repetitive, everyday, almost unconscious actions, giving rise to irrational situations. Three seated, nattily dressed women exchanged items from their purses; a man and a woman in their underwear kneaded bread dough and shredded newspaper on a medical examination table; a man in a chef's uniform sawed a steel pipe; two men in tennis attire snacked while watching television. Throughout the performance, a tape recording was played of Dine reading from a book of dreams he had composed in 1963 — his brooding, late-night thoughts made audible — while he silently sat amid the four groups and smoked, or stood and shuffled around the stage, all the while plagued by visions.[60] Dine was isolated, engulfed by semidarkness, unable to dispel the random thoughts and incongruous images swirling around his brain.

From 1966 to 1969, Dine did not paint and only rarely sculpted or drew, in part because his dealer, Sidney Janis, claimed that Dine owed him money and Dine did not want to give him paintings as payment,[61] but also because, for him, painting had lost its relevance.[62] So he turned to writing poetry, designing stage productions, illustrating books, teaching, and making prints on a more intensive schedule — all pursuits requiring contact with other people, expanding his horizons well beyond the confines of the art world. During these years, he sought the company of people who were not artists and lived outside of

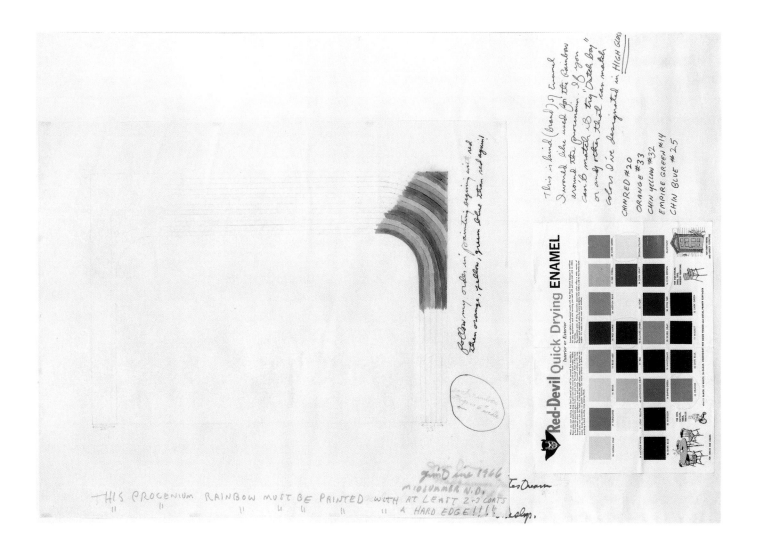

12. Jim Dine. *Proscenium Arch
(A Midsummer Night's Dream)*. 1966.
Paint samples, felt-tipped pen, and pencil
on tracing paper, 24 x 36 1/4" (61 x 92.1 cm).
Collection Nancy Dine

New York, feeling "completely alone and out in the cold in relationship to the New York art scene."[63] Drawn to poets and writers, Dine felt that "their minds were more subtle and more receptive to what I had to say, and they were more interesting to talk to, and to relate to socially. . . ."[64] As early as 1961, he had been nervous and uncomfortable about his quickly won "notoriety" and curtailed his social contact with other artists; but the events of 1965 and 1966 finally pushed him to break off his dialogue with the New York avant-garde, even if he did not immediately have a clear idea of what to do next.

With Dine already buffeted by his experiences with the rally and with his dealer, the final break came in 1966, when John Hancock asked him to work on costumes and stage designs for a new production of Shakespeare's *A Midsummer Night's Dream* staged at the San Francisco Actor's Workshop.[65] Dine executed more than thirty drawings for the costumes, props, curtain, proscenium screen, and backdrops after conferring in San Francisco with Hancock, who then freely adapted Dine's designs as he needed, sometimes getting second ideas from the artist,[66] but generally without consultation, disregarding his carefully considered organization.[67]

Dine envisioned three distinct classes of costumes for Shakespeare's three classes of characters, and placed them in a riotously colored world of rainbows and colored quilts (fig. 12). The artisans were to wear earth-color clothes covered by the tools of their trade, bent and broken by their life of labor; the fairies, colorful and fantastic costumes declaring their existence in another realm; and the nobles, conservative and elegant attire.

When Dine designed the costumes, he saw them as a way to define the role and personality of each character, even before their first word was uttered. He found figures in *Vogue* whose poses embodied for him the essence of each Shakespearean character, traced them, then dressed them.[68] He outfitted Theseus (fig. 13), the warrior-king of Athens, in a large overcoat of black velvet over a robe, black at the top, descending through all shades of gray, to white at the bottom, marked by a venetian blind of paint chips on one side of the drawing. Dine then endowed him with the stern chin and larger-than-life presence proper to a hero, for he seems to have to crouch just to remain within the page. Lysander (fig. 15), the youth who loves Hermia against her father's wishes, stands jauntily in the middle of the page like a peacock in his multicolor satin suit, surrounded by a swirl of torn pieces of colored paper and instructions written in many colors of ink.

On the other hand, Tom Snout the tinker (fig. 14) is an inarticulate, browbeaten laborer, his face dumb and expressionless, marred by relentless hardship. Dressed in coarse brown cloth, he slumps earthward under the weight of pots and pans he is to mend, which Dine so carefully recorded. Even the white of the top of the page seems to weigh heavily upon him. By such means, Dine was able to define character not only out of color and costume, but also with the space of a sheet of drawing paper.

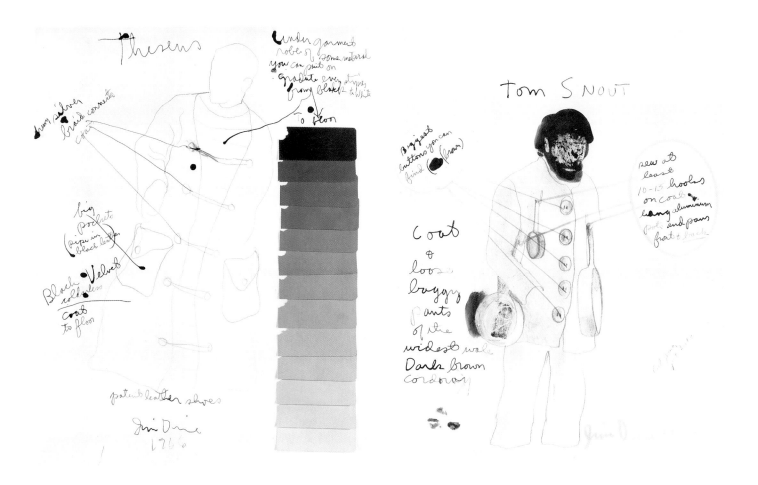

Then, in the realm of the fairies, Dine shaped a cast of fantastic characters, some whimsical, others menacing. The winged mist-green Moth (fig. 16) hovers on one foot in the middle of the page, floating in air, seemingly dancing with a lunar moth fluttering at his side. From the darker side of the fairy kingdom, rainbow-striped Puck (fig. 17), the great mischief-maker, looms large on the page like a professional wrestler, glaring out with coal-black features.

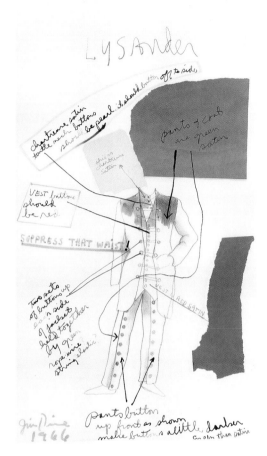

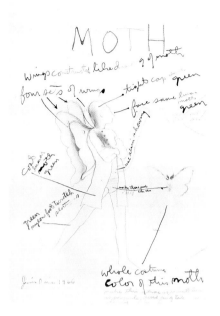

Since Dine would not appear on stage in this production, he could not use his own personal presence as a means of exploring the human condition, as he had in his Happenings; he could not himself elaborate on or refine a rough idea during rehearsal. He therefore had to pack into each drawing the physical and psychological presence that he wanted each character to carry. Dine brought to life a varied cast of characters with extraordinary efficiency and clarity by relying on his ability, cultivated since his earliest days in New York, to bring together a whole range of materials of various textures and colors: colored inks, pencil, torn paper, paint chips, glitter, and magazine illustrations. Clearly a keen observer, he used this skill to great advantage when molding his figures into distinct characters. Dine had not painted the figure since the *Car Crash* drawings. Working on *A Midsummer Night's Dream* gave him the opportunity to depict it again, and he was able to create his cast of characters quickly and assuredly. At a time when he was beginning a serious assessment of his career, this concentration on the figure — followed a year later by a similarly intensive study when he worked on a stage production of *The Picture of Dorian Gray* — had a crucial impact on his thinking, preparing for the time when he would turn to working from the figure in earnest.

In mid-1967, to distance himself as much as possible from the New York scene, Dine moved to London for several years with his family, a change with profound implications for his future. Freed from the overwhelming pressure of being famous, of having to constantly come up with new ideas, he could relax.

16. Jim Dine. *Moth*. 1966. Collage, crayon, felt-tipped pen, pencil, and ink on tracing paper, 16 3/4 x 11 3/8" (42.5 x 28.9 cm). The Museum of Modern Art, New York. Gift of Mrs. Donald B. Strauss

17. Jim Dine. *Puck*. 1966. Watercolor, pencil, and ink on tracing paper, 14 7/8 x 10" (37.8 x 25.4 cm). The Museum of Modern Art, New York. Gift of Mrs. Donald B. Strauss

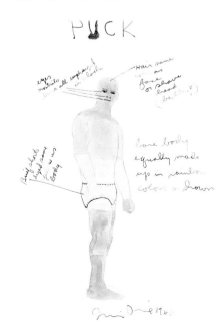

Instead of reacting nonstop to others, he had time to reflect and to search for an understanding of his own identity as an artist.[69] It was during the more than three years he spent in this new place that the basis for all his work since the mid-1970s first solidified: a dedication to drawing from the figure; the full reassertion of his expressionist tendencies; a refusal to follow the dictates of certain avant-garde movements; a growing appreciation of the art of the past; and a focus on "personal private conviction rather than public."[70]

In the winter of 1967–68, Dine worked with Michael Kidd and Michael White on a stage production of Oscar Wilde's *The Picture of Dorian Gray*, a collaboration sparked by friendship,[71] something he wanted to do, not felt he ought to do. Although the production was never staged,[72] the project was a momentous beginning to his stay abroad. Most important, it was the second time in about a year that he had drawn a large number of figures. This was one of several almost clandestine encounters he had with the figure in these years, including a number of "dry-print" self-portraits he made in 1970,[73] and a large group of drawings of heads from the summer of 1971.[74] All of these occasions were informal and private and did not use the ambitious mediums of painting and sculpture, allowing Dine to avoid the pressure of the avant-garde to remain abstract.[75] In this regard, the importance of all this work rests in the seeds it sowed.[76]

In *A Midsummer Night's Dream*, Dine had worked on a large cast of characters, but in a drama encompassing only a few days in their lives. On the other hand, for *The Picture of Dorian Gray* he had to consider the development of only a few characters, but over a much broader span of time, and thus regard the effects of time and circumstances on a given person. In order to more efficiently make a large number of costumes for each of the main characters, he adopted for each a pose that succinctly summed up the major aspect of that personality, which he then retraced for each costume change.[77]

This approach worked best with Dorian, who, of course, never physically changes, but who behaves in an increasingly self-indulgent and destructive manner. Dine outlined this evolution through the use of costumes that became more outlandish as the story progressed. Thus, Dorian first appears as a naive, blond young man in a simple blue satin outfit (fig. 18), and last as a high priest of debauchery in a floor-length silver gown, with blue dust in his hair (fig. 19). Besides his pose, only his face remained unchanged in the drawings — featureless, pristine, untouched by the damage he wrought on the lives of others.[78]

In contrast, Lord Henry, the cynical dandy, never wavers in his devotion to the pursuit of pleasure, but his body pays a dear price. Aloof and aristocratic, resplendent in his brilliant costume, Henry peers with slitted eyes over his fur collar, early in the story (fig. 20). Two decades later, however, run down by his life of wanton debauchery, he is reduced to a mere description of his wardrobe: "1 suit like yellow evening suit in mourning cloth no fur. 1 long

Left:
18. Jim Dine. *Dorian Gray's First Outfit*. 1967. Gouache, felt-tipped pen, and pencil on tracing paper, 29 3/4 x 20" (75.6 x 50.8 cm). The Museum of Modern Art, New York. The Joan and Lester Avnet Collection

Right:
19. Jim Dine. *Dorian Gray's Last Costume*. 1967. Gouache, felt-tipped pen, pencil, collage, and ink on tracing paper, 29 7/8 x 20" (75.9 x 50.8 cm). The Museum of Modern Art, New York. The Joan and Lester Avnet Collection

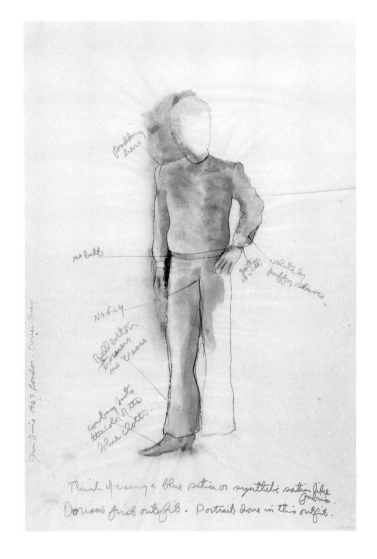

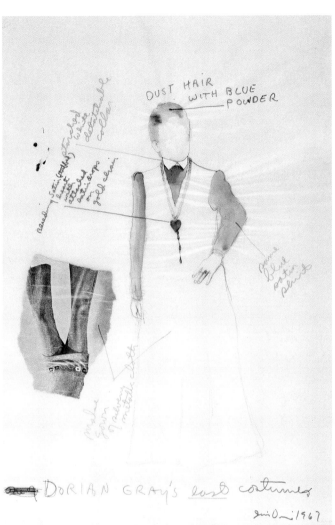

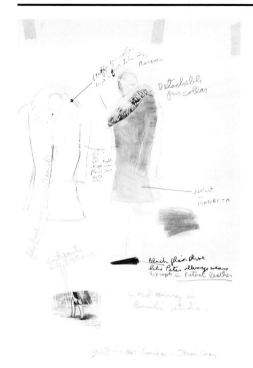

double breasted overcoat velvet collar in twill maybe. 1 black coat-jacket sombre Henry 20 years later." The proud, erect figure that Dine had created for the younger Henry no longer sufficed. Rather than drawing a new figure accurately showing Henry's decrepit condition, Dine simply listed what Henry was to wear and left blank the space where he stood in the other drawings — a ghost of his former self.

It is important in these drawings that Dine relied less on collage to convey his ideas about color and texture than he had in the *Midsummer Night* designs: for *Dorian Gray,* he drew and hand-colored the costumes. When he worked on *Midsummer Night,* he relied on familiar (that is, American) color chips, magazine illustrations, and so on. But these things were not readily available in England, and he hesitated about using the British equivalents precisely because they were unfamiliar, not part of his private landscape.[79] (However, he did resort to tearing some examples from magazines or books when he could not otherwise articulate what he was after.) This proved to be a significant exercise in drawing for Dine, as he had to rely more on his hand and less on existing images.

When he worked on the costumes and sets for *The Picture of Dorian Gray,* Dine was engaged in a dialogue with Minimalism, and this was evident in his concern for how objects in a space define and shape that space.[80] When visualizing the performance itself, Dine saw both the actors and the props as objects: "There was to be no background at all. It was going to be objects in space, and in fact, each costume, i.e., each character, would be an object in space like a piece of sculpture in an area. And there were going to be important pieces of furniture. No flats."[81] Indeed, one of the principal attractions of the book for Dine was that "Wilde was being extremely plastic and formal in what he said about the characters were like, what they looked like."[82] This is, of course, very much how Dine dealt with the personalities of the various characters and the changes they went through, by concentrating on how their costumes — "what they looked like" — changed as their lives wore on. The prop designs also came out of the way Dine thought about Minimalism, streamlined, "primary" structures that were functional objects. The bar, for instance, was a simple, squat cylinder covered with shiny black vinyl (fig. 21).

Wilde's London opened Dine's eyes to another time and another way of

20. Jim Dine. *Lord Henry in Basil's Studio.* 1967. Gouache, felt-tipped pen, pencil, collage, and ink on tracing paper, 30 x 20" (76.2 x 50.8 cm). The Museum of Modern Art, New York. The Joan and Lester Avnet Collection

living, different from his up-to-the-minute world of New York. The imaginative possibilities raised by the mysterious late Victorian city intrigued him,[83] and contributed in part to a loosening of the stylistic discipline he had earlier imposed on his work, releasing once again his natural expressiveness. This can be seen as early as his 1967 design for the *Red Piano* (fig. 22) for Lord Henry's flat, a heavily worked collage that differs markedly in its handling from the more controlled style of the costume designs. It was, in fact, in the designs for the props, each drawn by hand individually and not traced, that this first became evident. Dine himself was fully aware of this stylistic shift by the time he was working with Peter Cornwall-Jones on an illuminated edition of the script in early 1968, soon after the stage production was canceled. "There aren't many places today where you can still use your hands and still talk straight about something that's contemporary. Here was an opportunity to scribble again, and to stool smear again and to get your old thumb in there, and really I'd jump at any opportunity to do that."[84]

Dine took a typed copy of the script and added his own comments, prompts, and prop drawings over and throughout the text. So, at the point in the script when Basil was painting in his studio, and Dorian and Lord Henry were having their first conversation over refreshments in Basil's studio and garden, he drew on the text designs for the portrait's easel and for the service bar. On the facing page, he made a color lithograph of the studio's lamp (fig. 23). Six full-page prints after his stage-design drawings are interleaved throughout the text and four more are inserted loosely in the back, making the book the sumptuous object Dine wanted it to be. All of the prints and text illustrations have a loose, spontaneous quality that the costume drawings did not. They were put down with aplomb on the plate or stone anew, not traced, with the full knowledge that this was "one of the most indulged things" he had ever made, which he felt was entirely fitting for the subject.[85]

21. Jim Dine. *Bar, Tea Service*. 1967. Oil pastel, gouache, felt-tipped pen, collage, and ink on graph paper, 39 1/8 x 29 1/2" (99.4 x 74.9 cm). The Museum of Modern Art, New York. The Joan and Lester Avnet Collection

22. Jim Dine. *Red Piano*. 1967. Watercolor, oil pastel, collage, and ink on white paper on graph paper, 29 1/2 x 28" (74.9 x 71.1 cm). The Museum of Modern Art, New York. The Joan and Lester Avnet Collection

23. Jim Dine. Page 4 and facing plate (Act I, Scene 1) from *The Picture of Dorian Gray,* play adaptation by Robert Kidd of the novel by Oscar Wilde. London, Petersburg Press, 1968. Photolithograph and lithograph, each page 17¼ x 12¼" (43.9 x 31.1 cm). The Museum of Modern Art, New York. Gift of the artist

In the past, such a renunciation of a style associated with a particular movement would soon have been followed by involvement with another. But in London, there was nothing that he felt he could react to, no "abrasiveness" to spur him on.[86] By the summer of 1968, he had taken to heart what Clement Greenberg had recently said about the commercial, success-oriented thrust of the current art establishment in New York, feeling vindicated for what he had sensed for a while but had not been able to articulate.[87] This was one development of several that broke his fascination with the avant-garde. He stayed in London for several more years, enjoyed life, and rethought his priorities, so that he could begin to do what he wanted to do.

Dine's friendship with R. B. Kitaj, who lived in London, was just as important as the absence of a familiar avant-garde. He was the first artist with whom Dine felt comfortable,[88] and he set an important example through his determination to follow his own path and through his devotion to the figure. He offered Dine an example of the self-sufficient artist, an artist who worked on what he wanted and who did not feel pressured to keep coming up with new ideas for their own sake.

When Dine returned to the United States in 1971, he attempted to renew the old dialogue, but it was clear that his heart was not in it.[89] Within a few years, he thoroughly renounced any further involvement with the New York avant-garde and struck out on a path he set for himself.

Notes

1. Quoted in David Shapiro, *Jim Dine* (New York: Harry N. Abrams, 1981), p. 204.

2. "I have always been an artist as I have always known that is all I can do" (from a talk given at the 92nd Street Y, New York, December 12, 1985; excerpt printed in *Jim Dine: Paintings, Drawings, Sculpture* [New York: Pace Gallery, 1986], n.p.).

3. See Thomas Krens, "Conversations with Jim Dine," in *Jim Dine: Prints, 1970–1977* (Williamstown, Mass.: Williams College, 1977), p. 21.

4. See Shapiro, *Jim Dine,* pp. 205, 210. The work of de Kooning, Rauschenberg, and Motherwell and the criticism of Frank O'Hara had the most profound impact on Dine.

5. Krens, "Conversations with Jim Dine," p. 15.

6. The two Environments comprised the *Ray Gun Show,* which opened on January 30, 1960, and ran through March.
 Dine carried this concern for creating a total environment over into his first solo show (Reuben Gallery, April 1–14, 1960). In his review of the exhibition, Irving Sandler noted that "the works are crowded together on the walls to create an environment; rock-and-roll music will be played during gallery hours" (Sandler, "Jim Dine," *Art News,* 59 [April 1960], p. 17). According to Sandler, "Several of the works are coated with tar — a favorite ingredient — in which is embedded at random discarded clothes and other refuse."

7. See Lawrence Alloway, "Junk Culture," *Architectural Design,* 31 (March 1961), pp. 122–23.

8. See Barbara Haskell, *Blam! The Explosion of Pop, Minimalism, and Performance, 1958–1964* (New York: Whitney Museum of American Art in association with W. W. Norton & Co., 1984), pp. 18–19, 23–26.

9. For Dine's comments on how he deliberately affected a naive manner in his work during these years, see Frank Robinson and Michael Shapiro, "Jim Dine at 40," *Print Collector's Newsletter,* 7 (September–October 1976), p. 102; and I. Michael Danoff, *Emergence and Progression* (Milwaukee: Milwaukee Art Center, 1979), p. 79.

10. Dine's was one of several performances comprising an evening of theater, Oldenburg's *Ray Gun Spex.* Others were Oldenburg's *Snapshots from the City,* Dick Higgins's *Edifaces* [*sic*]*, Cabarets & Contributions,* Hansen's *Projections,* Kaprow's *Coca-Cola, Shirley Cannonball?,* Whitman's *Duet for a Small Smell,* and Grooms's *The Big Leap.* Programs for the evening are reproduced in *Happenings and Fluxus* (Cologne: Kölnischer Kunstverein, 1970), n.p.

11. See Dine's statement about this Happening in Michael Kirby, *Happenings: An Illustrated Anthology* (New York: E. P. Dutton, 1965), pp. 185–86.

12. Jim Dine, conversation with the author, December 6, 1990.

13. Jim Dine, "A Statement," in Kirby, *Happenings,* pp. 185–86. Dine also raised these issues in conversation with the author, December 6, 1990.

14. Krens, "Conversations with Jim Dine," p. 14.

15. See Danoff, *Emergence and Progression,* p. 79.

16. This was one of six performances at the Reuben Gallery's *An Evening of: Sound — Theater — Happenings.* Other works were: Kaprow, *Intermission Piece* (Happening), Whitman, *E.G.* (an opera, in which Dine appeared), Brecht, *Gossoon* (a chamber event), and Maxfield, *Electronic Music* (a concert). The program is reproduced in *Happenings and Fluxus.*

17. See Kirby, *Happenings,* p. 185. Dine liked the idea of music and sound in films and traditional theater and so adopted the idea for his Happenings (conversation with the author, December 6, 1990).

18. See Kirby, *Happenings,* p. 185.

19. "I wanted non-human actors. I just wanted vegetables to move and dance. I had an idea once to make a movie about a refrigerator that opened and the vegetables inside were dancing" (Dine, conversation with the author, December 6, 1990).

20. Dine, conversation with the author, June 13, 1991.

21. See Kirby, *Happenings,* p. 185. About the dance, Dine recalled, "I did a dance. I do not even understand how I did that dance. I could never do it now. But I did this dance that people cheered."

22. Ibid.

23. Alan Solomon, "Jim Dine and the Psychology of the New Art," *Art International,* 8 (October 1964), p. 52.

24. See Kirby, *Happenings,* p. 186.

25. Reuben Gallery, November 1–6, 1960. In the fall of 1960, the Reuben Gallery rented, for the purpose of staging Happenings, a storefront at 44 East 3rd Street (Dine lived upstairs and found the space), a few blocks from the main gallery at 61 4th Avenue. *Car Crash* was the first Happening performed there, and when creating the set, Dine left the space largely as he found it, except for painting everything white. Otherwise, the junk the previous tenant left behind provided him with a ready-made Environment (conversation with the author, December 6, 1990).

26. See Kirby, *Happenings,* p. 187.

27. Dine retained a good deal of control over the whole performance. In addition to writing the script for Pat Oldenburg's monologue (she sat on a high stool throughout the performance and could not move) and rehearsing the action beforehand, Dine made masks for the other two performers, Ratliff and Tersch. One had a howling expression (Ratliff), the other had a crying expression (Tersch). Only Dine could move about *and* change facial expressions.

 Nonetheless, compared to the Happenings of Claes Oldenburg, for example, *Car Crash* was loosely structured. This was in large part because most Happenings, including Oldenburg's, had many performers and so had to be mapped out more carefully. As the primary (and generally the only) performer in his own Happenings, Dine did not have to plan things out so carefully on paper beforehand. He could keep it all in his head.

28. See William C. Seitz, *The Art of Assemblage* (New York: The Museum of Modern Art, 1961), pp. 87, 88; and John Russell, "Jim Dine," in *Jim Dine: Complete Graphics* (Berlin: Galerie Mikro, 1970), n.p. Seitz commented on Dine's use of the automobile as "mass killer," and Russell on Dine's use of the car as a modern-day stand-in for the "Black Death, plague and pox, rolled into one."

29. See Kirby, *Happenings,* p. 187.

30. Dine wrote the monologue, which is reprinted in Kirby, *Happenings,* pp. 189–90. The rest of the script was composed by Dine five years later for publication in Kirby's book (conversation with the author, December 6, 1990).

31. Dine said that there had been many more studies, other than the three in the Museum's collection, but that they had been lost over the years. He could not remember specifically to what they pertained (conversation with the author, December 6, 1990).

32. Dine worked out the direction and the sequence of the action of the first act beforehand. On the reverse of the pencil drawing *Car Costume for Girl* (124.65), he wrote in pencil: "head lite dance starts / piece in darkness / angles of lite beams / the car constantly / eludes the beams / through audience and / around audience / man-woman & woman-man / stay in circle outside / of audience and beep."

33. Dine, conversation with the author, December 6, 1990. Dine remarked that he had "used it in a drawing this year."

34. *Crash Pastel* (1959), pastel on paper, illustrated in Shapiro, *Jim Dine,* pl. 59; *The Valiant Red Car* (1960), oil on canvas, illustrated in ibid., pl. 8; *Car Crash* (1960), oil paint, tar, and clothing on two joined pieces of burlap, illustrated in *Art in America,* 72 (November 1984), p. 7; four drawings titled *Crash* (1960), each red ink on paper, illustrated in Constance Glenn, *Jim Dine: Drawings* (New York: Harry N. Abrams, 1985), pl. 21; three studies for the Happening (1960), all in the Museum's collection; six lithographs, *Car Crash I–V* and *End of Crash* (1960), all in the Museum's collection, illustrated in *Jim Dine: Complete Graphics,* n.p.

35. See Kirby, *Happenings,* p. 191. Robert R. McElroy took several photographs of Dine and Anita Reuben hanging the show in the gallery's vestibule.

36. However, in some cases, it is not clear whether the crosses are meant to be grave markers or Red Cross symbols. This of course affects the reading of a given image. For instance, in the case of *The Valiant Red Car,* the grid of crosses over the picture plane clearly suggests a graveyard, while the crosses in the Happening could be seen as symbols of either destruction or salvation.

37. Russell, "Jim Dine," n.p.

38. See Fred W. McDarrah, *The Artist's World in Pictures* (New York: E. P. Dutton, 1961), p. 187.

39. Dine's silver costume of course was most appropriate, for, being a car, he had to look as if made of metal. It is interesting that this choice of material does land him squarely in a group of artists who in the late fifties and the sixties were using metallic aluminum material — usually paint — in their work: Jackson Pollock, who used industrial aluminum paint in a number of drip paintings; Frank Stella, in his series of burglar-alarm-tape-on-masonite works and in his Aluminum series paintings; Andy Warhol, who used aluminum (and gold) paint on several of his canvases (see Benjamin H. D. Buchloh, "Andy Warhol's One-Dimensional Art: 1956–1966," in Kynaston McShine, ed., *Andy Warhol: A Retrospective* [New York: The Museum of Modern Art, 1989], pp. 46–47).

40. In order to preserve the "purity" of the whiteness of the Happening, Dine had even considered dressing the audience in white smocks (see Kirby, *Happenings,* p. 192).

41. For the script of *Car Crash* and a detailed description of the action, see ibid., pp. 189–99.

42. Dine, conversation with the author, December 6, 1990. Dine stated that *Car Crash* "was nothing more than theater-in-the-round."

43. Ibid.

44. One can observe a similar evolution — the calming of a painterly style — in the work of Roy Lichtenstein, Andy Warhol, and Claes Oldenburg. Compare Lichtenstein's *Look Mickey* of 1960 with his *Drowning Girl* of 1963; see also the differences between Warhol's *Water Heater* of 1960 and his 1962 *Close Cover before Striking (Pepsi),* or between Oldenburg's Environment *The Street* at the Judson Gallery in early 1960 and its more austere reinstallation later that year at the Reuben Gallery.

45. Dine considers this to be his "most beautiful" Happening (Kirby, *Happenings,* p. 187).

46. For an outline of the action, see ibid., pp. 186–87. See also Shapiro, *Jim Dine,* p. 67.

47. See Shapiro, *Jim Dine,* p. 210. See also John Gruen, "Jim Dine and the Life of Objects," *Art News,* 76 (September 1977), p. 39. Dine recently commented: "It was a good time. It was a mistake to have stopped because I haven't seen a performance since then that was as good as the ones Whitman, Oldenburg, and I did" (conversation with the author, December 6, 1990).

48. Krens, "Conversations with Jim Dine," p. 15.

49. Dine, conversation with the author, December 6, 1990.

50. See Gruen, "Jim Dine and the Life of Objects," p. 39.

51. See Kirby, *Happenings,* p. 184.

52. See William Lipke, "New and Recent Art Books: New Media," *Studio International,* 174 (November 1967), p. 232.

53. Krens, "Conversations with Jim Dine," p. 15.

54. Quoted in "The Smiling Workman," *Time,* February 2, 1962, p. 44.

55. Although she did not like the piece, Jill Johnston noted in her review that it did turn the viewer's queries and thoughts back on herself (Johnston, "Jim Dine," *Art News,* 59 [February 1961], p. 15). The Environment was at the Judson Gallery in January 1961; the exact dates were not given in the review.

56. Krens, "Conversations with Jim Dine," pp. 22–33.

57. Dine's Happening was performed May 1–3, 1965. Other pieces in the rally were by Robert Morris, Trisha Brown, Deborah Hay, David Gordon, Valda Setterfield, The Once Group, Robert Whitman, Claes Oldenburg, Robert Rauschenberg, Karlheinz Stockhausen, Tony Holder, Öyvind Fahlström, Judith Dunn, and Steve Paxton. All but Oldenburg's performance were staged at an RKO theater at Broadway and West 81st Street; Oldenburg's was at Al Roon's Health Club on West 23rd Street. The program is reproduced in *Happenings and Fluxus.*

58. Dine, conversation with the author, December 6, 1990.

59. Ibid.

60. See Elizabeth Novick, "Happenings in New York," *Studio International,* 172 (September 1966), pp. 156–57. See also Caroline Windish-Graetz, "It Happened," *New York Herald Tribune,* May 5, 1965.

61. Dine, conversation with the author, December 6, 1990.

62. Krens, "Conversations with Jim Dine," p. 22. See also Edward Lucie-Smith, "Flamboyance and Eclecticism," *Studio International,* 171 (June 1966), p. 265.

63. Krens, "Conversations with Jim Dine," p. 22.

64. Ibid.

65. The production was at the San Francisco Actor's Workshop, March 11–April 11, 1966; Pittsburgh Playhouse, November 25, 1966–January 8, 1967; Theatre de Lys, New York, June 29–July 23, 1967.

Dine and Hancock had collaborated once before, on a Happening dealing with the Civil War, in 1964, for the Actor's Workshop, but it was not produced.

66. For reproductions of some of the "second-idea" drawings, see David Zack, "A Black Comedy . . . ," *Artforum,* 4 (May 1966). See also Virginia Allen, *Jim Dine: Designs for "A Midsummer Night's Dream"* (New York: The Museum of Modern Art, 1968).

67. Hancock disregarded much of Dine's highly imaginative and witty world (discussed below, in the text) and instead staged a heavy-handed "anti-romantic damnation not only of romance but of love between the sexes" (Zack, "A Black Comedy . . . ," p. 32). For instance, he cast a six-and-a-half-foot-tall man as fair Helena, used puppets for the fairies, and exaggerated the bawdiness of the play well beyond what Dine had intended. On the other hand, he did retain Dine's design for the proscenium arch and the rainbow-striped Puck; and some changes made for purely financial reasons did not in the end detract significantly from Dine's vision, such as when his costly costumes for the artisans were replaced by peasants' costumes (by another designer) from an earlier Actor's Workshop production of Brecht's *Edward II.* The set and costumes actually used in Hancock's production were the work of Robert LaVigne, the resident designer of the Workshop. Indeed, in the playbill LaVigne received credit for designing the costumes and sets, based on drawings by Jim Dine.

Dine deeply resented his treatment, and refused to attend the performances. The whole experience left him disillusioned with stage collaborations and the inevitable conflicts that occur when a large group of talented (and opinionated) people must work together. It also left him a little wiser, for he realized that not every collaboration would be an equitable situation (conversation with the author, December 6, 1990).

For Dine's views on collaboration, see: Pat Gilmour, "Symbiotic Exploitation or Collaboration: Dine and Hamilton with Crommelynck," *Print Collector's Newsletter,* 15 (January–February 1985), pp. 194–98; "Interview between Jim Dine and Marco Livingstone," in *Rise Up, Solitude: Prints, 1985–86* (Philadelphia: Dolan/Maxwell Gallery, 1987), p. 16; Suzie Hennessy, "A Conversation with Jim Dine," *Art Journal,* 39 (Spring 1980), p. 168.

68. Dine, conversation with the author, June 13, 1991.

69. See Gruen, "Jim Dine and the Life of Objects," p. 42.

70. Krens, "Conversations with Jim Dine," p. 21.

71. Dine, conversation with the author, December 6, 1990.

72. James Fox, who was to play Dorian, considered the costumes obscene and backed out of the production, forcing its cancellation (Dine, conversation with the author, December 6, 1990). See "Lithographs and Original Prints: Two Artists Discuss Their Recent Work," *Studio International,* 175 (June 1968), suppl. p. 337.

73. See Barbaralee Diamonstein, *Inside New York's Art World* (New York: Rizzoli, [1979]), p. 105. In 1976, Dine told Krens that printmaking "was the only medium in which, until just recently, I felt free enough to be figurative when the pressure was still on to make those field paintings with the tools hung on them" (Krens, "Conversations with Jim Dine," p. 32).

74. Krens, "Conversations with Jim Dine," p. 16.

75. An excellent example of the pressure he felt to remain an abstract painter is his series of robe self-portraits, which he began in 1963. He wanted very much to paint a self-portrait, but felt inhibited since figurative art was not à la mode. So he substituted for himself a robe from an advertisement that he felt looked as though he were in it. For the time being, then, he was able to balance the demands of the avant-garde with his personal desire to work in a more traditional form (see Diamonstein, *Inside New York's Art World,* p. 99; Glenn, *Jim Dine: Drawings,* p. 37; Gruen, "Jim Dine and the Life of Objects," p. 38).

76. Dine recently stressed the important role of the *Midsummer Night's Dream* and *Dorian Gray* designs in his turn to the figure (conversation with the author, December 6, 1990).

77. All the figures for a given character are the same size and have the same pose; for instance, in all of the drawings of Dorian, the figure is 20 inches (50.8 cm) high. Asked about this recently, Dine could

not remember where he found the figures, but guessed they came from British *Vogue* (conversation with the author, June 13, 1991).

78. Dine intended that Dorian's portrait be a 10-by-5-foot photograph that would be different each time it appeared; the final version was to have been a giant enlargement of Dorian's screaming face, from eyebrows to lower lip. (Dine described the changes throughout the illuminated script that he produced in 1968 with Peter Cornwall-Jones.)

He did not want a painted portrait. The reason for this was twofold: first, he wanted to avoid any connection with the Ivan Albright *Picture of Dorian Gray* (1943–44, oil on canvas, The Art Institute of Chicago) that appeared in the 1945 MGM movie version of the story, adapted and directed by Albert Lewin; second, because "London was a city of photographic processes, like in the work of Richard Hamilton" (conversation with the author, December 6, 1990).

79. See Robert Fraser, "Dining with Jim," *Art and Artists*, 1 (September 1966), p. 51.

80. In the winter of 1966–67, when he was Visiting Critic at the School of Architecture at Cornell University, Dine carried out a major sculptural project, *Nancy and I at Ithaca*. Conceptually, this provides a bridge between his work for *A Midsummer Night's Dream* and *Dorian Gray*. He thought of the entire ensemble of eight human-size sculptures in a theatrical sense, that is, as a cast of characters, each with its own personality — shape, color, and material — arranged in a small room so that there would be an ever-changing relationship between the various pieces as the viewer moved around the room. Some of this was basic to the work of certain Minimalist artists, such as Robert Morris in his large sculpture installations, and so was part of Dine's interest in that movement. It also had much to do with Dine's recent stage work, where he had been thinking on several occasions about a varied cast in a performance area, and which was ambitious in a similarly large-scale manner (see William Lipke, *Nancy and I at Ithaca* [Ithaca, N.Y.: Andrew Dickson White Museum of Art, 1967]; and William Lipke, "Perspectives of American Sculpture: 'Nancy and I at Ithaca,' Jim Dine's Cornell Project," *Studio International*, 174 [October 1967], pp. 142–45).

81. See "Lithographs and Original Prints," suppl. p. 337.

82. Ibid.

83. Dine, conversation with the author, December 6, 1990.

84. See "Lithographs and Original Prints," suppl. p. 337. There are four editions (A, B, C, and Supplementary), all from 1968, of Dine's book *The Picture of Dorian Gray* (see *Jim Dine: Complete Graphics*, nos. 47a–j). For the supplementary edition, Dine collaged each print.

85. Ibid.

86. See Fraser, "Dining with Jim," pp. 49, 51.

87. See "Lithographs and Original Prints," suppl. p. 337. For Edward Lucie-Smith's interview with Clement Greenberg, referred to by Dine, see *Studio International*, 175 (January 1968), pp. 4–5.

88. See Diamonstein, *Inside New York's Art World*, p. 105; Krens, "Conversations with Jim Dine," pp. 23–24; Gruen, "Jim Dine and the Life of Objects," p. 42.

89. Krens, "Conversations with Jim Dine," p. 16.

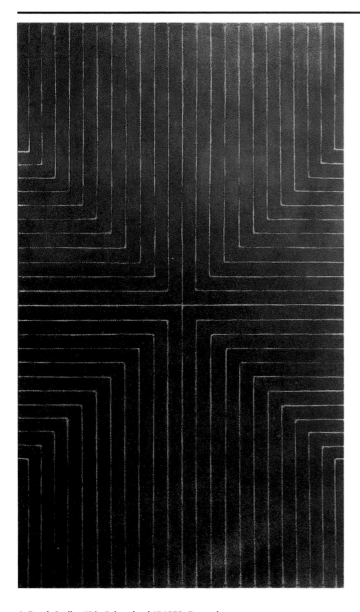

2. Ad Reinhardt. *Abstract Painting*. 1960–61. Oil on canvas, 60 x 60" (152.4 x 152.4 cm). The Museum of Modern Art, New York. Purchase (by exchange)

1. Frank Stella. *"Die Fahne hoch!"* 1959. Enamel on canvas, 10′ 1 1/2″ x 6′ 1″ (308.6 x 185.4 cm). Whitney Museum of American Art, New York. Gift of Mr. and Mrs. Eugene M. Schwartz and purchase through the generosity of the John I. H. Baur Purchase Fund, Charles and Anita Blatt Fund, Peter M. Brant, B. H. Friedman, Gilman Foundation, Inc., Susan Morse Hilles, The Lauder Foundation, Frances and Sydney Lewis, Albert A. List Fund, National Endowment for the Arts, Sandra Payson, Philip Morris Incorporated, Mr. and Mrs. Albrecht Saalfield, Mrs. Percy Uris, and Warner Communications Inc.

Overcoming the Limits of Matter: On Revising Minimalism

Rosalind Krauss

1. A Tale of Two (Black) Squares

I came to the sixties late, and from out of town. So The Jewish Museum's "Toward a New Abstraction" and the Modern's "Americans 1963," both of which opened in the spring of 1963, were news to me. Until that moment New York painting meant, as far as I knew, Willem de Kooning's abstract landscapes or Robert Motherwell's mural-size Elegies: Abstract Expressionism cresting on the cusp of the decade. Nothing had prepared me for the shock of those deadpan black paintings, by Frank Stella at one exhibition, by Ad Reinhardt at the other (figs. 1, 2). Nothing had set the stage of my experience for the entrance of Minimalism.

How long it took before I realized that these two sets of black pictures represented two different minimalisms — one bearing the capital M and facing forward into the decade; the second, small-m'd, and joining hands with other, similarly motivated, pictorial asceticisms from the past — I no longer remember. Yet it soon seemed obvious that what they had in common was, nothing.

For all that he might reiterate his art-as-art position, insisting on the formless, directionless, colorless, textureless, spaceless, relationless condition of the black squares, Reinhardt nonetheless seemed to think of Art as opening up some kind of back door in the mind, an expanding, pulsing awareness of the visual process itself. "Tao," he once wrote in a note to himself, "fills the whole frame yet you cannot keep track of it. . . . It is dim and dark, showing no outward form."[1] The black paintings became the vehicle for the staging of this "it" that one could not keep track of, except to acknowledge the infinitely slow pulse of perceptual change, to take account of the fact that perception *is* the registration of pure difference.

The long time that it takes simply to *see* the black paintings — to wait for the formless monochrome somehow to exhale the not-quite-colors of a kind of afterimage of a Greek cross that would appear to score the surface of the square, if it could ever be brought into focus in its entirety at any one moment — becomes the form of a meditation on perception. And perception is announced thereby as something that takes place as a *durée,* an unfolding, a diachrony. As one section of the nine-part grid thickens into the memory of

reddishness and advances out of the midnight of the rest of the work, declaring the upper beam of the cross, the leftward arm, say, until then a hovering density of blackened blue, retreats, becoming level once more with the painting's veil-like surface.

For all their mystery, for all the taciturnity of their refusal, these paintings lodge the totality of their effect in a sleight of hand through which the material surface of the picture appears to be supplanted by an optical membrane: a resonant film that seems the very envelope of vision, like the blackness you "see" when you shut your eyes. And this is the sleight of hand that depends on the vulnerability of human eyesight to optical illusion. Thus, although one cannot imagine Reinhardt feeling any sympathy for Josef Albers and the gregarious sunniness of his Homage to the Square (fig. 3), shored up as this long series was by the scientific positivism of his idea of visual research, it is nonetheless Albers's triumphant self-discipline and minimalist restriction, Albers's heritage of Bauhaus commitment to uncovering the *données* of perception, that provide a precedent for Reinhardt's black squares.

And their legacy? Who was to take on the mantle of that search for the perceptual nothing, the visual sublime? Certainly not Frank Stella.

It would come instead from quite another quarter. It would be lodged in the late 1960s in California. It would be shaped by Robert Irwin's rides into the desert in his shiny Fleetwood convertible, the sun glinting equally off the Cadillac's chrome and the far shimmer of the sand, and Irwin taking the radiance in with, "It's cherry." Years later one can still hear this excitement in Irwin's voice, describing the sunset over the Nevada desert: "There's like a haze of green floating between the pink and orange layers in the sky just above the mountain to my left. The sun dipped below the horizon about five minutes ago. The base of the mountain is purple already, and some of the canyons cutting into its face have gone jet black, but this greenish hue — it's not smog, it's *light* — just seems to be hovering, floating there above the rim of the ridge."[2]

A few years after making his black paintings, Stella had asked himself whether it would be possible to construct a painting out of nothing but color. The result of this question was his Moroccan series (fig. 4): alternating stripes of two different colors at maximum intensity bisected at the midpoint of their stretch across the surface of the canvas by a "fold" created by sliding the stripes off-register along this line of junction. Constructed this way, the painting is nothing but optical effect, the retinal excitement of simultaneous contrast, the production of a hue that "just seems to be hovering, floating there above the rim of the ridge." Stella's own response to these paintings was short and definitive. "Nope," he said. "You can't make a painting out of nothing but color."[3]

Whatever gorgeousness was to film the surfaces of Minimalist work, both paintings and objects, whatever the halations and reflections of light, the

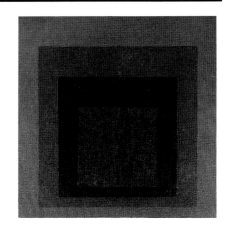

3. Josef Albers. *Homage to the Square: Coniferous.* 1958. Oil on composition board, 18 x 17 7/8" (45.6 x 45.4 cm). The Museum of Modern Art, New York. Gift of Jay R. Braus

opalescent splays of color, the gleams and sheen of burnished metal, it was always to be bracketed as by-product: so much industrial trash, the ephemeral waste thrown off in the process of shaping matter. Color was a part of Minimalism's irony. There was no way it could be taken straight.

Stella's black paintings had gotten down to business. And their business had everything to do with a surface, a surface within which nothing would be ambiguous. Everything that "happened" in the picture would be the result of real manipulations of that surface. Meaning would no longer be a function of illusion, of an imagined "inside" or "behind" the surface. Meaning, since it could form nowhere but on the surface itself, would be an effect of that surface: a meaning-effect.

It was Roland Barthes who made this vocabulary of *effect* part of the post-'68 critical lexicon: reality-effect; subjectivity-effect. Both outside (the real) and inside (the subjective) lost their independent status and were seen instead as merely the "effects" of language, of a tympanum, or weave, or text, that stretched between the outside and the inside as the culturally constructed interface between the two. It was that textual surface that was "real." All the rest was only its "effect." Barthes quotes Balzac summoning up the figure of Madame Lanty in his story *Sarrazine*.[4] "Have you ever encountered one of those women whose striking beauty defies the inroads of age? . . . Their visage is a vibrant soul," Balzac writes. The effect is of Balzac remembering, referring his reader back to a reality that preexists his writing. But it is the stereotype itself, signaled by "one of those . . . ," that — formed nowhere but in the space of the writing, *in* the very surface of the textual network as one text calls to another and together they build a particular "type," endowing it with this or that special glamor — preexists the real. Insofar as it can be said that Madame Lanty "herself" is a result of this stereotype, "she" can be seen to be an effect of language, which she does not precede, but follows, imitates, copies, pastiches. The reality-effect. The subjectivity-effect.

Stella's striped pictures — black, aluminum, copper, Day-Glo — preceded, of course, the American reception of this Structuralist-based ideology of the text. So Stella's total investment of the surface as the continuum within which a logic of conventions is elaborated, conventions (like the cruciform, the star, the ring-interlock, etc.) which do not reflect meaning but, instead, generate it, had different, more local sources. Jasper Johns, for example.

Stella's stripes had evolved from Johns's Flag paintings (fig. 5), in part from the way the ready-made object had served there as a defense against "composing," against what was seen as the arbitrariness of the personal choices necessary to aesthetic structure. But in this refusal of the personal, of the inward or expressive dimension inherent to the idea of individual choice, there was also inscribed Johns's professed attention to the writings of Ludwig Wittgenstein and the *Philosophical Investigations'* skepticism about the concept of "private language." The American saw Wittgenstein challenging the

4. Frank Stella. *Marrakech*. 1964. Fluorescent alkyd on canvas, 6'5" x 6'5" (195.6 x 195.6 cm). The Metropolitan Museum of Art, New York. Gift of Mr. and Mrs. Robert C. Scull

5. Jasper Johns. *Flag*. 1954–55. Encaustic, oil, and collage on fabric mounted on plywood, 42 1/2 x 60 5/8" (107.3 x 153.8 cm). The Museum of Modern Art, New York. Gift of Philip Johnson in honor of Alfred H. Barr, Jr.

6. Frank Stella. *Luis Miguel Dominguin, II.* 1960.
Aluminum paint on canvas, 8 x 6' (243.8 x
182.9 cm). Private collection

notion that, for example, when I say "my toothache," the meaning of *tooth-ache* is somehow relayed through, and thus secured by, an experience that I alone can have, an experience that is inward, private: language being an expression of this privacy. What he saw instead was a kind of linguistic behaviorism that argued that it is the conventional, public character of language that, itself, conditions feelings, constructing the illusion of inwardness: constructing what we could think of as the privacy-effect. If the armature of Johns's *Flag* was a defense against composing, it was also the means to an impenetrable surface that no amount of "expressionist" brushwork could excavate toward the putative seat of private language.

Stella did not find his ready-mades, like Johns's Flags, in the social field, but rather, in the geometrical field of the very surface he was working. As his stripes repeat the "facts" of this field, in their banal, matter-of-fact way, however, these elements begin to do something else. They begin to organize the surface in relation to that very conventional sign or symbol which is made by intersecting a horizontal with a vertical, namely the cross-sign or cruciform. This is not to say that all along a black painting like *"Die Fahne hoch!"* (see fig. 1) was a picture of a cross. It is much more to say that it is a painting that releases its viewers into an experience of the way that both cross and picture (rectangular format) are conventional forms, mutually determining each other, both of them, at their distant cultural origins, logically deduced from a set of very simple, material facts.

In these pictures Stella was able to go very far in the demonstration of the privacy-effect, both its capacity to haunt and its utter dependence on surface, as in the aluminum picture *Luis Miguel Dominguin* of 1960 (fig. 6). Departing very slightly from the regular rectangle, the work's physical shape has a notch removed from the center of its upper edge and two four-inch slices subtracted from part of its lower sides. True to form, the bands, beginning by symmetrically cupping the shape of the central notch, radiate outward. Yet, as if by magic, something of the majesty of the dead bullfighter emerges from this seemingly mechanical work, something of the mystery surrounding the fallen toreador for whom the picture is named. Once again the cruciform organizes itself, this time taking on the quality of an outstretched cape, a cape now with an added resonance as its impossible "folds" are radiant with a strange, silver light. The point, however, is that the painting is not so much an icon as a meditation on the logic of the icon, on how such a form might have come into being as a vehicle of cultural meaning.

If Stella was analyzing the surfacing-into-meaning of the icon, of the conventional sign, in canvases whose shapes determined and were determined by such signs, Robert Morris's sculpture was analyzing the body as a field which, like Stella's pictorial surface, is the external plane on which meaning occurs. In 1967 he made a group of sectional fiberglass objects, like the eight-section piece which configures a large, inert, stadium-shaped donut (fig. 7).

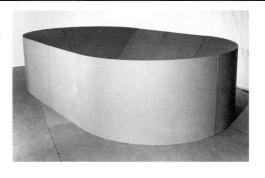 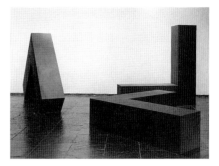

Going further than earlier mono-lithic objects — his three *L-Beams* of 1965 (fig. 8), for example — in its refusal of the power of geometry to legislate the coherence of the form a priori, this work refused the residual coherence given by the L-shape's armature and instead con-stituted the simple geometrical

Left:
7. Robert Morris. *Untitled (Wedges)*. 1967. Fiberglass; eight sections: four, 47 x 48 x 47¹/₂″ (119.4 x 121.9 x 120.7 cm); four, 47¹/₂ x 85 x 47¹/₂″ (120.7 x 215.9 x 120.7 cm). Solomon R. Guggenheim Museum, New York

Right:
8. Robert Morris. *Untitled (L-Beams)*. 1965. Stainless steel; each component, 8 x 8' x 24″ (243.8 x 243.8 x 61 cm). Whitney Museum of American Art, New York. Gift of Howard and Jean Lipman

wholes from sections that fit together to make the entirety. But these sections could also be readjusted to make other forms as well. Indeed, the sectional condition of this work allowed Morris to reconfigure it differently each day of its month-long period of exhibition. And this performed a statement not just about the object's contingency, its body's surfacing-into-meaning, but also that of its viewer.

A three-dimensional, freestanding medium, sculpture naturally mirrors the body of the person confronting it, working through the identification between bodies, counting on how we sense through our own corporeal selves the meaning of this represented gesture, of that sculpted stance. No matter how abstract a sculpture may be, it nonetheless occurs in the field of the body. This had been the lesson taught by half a century of modernist "abstract" sculpture in which no matter how perfect, how crystalline the geometry of the object became, no matter how smooth the curvature of its elegant shell, in the field of meaning it always served to mirror the being regarding it. Modernist sculpture had held up a mirror of fixed, stable forms, models of rationality, of organic coherence, of technological mastery. Morris's model reflected none of these. Neither the geometry nor the meaning is fixed beforehand: no rules, no laws, no universals. And this applies to the bodies on both sides of the mirror.

2. A Tale of Two Sublimes

> *To be an artist is not a matter of making paintings at all.*
> *What we are really dealing with is our state of consciousness*
> *and the shape of our perception.*
>
> Robert Irwin

If Minimalism was characterized through this worry about surface, about the interface formed by materials as they stretched across the frame of either painting or three-dimensional object, aligning the meaning of the work with its physical medium, as that medium "surfaced," contingently, into the world, the California art of the sixties had an abhorrence of the physicality signaled by surface. The real medium of this work, John Coplans was fond of saying,

9. Robert Irwin. *Untitled*. 1962–63. Oil on canvas, 6′ 11 1/8″ x 7′ 1/4″ (211.1 x 214 cm). Norton Simon Museum, Pasadena, California. Gift of the artist

10. Robert Irwin. *Untitled*. 1968. Synthetic polymer paint on metal, 60 3/8″ (153.2 cm) diameter. The Museum of Modern Art, New York. Mrs. Sam A. Lewisohn Fund

was the viewer's perceptual process.[5]

Thus it is no surprise that when Irwin's work began to be received in New York, his enterprise should be seen in relation to Reinhardt's. This reception occurred just at the point where Irwin had abandoned the conventional canvas format — no matter how minimally inflected, first with paired lines (fig. 9), then with dots — and had begun to work with large, slightly convex discs, projected from the wall (fig. 10). Everything about these objects that Irwin showed in 1968 "revealed his preoccupation with a range of coloristic subtlety and spatial suspension, which work to eliminate a consciousness of the paintings' actual physical limits and surfaces."[6] Irwin's disc pictures were white where Reinhardt's had been black, but everything about the imperceptibly close-valued color, the suspension of the convex planes from the wall, the disorientation of their lighting that made them seem to hover above a clover-leafed bed of shadow, conspired to dissolve the concreteness of the picture plane, to diffuse the edges of the pictorial object, to create the sense that an almost invisible veil was floating "somewhere in front of the actual white surface of the canvas."[7]

By 1977, with Irwin's show at the Whitney Museum, the disjunction between his position and that of the Minimalists was spectacularly clear. They were making objects; he was "finding phenomena." Irwin was trying — with one black line taped down the middle of a floor; with one suspended stretch of almost invisible scrim (fig. 11); with the imperceptible change of a room's cylindrical columns as one is recast as square — to package "consciousness,"

11. Robert Irwin. *Fractured light — Partial scrim ceiling — Eye level wire.* **Installation at The Museum of Modern Art, New York, 1970**

to articulate a given space as resonant with "experience" in all its multidimensionality: the experience of the structural relationships of the spatial volume; the experience of light, of movement, of sounds; the experience of myself not so much experiencing this experience, as expanding into it. The extreme reductiveness of Irwin's means had nothing to do with the Minimalist concern for shape and opacity. "Irwin's search," it was clear, "is for transparency rather than opaqueness. His work seems to require a seeing through rather than a looking at. . . . His interest is in phenomena, not in the edges which contain it. . . . Irwin's interest is on the other side of the frame. He begins where Minimalism stops — at the edge."[8]

Dissolving the edge had taken Irwin, and James Turrell with him, into hours of isolation in echo-free (anechoic), totally light-blackened chambers where "you had no visual or audio input at all, other than what you might produce yourself. You might begin to have some retinal replay or hear your own body — hear the electrical energy of your brain, the beat of your heart, all that sort of thing."[9] As part of the Art and Technology project Maurice Tuchman had organized for the L.A. County Museum in the late sixties, Irwin and Turrell were paired with Ed Wortz, an environmental psychologist working for NASA. After the anechoic chambers, Wortz helped them set up Ganz fields, which Irwin describes as "visual fields in which there are no objects you can take hold of with your eye; that is, three hundred and sixty degrees of homogeneous color — in our case white — which suggests the sensation you might experience by sticking your head inside a giant, evenly lit Ping-Pong ball."[10]

Irwin described the result of the sensory-deprivation experiments as an almost unimaginable heightening and intensifying of perceptual experience. "For a few hours after you came out," Irwin recounted, "you really did become more conscious — not just that leaves move but that everything has a kind of aura, that nothing is wholly static, that color itself emanates a kind of energy."[11] But whether the state of experience was the nearly unmanageably profuse swarm of detail around one outside the chamber, or the plunge into the gray velvet of biofeedback inside it, the consciousness Irwin sought was wholly transparent, without limits, without "edge." He was looking for states of intensity which would escape all possibility of measure, a sensory plenum into which one would simply dissolve.

There is a word for what Irwin was looking for in this nothing that could be experienced as infinitely full, a word he doubtless would not like. Nonetheless the phenomenon is generally pointed to by the term *Sublime*.

Sublimity had entered the working critical vocabulary of the 1960s when Robert Rosenblum moved to generalize Barnett Newman's desire for a noumenal abstraction into the master signified of Abstract Expressionism. The notion of the "abstract sublime" that he plotted in relation to the work of Newman, Clyfford Still, Mark Rothko, and Jackson Pollock, derived its

applicability to abstract painting from Kant's insistence that the sublime is not to be found in nature but in the imagination's intuition of absoluteness — an absoluteness that cannot, therefore, be placed in comparison to anything within the empirical field. "The sublime is that," Kant writes, "the mere ability to think which shows a faculty of the mind surpassing every standard of sense."[12] But the urge toward the iconographic entered Rosenblum's discussion almost immediately; and "immensity," "boundlessness," "inexhaustibility" were soon supplied with natural coordinates — geological, meteorological, astronomical — as the "abstract sublime" was folded into nineteenth-century transcendentalist landscape: Friedrich's *Monk by the Sea* as a precedent for Rothko; James Ward's *Gordale Scar* as a logical origin for Still; Turner's *Snowstorm* as an emotive source for Pollock. "We are plunged into divine fury," Rosenblum wrote of the Turner in one sentence so that in another he could speak of the "superhuman turbulence" of Pollock's dripped pictures, of the "boundless web of inexhaustible energy" they produce.[13]

Leaving aside the possible unhelpfulness of using the "sublime" as an interpretant for Pollock's work, the effect of this move toward iconographicization — toward projecting imagery into abstract painting — is to render transparent what had been formally constructed as opaque, to pierce the pictorial surface as surely as if one were opening a window onto the real. It was thus to enlarge the conditions of possibility within which Abstract Expressionism could be received. While Stella was looking at the puddles of aluminum clotting the field of Pollock's drip paintings and seeing in them a radical formula for establishing a kind of surface repellence;[14] while Louis was observing the bleeds and stains that soaked the canvas as a way to produce a non-illusionistic anti-spatial halation; this third reading produced transparency: the sublime, the absolutely great, is what art opens onto when it opens up onto the world as perceived under certain optical conditions.

This was a lesson that had great resonance in California.

3. A Tale of Two Spaces

James Turrell is, doubtless, the most effective exponent of the California Sublime. Like Irwin he is not interested in surface but in transparency, in promoting the effect that if I am in the presence of mystery, it is one that is unmediated; it is in the same room with me. All of his work, the Projection Pieces begun in 1966, the Skyspaces, the Space Division Constructions, produce an intense illusion of density and substance accompanied by an acknowledgement of the "nothing" that is insistently there. It is the "nothing"'s capacity to change that provokes the most awe.

The Space Division Constructions (fig. 12), in which a partition with a large opening in it divides a room into a space to be occupied and one — a "sensing space" — that is not, produce the initial impression that a large rectangle is painted on a solid wall. "Advancing toward the sensing space, the

12. James Turrell. *Avaar*. 1976 (installed at the Herron School of Art Gallery, Indiana University–Purdue University at Indianapolis, 1980). Ambient light. Collection the artist

opaque surface," Turrell says, "will slowly yield, become transparent and open out to reveal another room. The quality of light in this other room is very homogeneous and appears as a green-gray to blue-gray mist. However, the transparent surface holds in its strength, so that even on approach there seems to be a glassy, transparent skin that is looked through. The surface seems physically tangible, and the space has a quality of having 'gelled up.'"[15]

Turrell is specific about the condition of ineffability he wants to induce. Once the viewer has come close enough to the "sensing space," the piece "dissolves" and reveals its existence. "This is like looking behind the stage to find the mirrors," he tells us,

only to discover there are none. Here the quality of illusion that is utilized really seems to be more one of materialization, and the koan *that is posed is most easily understood not by seeing the piece as first one thing and then another, but by seeing the piece open to yield its other aspects through moving in the space outside it. The power of the physical presence and tangibility of the light-filled space and its changing sense of existence tend to make it feel like the dream that coexists with the awake state.*[16]

It was Count Panza di Biumo who found the *koans* posed by Turrell's work most compelling. It was in Santa Monica, in 1973, that he saw a Skyspace (fig. 13) in Turrell's studio. "It was a small opening, about three feet wide, and the room was perhaps ten feet by twenty feet. We sat in this room and saw the sunset through the hole. At the beginning the sunset was dark blue, and the space inside looked empty. The dark blue appeared to be on the

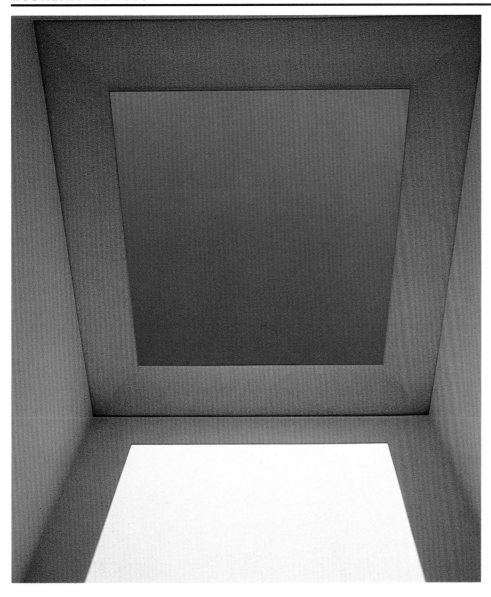

13. James Turrell. *Sky Window I*. 1975. Skylight and interior ambient light. Collection Giuseppe Panza di Biumo, Varese, Italy

surface of the wall. . . . The opening looked like a surface, not a void. When the light of the sunset began to change, this feeling shifted from an empty space to a surface to a solid colored material. It was very strange to see something that didn't exist but, at the same time, was real."[17] Count Panza's sensibility was right in accord with Turrell's. Instinctively he understood the California Sublime.

Count Panza had Turrell execute three rooms in his villa at Varese, Italy. He invested heavily in California light art. A disc and two window pieces by Irwin, a room by Maria Nordman, fourteen projects by Doug Wheeler. . . . Further, Count Panza understood that California — right at the crossroads between the new physics and Eastern mysticism — was the right place from which to take off into the future. "Turrell is a man," he said, "like Irwin, with a broad knowledge of science and philosophy. . . . His vision of the universe is great."[18]

4. Dr. No

We are all fond of reviewing in our minds the trajectory Walter Benjamin traces of art's development as it has been successively reshaped by the evolving means of its production, breaking through a path that moves steadily from private to public, from cult object made and viewed only by a priestly caste to exhibition object made in the service of and disseminated by secular powers. With the advent of mechanical reproduction this dissemination increases exponentially and the work, now securely lodged at the interface between private and public, makes of the public sphere both its subject and object. For on the one hand, new forms (like film, television, newspapers) tend to dissolve the individual author into the collectivity of "the producer," and on the other, meaning is increasingly focused on the exteriorization of subjectivity.

It was Minimalism more than any other movement that produced a climax of this sense of the radical contingency of both object (whose simple geometries were shown to be utterly porous to the effects of context) and viewing subject (who was shown to be a function of "lived bodily perspective," a subject who coheres, but only provisionally and moment by moment, in the act of perception). It was Minimalism that more than any art before it staked everything on what it means for experience to be entirely a function of external, public space. But curiously enough, it was Minimalism that, to a degree unprecedented within the history of a hundred years of modernism, was largely collected by a single individual, and thus ended up almost entirely in private hands.

If Count Panza di Biumo bought Minimalist works by the dozens and hundreds, it was to satisfy his own taste and his own sense of the meaning of this art. And for him Minimalism represented an essentialist, idealist, purist, experience: mind soaring free of matter. Once, when it was suggested to him that Robert Morris's work, for instance, had a great deal to do with the body,

with eros, with the mind projected downward, away from concept and into compulsion, he adamantly refused such a blasphemy. Morris's work was noble, he insisted, rationalist, transcendent. It was "the attempt to look for something essential in shapes . . . to avoid what is not necessary and to look only for what is permanent. Rational forms are related to something permanent; pure shapes are an image of the capacity of man to think." If the work was great it was because it was not an exploration of contingency, history, time, but a delivery of truth: "I believe that the greatest emotion of life is knowledge, the discovery of truth. The research of truth is the main goal of man. This art revealed the research of truth through simple forms."[19]

With a taste for the metaphysical, Panza rewrote the Minimalist project to suit his own sensibilities. Dan Flavin's work (fig. 14) was quickly dematerialized into eddies and clouds of colored light, since unlike the artist, Panza didn't take the material presence of the fluorescent tubes seriously, saying, "But this quality is less important in Flavin; it's more important that the work is not confined to the shape of the material but expands into the volume of

14. Dan Flavin. *Untitled (to the "Innovator" of Wheeling Peachblow)*. 1968. Fluorescent lights and metal fixtures, 8' 1/2" x 8' 1/4" x 5 3/4" (245 x 244.3 x 14.5 cm). The Museum of Modern Art, New York. Helena Rubenstein Fund

the room." The result of this interpretive conviction is the *Varese Corridor,*[20] in which the disembodied glow of works in a succession of small rooms fills the open doorways along a darkened, barrel-vaulted hallway of Panza's villa with intense rectangles of irradiated hue: crimson, pale blue, violet, yellow. . . . It is less like a Minimalist Flavin and more like the set of a sci-fi movie, some newly wrought ending for *2001,* where, in the Cartesian hotel suite in the sky, the astronaut is being gathered into the hands of God.

Count Panza is nothing if not frank about his desire to control the way his collection is displayed in that afterlife it will lead away from his private protection. As a condition of selling the Abstract Expressionist and early Pop part of the collection to MOCA in Los Angeles, he "asked and the museum agreed, that the installation go according to my instructions." These directives were concerted toward preserving the chapel-like quality of the converted stables in Varese, with each space consecrated to the work of a single artist, so that, as Panza says, "in some way, you breathe the soul of the artist."[21]

An experience like the *Varese Corridor* is thus not necessarily confined to Varese. It can be, I found out lately, reestablished elsewhere, particularly as Count Panza controls the installation of his collection within a sequence of museums. Thus in the Musée d'Art Moderne de la Ville de Paris, where a large portion of the collection was displayed in the summer of 1990, under the Count's strict supervision, the metaphysical Flavin-effect was in high gear, with pools of light ricocheting off the gleaming floors and walls of darkened rooms, and penumbras of color glowing from far-off, still invisible spaces. And in this twilit installation in which the dematerialization of the objects was nothing short of spectacular, the emphasis had curiously shifted away from surface and onto work whose medium was "the viewer's perceptual process" itself. What had pride of place within this presentation was the work of Bruce Nauman (fig. 15), particularly those experimental spaces which recreate, in various ways, the intensification of emptiness that is the goal of the anechoic chamber. And, like a kind of Holy of Holies, in the very center of the collection, was a Space Division Construction by James Turrell. Minimalism had been folded at last into the arms of the California Sublime.[22]

5. History Is a Matter of Who Gets to Write It

In the 1960s, even while the artists themselves were making their hostility to what they called "idealist aesthetics" as clear as was humanly possible, Minimalism was being defended by most of its critic supporters on the grounds of this very idealism. It was described as having plunged to the heart of matter and to have found the crystalline essence of form.

But art history does not simply get written by historians. It is also the deposit left by successive acts of interpretation as other artists go about their work. This issue of contingency that Minimalism had forced into the open, the permeability of both subject and object to what goes on in the space in

15. Bruce Nauman. *Yellow Room (Triangular)*. 1973 (installed at the exhibition "Un Choix d'art minimal dans la collection Panza," Musée d'Art Moderne de la Ville de Paris, 1990). Wallboard and yellow fluorescent light. Solomon R. Guggenheim Museum, New York

which both coexist, became the basis of a series of interpretive rewritings in the decades that followed the 1960s. Since "what goes on in the space in which both coexist" could be seen to be more than the "space, light, and the viewer's field of vision" to which Morris had referred when he recommended taking "relationships out of the work and mak[ing] them a function" of their context,[23] this coordinating matrix could be understood to include the institutional construction of that very "space": the legal and financial "arrangements" that shape and control it; the discursive practices that make possible what can become visible within it. To further this part of the project after 1968 became the goal of artists ranging from Robert Smithson (fig. 16) and Daniel Buren to Hans Haacke and Michael Asher. The other part of the Minimalist project, raised by its staging of the subject's experience of his or her own contingency, was also broadened in the seventies and eighties by successive artistic practices, these focusing on a critique of the representation of the subject, widening the "space" of interaction to include all those matrices — language, the media — which both precede and exceed the bounds of the individual. The work, for example, of Cindy Sherman, Barbara Kruger, Jenny Holzer, Richard Prince, Sherrie Levine, may have little to do with the forms of Minimalism but takes up the critique of "private language" right where it left off.[24]

This collective act of interpreting Minimalism by extending its sphere of relevance to contemporary artistic practice and reception, one which made

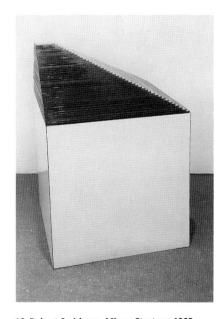

16. Robert Smithson. *Mirror Stratum*. 1968. Mirrors on formica-covered base, 25 1/2 x 25 1/2 x 10 1/4" (64.8 x 64.8 x 26 cm). The Museum of Modern Art, New York. Purchase

contingency, contextualism, "effect," the salient aesthetic issues of a succeed-ing generation, is one way in which the "history" of the movement has been written. But another page of that history is now being filled in by the impact of the release, in the 1990s, of Panza's collection back into the public realm. For that collection, which has been inscribed by another set of interpretive acts, those of Panza himself, has, through the effect of its remaining together, become a kind of framing device through which Minimalism is being reintro-duced as an historical object. And that device will tend to produce new emphases, to articulate new relationships among objects, to conjure up new centers of gravity, to rethink the movement according to its supposed interest in a "metaphysical entity." Thus, even while it will restore to the public the contents of a personal holding, the operations on behalf of the Panza Collection have already had the effect of an historical recoding of Minimalism in the direction of privacy, interiority, spirituality. Whether this interpretation will be transitory, or whether it will have some staying power as an act of redefinition, will be a part of the art history of the nineties as it succeeds or fails to do justice to the aspirations of the sixties.

Notes

1. Quoted in Margit Rowell, *Ad Reinhardt and Color* (New York: Solomon R. Guggenheim Museum, 1980), p. 26.

2. "Talk of the Town," *The New Yorker,* September 30, 1985, p. 28.

3. In a conversation reported to the author by Michael Fried.

4. Roland Barthes, *S/Z,* trans. Richard Miller (New York: Hill & Wang, 1974), p. 34.

5. John Coplans, *Los Angeles 6* (Vancouver, B.C.: The Vancouver Art Gallery, 1968), p. 9.

6. Emily Wasserman, "Robert Irwin, Gene Davis, Richard Smith," *Artforum,* 6 (May 1968), p. 47.

7. Ibid.

8. Edward Levine, "Robert Irwin's Recent Work," *Artforum,* 16 (December 1977), p. 26.

9. Quoted in Lawrence Weschler, *Seeing Is Forgetting the Name of the Thing One Sees: A Life of Contemporary Artist Robert Irwin* (Berkeley and Los Angeles: University of California Press, 1982), p. 128.

10. Ibid., p. 130.

11. Ibid., p. 129.

12. Immanuel Kant, *Critique of Judgement,* trans. J. H. Bernard (New York: Hafner Publishing Co., 1951), p. 89.

13. Robert Rosenblum, "The Abstract Sublime," *Art News,* 59 (February 1961), p. 56.

14. Stella speaks of this in the film *Painters Painting* by Michael Blackwood. Yve-Alain Bois called my attention to his comment.

15. *James Turrell: Light and Space* (New York: Whitney Museum of American Art, 1980), p. 35.

16. Ibid., p. 36.

17. Quoted in Christopher Knight, *Art of the Sixties and Seventies: The Panza Collection* (New York: Rizzoli, 1988), p. 47.

18. Ibid.

19. Ibid., p. 42.

20. Illustrated, ibid., pp. 36–37.

21. Ibid., p. 30.

22. For further discussion of this installation, see my "The Cultural Logic of the Late Capitalist Museum," *October,* no. 54 (Fall 1990), pp. 3–17.

23. See Robert Morris, "Notes on Sculpture," in Gregory Battcock, ed., *Minimal Art: A Critical Anthology* (New York: E. P. Dutton, 1968), p. 232.

24. Hal Foster discusses the way much of postmodernism in both its critical modes (the critique of institutions, the critique of the representation of the subject) and its collaborative ones (the transavant-garde, simulation) is nascent within the Minimalist syntax, both spatial and productive, in his important analysis "The Crux of Minimalism" (in *Individuals: A Selected History of Contemporary Art, 1945–1986* [Los Angeles: The Museum of Contemporary Art, 1986]).

In 1966 The Museum of Modern Art published Robert Venturi's Complexity and Contradiction in Architecture. *A critique of the reductivist aesthetics, as well as the functional and structural determinism, of the modern movement, it proposed an alternative, an architecture of complexity and contradiction, that sought to reconcile the multiplicity of forces shaping a building and make of them an architecture of the difficult whole. Twenty-five years later, in 1991, it is clear that the book caused an important shift in twentieth-century architectural sensibility. It made the study of the architecture of the past again relevant to contemporary practice, and the return to historical eclecticism in architecture and urbanism can partly be ascribed to it (although the exhibition "The Architecture of the École des Beaux-Arts," organized by Arthur Drexler at The Museum of Modern Art in 1976, and the grassroots preservationist movement were also responsible). However, eclecticism as such was not Venturi's goal; in the end his book's significance may be judged on the unexpected range of influences it has exerted. One of its most important consequences has been, in fact, to enrich and revitalize the modern movement.*

<div align="right">S.W.</div>

Complexity and Contradiction Twenty-five Years Later: An Interview with Robert Venturi

Stuart Wrede

Stuart Wrede: I think for a lot of people, in fact a whole new generation, what happened in the fifties and early sixties is not always clear. So, if you wouldn't mind, could you reiterate the reasons why you wrote the book, and the state of architectural practice at the time?

Robert Venturi: First of all, I think one can safely generalize and say that it's very hard to understand, and very hard to remember, the recent past. It's much harder, maybe, than with the distant past. And in terms of taste, it's probably harder to *like* the recent past. For example, you might look at the wedding photograph of your parents and say, "Oh, what a funny dress my mother has on." But if you looked at the wedding photograph of your grand-parents, you'd probably say, "That's a nice dress." You can more easily like things from the distant past, because of the way cycles of taste work.

It's hard to realize how different things were then in architecture. At that time, I was a young teacher at Penn,[1] along with Denise Scott Brown, and we were the black sheep of the faculty, partly because we hadn't gone to Harvard, the sanctuary of high modern architecture. Harvard was *the* place where young people went; it was the only place to go, besides MIT. If you'd gone to Princeton, as I had,[2] where history was acknowledged — where modern architecture was very much accepted but was seen in the broad context of history, as part of a natural evolution, rather than as the end of history and the creation of a new order — well, you were looked upon as an infidel. I'm over-simplifying, but to some extent the Bauhaus approach, the modernist, pro-gressive approach, resembled that of a divinity school instead of an architectural school — the divinity school proclaims, so to speak, the final Word; and you learn by implication to be a priest rather than an artist.

I was very lucky to have been educated in a place where we weren't get-ting The Word. We were getting at what was appropriate for the time, seen in the context of the evolving past, and by implication we could evolve and grow out of the present.

Wrede: What you are suggesting is that at these other schools, year one started with the founding of the Bauhaus?

Venturi: Yes, that's right; at Princeton, architecture didn't start with the founding of the Bauhaus. And it is interesting that a historian, like Siegfried Giedion, more or less the official historian of the Bauhaus-oriented modern movement, would look at history in a highly selective way. He selected Baroque architecture and industrial vernacular architecture of the recent past as what he called "constituent facts" of history, as opposed to "transitory facts." "Transitory facts" were bad ones that didn't lead to modern architecture; "constituent facts" were good facts that did.[3]

The point is that for someone to look at history and use historical analogy, as I was encouraged to do at Princeton, and then to be inclusive in my approach was unusual at that time. So too was acknowledging a mannerist approach, rather than one involved with pure principles and pure harmony and pure progress. My method and its conclusions seemed strange.

I was hardly exaggerating when I said, at the time, that I was including in this book things I couldn't put in my theory course then for fear of the accusation I was corrupting the morals of minors. At Penn, I was doing things that were not within the orthodox tradition of modernism, of the German Bauhaus, of the rather Puritanical, New England–Gropius way of thinking.

Wrede: Your teaching was seen as subversive?

Venturi: Yes. So in a way, the book came out of feeling frustrated by the strictures of the curriculum typical of schools of architecture then. I think my theory course was the only theory course at that time in this country.

Wrede: Yale didn't offer one until you came up and taught us in 1966.[4]

Venturi: Indeed. At Penn the idea of teaching a class devoted to architectural theory originated, I'll admit, with Dean Holmes Perkins, a Harvard man par excellence and a very orthodox modernist, but he did choose it and me. Of course, now the pendulum's swung too far the other way, to the point where there is in my opinion too much theory — architecture as built theory, frozen theory, as I say. What the orthodox modernist feared has happened: you forget that architecture is a craft — that it is not sculpture but shelter.

Therefore, the book came out at a time when modern architecture was the end-all; the progressive approach was the end-all. It was a highly formalistic approach also; it did not allow for a symbolist or a mannerist view of the arts: that is, one that acknowledged ambiguity over clarity, richness over simplicity. Such a way of thinking was unusual then.

What helped me was my interest in history: my use of historical analogy,

my fascination with mannerist architecture, and a realization that ours was a period which was essentially mannerist; our culture was entering what could be called a mannerist phase.

Wrede: You mentioned Princeton and the fact that you studied there as important to the formation of your thinking as an architect. Aside from the obvious openness to history at Princeton, was what you called "the mannerist sensibility" part of the Princeton education, or was that something you developed personally?

Venturi: The mannerist side of my thinking I did not derive directly from Princeton, but it can be said to have been permissible there. The mannerist sensibility and its significance dawned on me at the end of my stay in Rome as a Rome Prize Fellow at the American Academy in 1954–56. And I discovered that what was most exciting and interesting to me was Mannerist architecture, the architecture of the sixteenth century, including the work of Michelangelo (fig. 1). Of course, "mannerism" is two things: as Mannerism it refers to a specific historical style, and as mannerism it's also a universal trend you can find throughout architecture. The relevance of mannerism and Mannerism occurred to me at the end of my stay in Rome, as I have said, and it came through my observations of historical architecture in Italy especially, my standing back and observing my reactions and realizing what really turned me on.

1. Michelangelo Buonarroti (with 19th-century restorations of the attic by Virginio Vespignani). Porta Pia, Rome. 1561–65

After I returned to the United States, I talked a lot to my friend Phillip Finkelpearl, the distinguished English scholar who had introduced me to the New Criticism in literature and now broadened my view of mannerism. I learned a lot about using a common, everyday vocabulary in complex and paradoxical ways — about using different levels of meaning. Now, since that time, an awful lot of literary criticism has been worked into architectural theory, I think very often in bad ways: semiotics, deconstructionism, and all that, rather poorly translated from one medium to another. Very often these parallels can work, but one does have to be careful with them. You can't embrace them; you just have to take them with a grain of salt. And I myself learned a lot from the New Critics: about ambiguity from Empson and others, and a lot about the power of everyday things from T. S. Eliot.[5]

So the book, to some extent, came out of all these influences and situations, with Princeton piquing my natural interest in and fascination with historical architecture; I learned, through Jean Labatut and Donald Drew Egbert, how to work with historical analogy and sense the nature of architectural evolution. And from my subsequent Rome experience I "discovered" mannerism. And eventually out of these currents evolved my recognition, along with Denise Scott Brown, of symbolism, manifest in our later book, *Learning from Las Vegas*. I began to realize that architecture wasn't essentially

abstract form determined by structural and functional requirements: there were also references; there was also ornament. One thing led to another and they built on each other.

Essentially it came from a young person who was careful to acknowledge his reactions by saying, "This turns me on, but that doesn't," rather than, "What *should* turn me on? What have my teachers told me I should like? What is the latest thing?" You really need to get out of that mind-set and ask, "What really *is* turning me on?" That, of course, happened later too with Denise and me in *Learning from Las Vegas,* when we said to ourselves, "Hey, the Strip turns us on. It horrifies us *and* it turns us on" (fig. 2).

2. "The Las Vegas Strip by Day," from *Learning from Las Vegas,* 1972

Wrede: You mentioned a little earlier your feeling that this was a mannerist period, in society at large, at least. But in modern architecture at the time, mannerism was hardly à la mode. Or at least, the few buildings that might have been thought of as mannerist (fig. 3) weren't presented in these terms; such interpretations would happen later. This is an interesting issue because implied in it is a zeitgeist argument.

Venturi: I think simply that zeitgeist should take care of itself; it should not be implemented, but rather incidentally discovered.

And it is true that I came to see mannerist configurations in the work of Alvar Aalto and Le Corbusier (but not in Frank Lloyd Wright nor Mies van der Rohe). So one of your jobs as an artist is to sense what's in the air, be of it, and communicate it, without using obscure language. It was, and still is, a time of complexity and contradiction in the sense that there is no one universalist view in a shrinking world. Pluralism, that much-used and abused word, we have to acknowledge. Very simply, what turns people on more often than not are rich aesthetic effects involving many languages based on many tastes and cultures.

3. Le Corbusier. Millowners' Association Building, Ahmedabad, India. 1954

I think Minimalism has nothing to do with our time, or that of twenty-five years ago. The reformist simplicity of the heroic period of modernism was valid in the twenties and thirties, and I did not and we did not bash the architects of that period; we are evolving beyond them naturally, the way they went beyond somebody.

Wrede: How much did this have to do with your feeling that by the early sixties, the vitality of the modern movement had dissipated?

Venturi: Much late modern work looks boring now, even though the whole idea of it was to take modernism and make it heroic and dramatic, promoting the articulation of forms as a substitute for ornament (fig. 4). There can be wonderful late phases of movements that are full of spirited decadence, if you will, but I don't think late modern had that. Late modern is boring because it

4. Kallmann, McKinnell and Knowles. City Hall, Boston. 1963–68

tried to be so puritanical *and* heroic.

What I am referring to is different from the boring that Andy Warhol appreciated when he said, "I like boring things." We used "ugly and ordinary" (boring, if you will) elements in a building like Guild House — brick, sash windows, the TV antenna — to give a realistic expression of the use of the building and a meaning familiar to the inhabitants (fig. 5). Actually the term "ugly and ordinary" derived from a derisive description of our Transportation Square office-building project in Washington, D.C., which we adopted as a positive slogan.

5. Venturi, Cope and Lippincott. Guild House, Friends Housing for the Elderly, Philadelphia. 1960–63

Wrede: The terms by which you presented your ideas in the book, I assume, were carefully considered at the time.

Venturi: Yes.

Wrede: I think it's interesting that you start out in the book by saying, "I like complexity and contradiction in architecture."[6] This presents the argument in very personal terms, as opposed to, say, Le Corbusier, who presented his ideas in the broad social terms of "architecture or revolution,"[7] or in terms of the inevitable: There will be a new architecture whether we like it or not. Presumably, framing the argument in such personal terms had a strong polemical intent at the time you wrote it.

Venturi: I wrote "I like" very consciously at the beginning of my argument to establish myself as an artist writing rather than a theorist — relying on intuition first and then reason: do I like it? Then I will test it and see if it's valid. I try to see whether it still makes sense and connects with experience and with life.

So in a way, the book was a testing of what "I like." And a person in each generation has to do things his own way. Lie back, look at your reactions and ask, "What do I like?" But naturally, you can't just proclaim what you like. You have then to justify it and test it, and I did that by writing a half an inch thick series of pages.

Wrede: I thought it was interesting that the "I like" came first.

Venturi: Yes, that's significant. In a symposium recently, Peter Eisenman said, "Oh come, Bob; when you were writing *Complexity and Contradiction,* weren't you trying to shock?" And I said, "No, I was just trying to make sense." And in my writing I was trying to employ an easy style in an American literary tradition using simple, ordinary, everyday words, and relying on easy rhythms to get ideas across. I was leaning over backwards not to be pretentious and to be understandable. That's different from academic writ-

ing that predominates today, a style that makes me suspicious of the content. Writers today seem to have to be esoteric in order to be profound — to be complex and contradictory themselves to express the idea.

Wrede: And then later in *Complexity and Contradiction,* in your testing of the "I like," you talk about your sense of the complexity of the times.

Venturi: The complexity of the aura, the aura of the times.

Wrede: But you didn't offer a utopian vision, presumably because an architecture of complexity would not necessarily solve the world's problems.

Venturi: That's right. And again, that was a form of reaction to the first part of the century, which I grew up in and to some extent was part of. My mother was a socialist and was interested in, had great faith in, an implementation of an ideal social, economic, and political organization. I think our generation was saying that you can't be that sure, things are not that simple anymore. Socialism doesn't necessarily work, but that doesn't mean you know capitalism works. The whole situation is complicated now; you can't be so easily ideological now.

Wrede: Along those lines, what is your personal assessment of the book now, twenty-five years later? What are your general feelings today about the positions you took then?

Venturi: I think I'm a harsh critic of myself. As an architect, I look at almost any building I've designed and say, "My God! This detail is no good and that detail is no good," even if I think the whole is very right. But when I look at this book, granted I've never entirely reread it, I have a feeling of satisfaction. I agree with it, think it's valid today, and well presented. A lot of what has happened and is happening now justifies the book, although it is sad that its use of historical analogy was misunderstood as promoting historicism and historical references and symbolism per se. But I think what I said then remains right and relevant; it has sustained me and others despite simplistic or wrong misinterpretations: anything good can be and usually is corrupted eventually.

It's interesting to me that my old teacher, whom I adore as a great teacher, Donald Drew Egbert, said when the book came out that it should have been titled "Complexity and Contradiction in Architectural Form." Well, in those days you didn't have to say "architectural form," because you meant "architectural form" when you said "architecture." It was a very formalist period. But in a sense, the dimensions of meaning and symbol were embedded in the book. It was there in that first book waiting to be brought out in the sec-

ond one I wrote with Denise Scott Brown and Steven Izenour, *Learning from Las Vegas*. And then the idea of mixing styles, of eclecticism that can be a part of mannerism, evolves from it as well, but wasn't explicitly identified in that text.

And *Learning from Las Vegas* evolves from *Complexity and Contradiction* in another way; at the end of the earlier book, I illustrate the commercial highway and Main Street, U.S.A. (fig. 6), and I say in the seeming banality of Levittown and Main Street and in the seeming chaos of the commercial Strip, there might exist a unity and an order that we can't yet find.[8] I like the way the old book contains the germ of the new book. It is nice that I have evolved beyond *Complexity and Contradiction*, but I still feel good about it; I certainly don't wince when I look at it or think about it.

Wrede: While you were talking about the end of *Complexity and Contradiction* as a preamble to *Learning from Las Vegas,* I was struck by an amusing point about it, because in the middle of *Complexity and Contradiction* you make a reference to Times Square, which you praise, but in opposition to that, you talk disapprovingly about the banality of the roadside architecture and Levittown. You wrote:

It seems our fate now to be faced with either the endless inconsistencies of road-town [fig. 7], which is chaos, or the infinite consistency of Levittown [fig. 8], which is boredom. In roadtown, we have a false complexity; in Levittown, a false simplicity. One thing is clear — from such false consistency real cities will never grow. Cities, like architecture, are complex and contradictory.[9]

Venturi: That points out an inconsistency I was not aware of in the book; it shows an evolution in my thinking within the book and perhaps indicates an influence of Denise Scott Brown at the time, whose advanced thinking concerning American urban design and planning is not as well known as it should be.

You might also refer to the preface to the second edition of *Complexity and Contradiction,* which covers my thoughts along with Denise's at that time [1977] concerning some of the things we're now discussing as well as some of the misapplication of my ideas and the way that led to our second book.[10]

Left:
6. "Typical Main Street, U.S.A.," from *Complexity and Contradiction in Architecture,* 1966

Center:
7. "Highway, U.S.A.," from *Complexity and Contradiction in Architecture,* 1966

Right:
8. "Developers' Houses, U.S.A.," from *Complexity and Contradiction in Architecture,* 1966

Wrede: It is interesting that although you did not explicitly deal with urban design, the whole discussion of historical architecture and historical contexts in *Complexity and Contradiction* led both directly and indirectly to a new appreciation of traditional urban design in contemporary urban planning.

Venturi: That's right, and with bad as well as good results. We all suffer now as architects from having to submit ourselves to goody-goody urban-design review boards in certain municipalities and having thrown back at us in certain perverse forms the fruit of some of our earlier ideas.[11]

I might mention something that hasn't been talked about much, although Denise has touched on it.[12] The idea of context, which was discussed in *Complexity and Contradiction,* but not explicitly, and which today is central to urban-design thinking, came out of my master's thesis at Princeton of 1950.[13] My main point was that change in context caused change in meaning, an idea derived from gestalt psychology. I employed the word "meaning," as opposed to expression, a word no one had used in architecture, or hadn't used for a long time. The subject of my thesis was a chapel for the Episcopal Academy, where I had gone to school.

I remember the moment vividly in the spring of 1950 when in the library in Eno Hall (which then housed the psychology department) I found the word "context" in my reading about gestalt psychology. For me it was a true moment of discovery: "Eureka! I have found my thesis! Meaning derives from context." Today this idea has become a cliché, but it represents a valid architectural concept which for us is still basic to our aesthetic, a fundamental source for our design, and relevant in a broad way in urban design.

Wrede: How influential was Pop art on your thinking?

Venturi: Pop art was very influential. I think we have acknowledged that debt.

Wrede: In *Complexity and Contradiction* you touch on a few of the Pop art paintings of the time.[14] Did they open the door to the Las Vegas study?

Venturi: Yes, they helped open it. Pop art was important in two ways. It connected with the idea of context, where you take something familiar, put it in a new context and give it a new meaning (fig. 9): you take the Campbell's Soup can, you put it in a frame in a museum — as well as change its scale, as with Claes Oldenburg — and make of it art (fig. 10). And then, of course, Pop connected with the significance of the ordinary and the validity of convention. In this regard we were influenced by our critics as well. We presented a design for the Transportation Square office building for Washington, D.C., to the Washington Fine Arts Commission in 1968 (fig. 11), and Gordon

Left:
9. Venturi, Rauch and Scott Brown. Project for Times Square, New York. 1984. Model

Right:
10. Andy Warhol. *Campbell's Soup*. 1965. Oil silkscreened on canvas, 36 1/8 x 24 1/8" (91.7 x 61 cm). The Museum of Modern Art, New York. Elizabeth Bliss Parkinson Fund

Bunshaft referred to our work as "ugly and ordinary."[15] We took that as a compliment; after all, Gothic and Baroque were originally derisive terms.

Wrede: Of course Pop art glorified the ordinary. But the phrase "ugly and ordinary" first appeared in *Learning from Las Vegas,* your second book.

Venturi: That's right, because "ugly and ordinary" was about reference, I think, and symbolism, more than about form. I think our building design reminded Bunshaft of ordinary things; it wasn't so much a matter of the forms of this complex building as the symbolism of it. Yes, Pop art was very important for its strong association with the ordinary. Denise knew this earlier than I did. She understood the relevance of Pop art before I did.[16] By the way, Gordon Bunshaft squelched our project, which was a very big setback for our young office.

Wrede: In *Learning from Las Vegas,* you have a whole polemic about Guild House in which you talk about "ugly and ordinary," and "ordinary and conventional."[17] But of course Guild House was designed much earlier, in 1960, and the book was published in 1972. At the time you were designing Guild House, how much did you see it as a form of polemic?

Venturi: That's very interesting. I think if you're a good artist, most of the time what you articulate and write about you've already done. I think that's a safer stance, and that's what happened here. I first *did* the "ugly and ordinary,"

11. Venturi and Rauch. Project for Transportation Square Office Building, Washington, D.C. 1968. Model

and later identified it and articulated why. It's less ideological that way. It's not saying, "I like this ideology; I'm going to make my work conform to it." I think first as an artist who has a job to do.

So you're right; I looked back and only then said, "Ah, this is 'ugly and ordinary.'" And part of the quality of the ordinary in Guild House derived from using windows — windows as holes in the wall and that contained mullions. And there's no question that using this explicit window previously in my mother's house (figs. 12, 13) was at that time shocking. I had had to work very hard to make the manufacturer insert the crossbar in the window, which was really an Arcadia sliding door. That made it, symbolically, a window. And the last thing you ever wanted to put in a late modern building was windows! Of course you employed windows, but they were camouflaged as horizontal or vertical strips in the walls via spandrels or as absences of wall. You would go to any lengths to disguise windows or abrogate them.

During the heroic period you would find holes in the walls as in Mies's Weissenhofsiedlung in Stuttgart in 1927 (fig. 14) or in Le Corbusier's Villa Savoye. But, of course, now windows with mullions are ubiquitous, from Aldo Rossi to whomever.

I think in Guild House I was glorying in being conventional for a particular reason — to make the architecture like that of the buildings where the residents had lived before. At that time a lot of poor people and some old people were being moved into housing based on European socialist ideals and images of the architectural avant-garde of the twenties and thirties. I was determined that these inhabitants were not to be forced into someone else's retardataire social revolution of which they wanted no part. So the familiar-looking building was of brick, with windows.

Left:
12. Venturi and Rauch. Residence, Chestnut Hill, Pennsylvania. 1962–64

Right:
13. Venturi and Rauch. Residence, Chestnut Hill, Pennsylvania. 1962–64. Window

So, yes, you're right, the intellectual justification of these buildings came after they were designed.

Wrede: At the beginning, when you were designing Guild House, the whole thing was a kind of intuitive polemic?

Venturi: Yes, I think so. I did work that embodied certain ideas which, over time, became evident to me. I wrote my books to understand those ideas.

14. Ludwig Mies van der Rohe. Weissenhof-siedlung, Stuttgart. 1927

Wrede: In *Complexity and Contradiction,* you talk about Main Street being "almost all right," and that would seem to relate to the whole idea of Guild House.

Venturi: I think it relates to a reaction against the modernist progressive view that advocates total and universal reform of the urban landscape toward utopian goals, and promotes, instead, a reappraisal of what's there, and evolving realistically out of that and building on it in urbanism and architecture. It's funny that an example of that approach today might be Seaside, Florida, which is a manifestation of Main Street as "almost all right."

Wrede: But Seaside is a very nostalgic version.

Venturi: You're right. "Main Street is almost all right" is not only anti-utopian, but also anti-nostalgic.

Wrede: Let me go back to the sixties again. How was the book received when it first came out?

Venturi: It didn't make a big splash. But I do remember a wonderful negative response about that time toward the North Penn Visiting Nurses Headquarters of 1961 (fig. 15), which appears in the book. I had written a squib to accompany photographs I had submitted to *The Architectural Forum,* hoping it would be published. It *was* published with one little photograph in the news section at the beginning of the issue with a quotation from me that had evidently sounded pretentious to the editor; his response was, "But where does this kind of architecture go from here?"[18] Well, we all know the answer now.

Concerning the book there was not much acceptance and quite a lot of resistance. But Vince Scully liked it and promoted it, and so did Bob Stern. And the book sold relatively well — it's still in print. How much that is due to sentiment on the part of your institution, I don't know, but it is unusual for a book to be in print after so many years. And it has been translated into ten languages!

15. Venturi and Short. North Penn Visiting Nurses Association Headquarters, Ambler, Pennsylvania. 1961

Wrede: Do you remember a particular example of hostility toward the book?

Venturi: Steven Izenour recalls that when he was a student on a Fulbright Scholarship at the Royal Danish Academy of Architecture in the late sixties, he was called into the dean's office one day and instructed not to leave the book lying around the school!

There was a general hostility to our design, much of it stemming from the fact that our architecture is not easy to take. It's not overtly sensual. Our architecture is not a manifestation of our theories, but it parallels the theories and is not instantly likeable.

All during that period we were not well accepted and we did not get big commissions. On the other hand, there were always a number of people who admired us and respected us. They were a minority but they were there and we forever remember them. So I can feel somewhat paranoid but not terribly paranoid.

Wrede: How do you feel about the way things have changed, now that the ideas in the book are generally accepted?

Venturi: I think a lot of what goes for deconstructivism (fig. 16), among other things happening today, is a manifestation of the book. I think much of it *is Complexity and Contradiction,* with certain enormous ironies. To use the now old-fashioned modern vocabulary based on industrial elements in mannerist ways is combining mannerism and modernism to absurd degrees, almost oxymoronic: it's often like a Puritan lady doing the cancan — it's *crazy* mannerism! — an extreme form of what that book stood for. I think some of what's happening is an extremist and obscurantist manifestation of *Complexity and Contradiction.*

Wrede: It has occurred to me as well that the arguments advanced by the deconstructivists parallel arguments in *Complexity and Contradiction,* but are used, obviously, to justify other aesthetics.

Venturi: I'm more resentful now than I was before. I used to think, if my argument is not accepted, that's okay. Now, I think its message is a part of the ethos, accepted, and behind a lot of architecture today — in the work of many of those who disdain the book. And then there are those whose work derives from it, but who are not aware of that because the content of the book has become inherent in our ethos.

Wrede: This may be indirectly related. In your preface, you quote Henry-Russell Hitchcock:

16. Eisenman Robertson Architects. Project for Biocenter, University of Frankfurt. 1987. Study model A

Once, of course, almost all investigation of architecture of the past was in aid of its nominal reconstitution — an instrument of revivalism. That is no longer true, and there is little reason to fear that it will, in our time, become so again. Both the architects and the historian-critics of the early twentieth century, when they were not merely seeking in the past fresh ammunition for current polemical warfare, taught us to see all architecture, as it were, abstractly, false though such a limited vision probably is to the complex sensibilities that produced most of the great architecture of the past. When we reexamine — or discover — this or that aspect of earlier building production today, it is with no idea of repeating its forms, but rather in the expectation of feeding more amply new sensibilities that are wholly the product of the present. To the pure historian this may seem regrettable, as introducing highly subjective elements into what he believes ought to be objective studies. Yet the pure historian, more often than not, will eventually find himself moving in directions that have been already determined by more sensitive weathervanes.[19]

17. Mellor, Meigs and Howe. H. F. C. Stikeman House, Chestnut Hill, Pennsylvania. 1921–23. View from the garden

Would you like to comment on the classical and eclectic revival of the last fifteen years?

Venturi: I think it is still wonderfully true — exposing the fundamental significance of artistic intuition. And it points up one of the fundamental problems today — that architects start with philosophical, psychological-perceptual, and critical theory, and make the architecture conform to it.

Concerning revivalism, I would say ours is an aesthetic of eclecticism — of many architectural vocabularies that are valid, and vocabularies admitting historical reference (as opposed to revivalism) are among them. One of our mistakes is there's too much discussion involving a kind of *battle* of styles, similar to a situation in nineteenth-century England — and it's going on there now; so, among historicists, modernists, or whomever, you get angry people making snide remarks about each other, and it's boring and silly.

The point should be: is it good architecture? I know of historicist architecture, such as Pennsylvania farmhouses built in the twenties, that are beautiful works of architecture (fig. 17). They're gems. I also know of buildings by William Lescaze and George Howe of the same era that I still can like very much as exquisite examples of the International Style (fig. 18).

18. Howe and Lescaze. Philadelphia Savings Fund Society. 1929–32

That is a long preface before saying that I, myself, am unhappy about literal revivalism. There are enormous dangers in such revivalism. It often becomes sentimental nonsense that results in dead art. I think it is much more sophisticated and appropriate for our time to promote what we call "representation" of historicism, or make references that are not literal quotes or borrowings, but that embody certain ideas and forms that are particularly relevant to our own time (fig. 19). There's a tradition of that in Edwardian and Victorian architecture.

NORTHWEST ELEVATION

SOUTHWEST ELEVATION

19. Venturi and Rauch. Project for Yale University Mathematics Building (with Leet Oliver Building, 1908, by Charles Haight, on right). 1969. Elevation drawings

Literal revivalism I am very much against. But it isn't like killing somebody; if it's going to be done, I'm not going to get angry about it. And I can even concede that I might say about a building, "As a tour de force it's good."

But you do have to have the critical sensibility to judge quality, even though no building, in terms of its aesthetic or style, is going to hurt anybody, assuming it stands up. And so in general, I am not happy about revivals and I'm not happy about so-called postmodernism being identified with our approach, which is much too complex for adopting in too literal a manner neoclassical forms. An article I wrote about eight or nine years ago, based on my Gropius Lecture, was my answer to postmodernism.[20] And there I go into all of this: how, in a way, *plus ça change* — that in twenty-five years you go from Le Corbusier to Ledoux (fig. 20).

Wrede: Do you feel that the creation of the architecture that you speak of, an architecture of complexity and contradiction, finally depends on a finely honed individual sensibility? Or do you see there being a methodology that's teachable? (Beyond a certain consciousness-raising for all architecture students.)

Venturi: I think the ideal is that you, the artist, rely on your sensibility, tolerance, and sense of appropriateness. But you must learn to adapt to the context and the ethos of a particular place, to a particular client, and to particular references, historical or otherwise, that are part of the symbolism of the build-

20. Claude-Nicolas Ledoux. Barrière de La Villette, Paris. 1784–89

ing. Now, this is very hard to teach. It's much easier to say, "Look, the modernist (or whatever) approach is right, and we will teach you a vocabulary that you will conform to." Now, that isn't entirely bad. That's basically the way Mies taught, at a time when there was thought to be somehow one universal method, an ideal way. Whether he would have put it this way, I don't know, but you could say there was an industrial process that had become universal as an aesthetic, and it was appropriate everywhere and we could all do things in the same way.

Well, of course, we now live in a period where there is enormous intercommunication, where we all know each other well, and instead of becoming more alike, we now pride ourselves on becoming more different.

And so an artist has to be taught to be sensitive concerning these things. In relation to this, I think that an artist is best taught by other artists, and what's worrying me a lot is that now they're being taught all too frequently by theorists and academics who are not in the real world of producing buildings. Therefore, the professors are teaching particular ideologies, not architecture. In a way, that is a worse danger than having an artist who, as Mies did, teaches his own personal view, because you can go beyond that view and still say, "Well, okay, that's his method and I'm going to learn it very well." That's usually what happens. You learn your ABC's from the master and then you go on and write great sonnets of your own or you write lousy sonnets, but you somehow relate to that master's vocabulary.

In a sense the ideally prepared artist is one whose sensibilities remain open and sensitive to particular places, times, issues, and then goes from there. Nonetheless, there will be, inevitably, an identifying similarity to each person's work at a particular time. There was the battle of styles in the nineteenth century in London, but you can always identify the decade of any building in that period.

Wrede: Speaking of Mies: I know that in a sense you've always admired Mies's work, but obviously he and his followers served as a kind of foil in *Complexity and Contradiction.*

Venturi: Right.

Wrede: In retrospect, would you see Mies's work perhaps more as an architecture of complexity and contradiction — in terms of the levels of meaning in his work?

Venturi: That's really hard to answer; I haven't thought about it. There's no question that if you were listing the ten great architects of the twentieth century in the West, Mies would be there. Again, it is a question of what I was saying earlier: you admire the work for fulfilling its goals, for its quality, even

if you don't consistently agree with its goals.

Wrede: You once rephrased Mies's "Less is more" when you said "Less is a bore." Today, would you revise your own slogan?

Venturi: No, but I hope someone of today's younger generation will do that appropriately. I have to say no, I would not revise the slogan today because not only should our architectural aesthetic acknowledge complexity and contradiction, but our view of our whole ethos must be tolerant and inclusive.

But actually, I think Mies did better than his famous epigram when he said somewhere that the more of his good ideas he throws out as he designs, the better the project gets. That's being a mature artist. When you're young, you're so proud of your ideas, you can't bear to discard them; you fear you won't have another chance to use them.

Mies was a great universalist architect, and I still have mixed feelings about him. He put me on the wrong track, for instance, along with other people, modernist architects like Bruno Taut and Walter Gropius, concerning Japanese architecture, when he chose to look at Japanese architecture out of its overall visual context, to focus on the great buildings of Kyoto and edit out the elements of the garden, the patterned and richly colored kimonos that complemented it (fig. 21).

Mies had the same impact on how I felt about Schinkel (fig. 22). I did not like Schinkel until I saw his work, because he had been explained by Mies as a goody-goody dry classicist. When I *saw* Schinkel, I discovered he's one of the great mannerist architects of all time.

Aalto is the modernist I connect with the most. I admire Mies. But I love Aalto. But I also didn't particularly love Aalto until I saw his work (fig. 23). This is because previously I had thought of his combinations of ordinary and conventional elements of modern architectural design as clichés.

Wrede: You already observed something that I wanted to talk about. The explicit discussion of meaning and symbolism appears in *Learning from Las Vegas,* whereas the discussion in *Complexity and Contradiction* is more about formal complexities. How did your thinking on symbolism develop? In a sense, why did that appear in the second book?

Venturi: You should ask Denise this question too, about the origins of our "rediscovery" of symbolism revealed in *Learning from Las Vegas,* because she was very much involved. Very simply, *Complexity and Contradiction* was about form in architecture, and *Learning from Las Vegas* was about symbolism derived from looking at commercial signs and saying, "I hate them *and* love them." (In a way, that was my original attitude toward mannerism.) And then, via the symbolism within the commercial strip of Las Vegas as we

21. Chashitsui house for tea ceremony

22. Karl Friedrich Schinkel. Schauspielhaus, Berlin. 1819–21

23. Alvar Aalto. Cultural Center, Wolfsburg, Germany. 1959–62

returned to Rome, we could appreciate the iconography of the buildings there we had admired earlier, as modern-oriented architects, primarily for their formal and spatial characteristics.

So, we began to see in terms of iconography, symbolism, and meaning as we looked again at the statued facade of Amiens (fig. 24), to see it as a billboard to be read as such by its medieval perceivers who could "read" its messages. Naturally Pop art was important at the time too, and other things were in the air as well. For example, Denise will point out that the Independent Group in London in the fifties were also looking at commercial art in relation to fine art and architecture (fig. 25). So in some ways, we were not that much the first. But within my own experience, we were the first to return to the element of symbolism in architecture. Essentially, we learned from looking at highways, from Tom Wolfe,[21] Pop art (fig. 26), and Las Vegas (and Los Angeles). So we went from commercial signs along the Strip back to iconographic buildings in the piazza.

But we explicitly did not try to apply semiotics to architectural symbolism. The too-literal application of one discipline leads usually to pretension more than revelation.

So again we go essentially from the intuitive and the visual to the analytic and the theoretic in our thinking. Most ideas come from the gut, but if you're an architect you cannot work them out so well until you get clients. At the beginning I had little opportunity to build, so despite the above, and because of it, I wrote about my ideas — more for myself than for anyone else.

Wrede: When you discuss your mother's house in *Complexity and Contradiction,* you say a lot about its complexity and contradiction, but you weren't talking about creating a symbol of a house or about the figural image of the front facade.

Venturi: I wasn't. The kind of revelation about its symbolic dimensions came later. There's no question that I talk about the house in essentially formal terms concerning complexity and contradiction.[22] The contradiction between the inside and the outside, for example, which was hard to take at the time. But I was not referring at all to elemental associations and elemental shelter involving the gable-facade, the door, the window, and the chimney. That revelation or interpretation came later, as *Learning from Las Vegas* evolved.[23] I like what happened because an artist should make things that contain dimensions beyond the immediate or original or explicit. I love it when people see things in buildings I've designed that I hadn't seen or originally intended and that I agree with.

I think the idea of architecture as elemental shelter is relevant today, especially when such flamboyant and abstract theories abound almost as a substitute for architecture itself.[24] This idea has been reflected in our work all

24. Amiens Cathedral. 13th century. West facade

25. Richard Hamilton. *Hers Is a Lush Situation.* 1958. Oil, cellulose, metal foil, and collage on panel, 32 x 48" (81.3 x 121.9 cm). Private collection

26. Jasper Johns. *Flag.* West Islip, Universal Limited Art Editions, 1960. Lithograph, 22 1/4 x 30" (56.5 x 76.2 cm). The Museum of Modern Art, New York. Gift of Mr. and Mrs. Armand P. Bartos

along — although it is relatively new in my thinking. Frederick Schwartz is composing a book called *My Mother's House,* with all the sketches and early models now in your collection at the Museum.[25] I think Aldo Rossi and Vincent Scully are contributing essays to the book.

Wrede: In *Learning from Las Vegas,* and I assume both you and Denise wrote this, in the chapter "Theory of Ugly and Ordinary and Related and Contrary Theories," you talk about the architecture that you had done up to then. And you seem to say that you really didn't live up to the ideas in *Complexity and Contradiction.* You wrote:

Let us describe our own experiences as architects to explain how we came to ugly and ordinary architecture. After the appearance of Complexity and Con-tradiction in Architecture, *we began to realize that few of our firm's buildings were complex and contradictory, at least not in their purely architectural qualities of space and structure as opposed to their symbolic content. We had failed to fit into our buildings double-functioning or vestigial elements, circumstantial distor-tions, expedient devices, eventful exceptions, exceptional diagonals, things in things, crowded or contained intricacies, linings or layerings, residual spaces, redundant spaces, ambiguities, inflections, dualities, difficult wholes, or the phe-nomena of both-and. There was little in our work of inclusion, inconsistency, compromise, accommodation, adaptation, superadjacency, equivalence, multiple focus, juxtaposition, or good and bad space.*[26]

Venturi: Well, we were bragging in a way. We were acknowledging that in our buildings at that time, we didn't have much opportunity to involve those kinds of elements because the architectural programs we faced in our archi-tecture were modest and simple (fig. 27). We weren't at that time designing museums or other complex institutional buildings; so we were resisting going against the nature of these programs for the sake of justifying, or in order to justify, our theories: we were being true artists. We were not making of the architecture a vehicle for the ideas.

But it is true also that a lot of complexity came in inadvertently via non-formal elements, symbolism in particular. Sometimes your theory is ahead of your work, and sometimes your work is ahead of your theory; in this case, the work was ahead. The "ordinary" qualities characteristic of Guild House and my mother's house weren't acknowledged in *Complexity and Contradiction,* but they're there. So, in a way, the architecture was ahead, which is better. I wasn't saying it was wrong — not having those things in the buildings.

Wrede: But could one also see that paragraph in *Learning from Las Vegas* as signaling a shift toward a greater concern for symbolism?

Venturi: I would love to have done buildings that had layers of symbolism. For instance, our Sainsbury Wing of the National Gallery in London has layers (although not as eloquent as they should be, for reasons beyond our control). It just happened we didn't have opportunities for layering. Maybe I wasn't explicit enough when I said we were not making buildings as vehicles for theories. First we would design, and then we would check it out and say, "Hey, we didn't use much of this; we didn't use much of that." Or else we would discover we did promote our theories, unconsciously, in our building. My teacher at Princeton, Jean Labatut, referred to "creative forgetfulness." When you work as an artist you forget your predilections, your ideology or theory; and only later you say, "Ah, this really connects with what I've been thinking." An artist leaves his theoretical baggage behind as he works.

27. Venturi and Rauch. Trubeck and Wislocki Houses, Nantucket Island, Massachusetts. 1970

Notes

In the course of his career, Robert Venturi has been a partner in a number of firms bearing his name. In the captions for illustrations of these firms' work, therefore, the following designations appear: in 1958–61, the firm was known as Venturi, Cope and Lippincott; 1961–64, Venturi and Short; 1964–80, Venturi and Rauch; 1980–89, Venturi, Rauch and Scott Brown. Since 1989, the firm has been known as Venturi, Scott Brown and Associates.

This interview was conducted in January 1991.

1. Robert Venturi was an associate professor of architecture at the University of Pennsylvania from 1957 to 1965.

2. Mr. Venturi received his AB degree, summa cum laude, in 1947, and his MFA in 1950.

3. Siegfried Giedion, *Space, Time, Architecture* (Cambridge, Mass.: Harvard University Press, 1944), part 1. For Venturi's discussion of this issue, see Robert Venturi, Denise Scott Brown, and Steven Izenour, *Learning from Las Vegas* (1972; rpt., Cambridge, Mass., and London: MIT Press, 1989), p. 104.

4. Mr. Venturi was the Charlotte Shepherd Davenport Professor of Architecture at Yale from 1966 to 1970.

5. On Venturi's learning from Eliot and Empson, see *Complexity and Contradiction in Architecture* (1966; 2nd ed., New York: The Museum of Modern Art, 1977), pp. 13, 20–23, 43.

6. Ibid., p. 16.

7. "It is a question of building which is at the root of the social unrest of to-day: architecture or revolution" (Le Corbusier, "Architecture or Revolution," a section of his *Towards a New Architecture* [1927; rpt., New York: Praeger, 1960], pp. 13–14).

8. *Complexity and Contradiction in Architecture,* pp. 104–05.

9. Ibid., p. 54.

10. Ibid., pp. 14–15.

11. See "Appendix: On Design Review Boards and Fine Arts Commissions," in *Learning from Las Vegas.*

12. Denise Scott Brown, "The Teaching of Architectural History," *Arts and Architecture,* 84 (May 1967), p. 30; and "Urban Structuring," *Architectural Design,* January 1968, p. 7.

13. "Context in Architectural Composition: A Chapel for the Episcopal Academy, Merion, Pa., 1950" (submitted in partial fulfillment of the requirements for a Master of Fine Arts degree, Department of Architecture, Princeton University). The only known copy of the thesis is now lost.

14. *Complexity and Contradiction in Architecture,* pp. 34, 58–59.

15. See *Learning from Las Vegas,* p. 128.

16. Denise Scott Brown, "On Pop Art, Permissiveness and Planning," *Journal of the American Institute of Planners,* 35 (May 1969), pp. 184–86 (reprinted in *Architectural Yearbook,* 13 [1971], pp. 63–64); and "Learning from Pop," *Casabella,* nos. 389–390 (May–June 1970), pp. 14–46 (reprinted in *Journal of Popular Culture,* 7 [Fall 1973], pp. 387–401).

17. *Learning from Las Vegas,* pp. 90–103.

18. "Pennsylvania Clinic," *The Architectural Forum,* 119 (October 1963), p. 17.

19. Quoted in *Complexity and Contradiction in Architecture,* pp. 13–14, from remarks originally published in *Perspecta 6: The Yale Architectural Journal* (1960), p. 3.

20. "Diversity, Relevance and Representation in Historicism," *Architectural Record,* 170 (June 1982), pp. 114–19, the text of a talk given by Venturi at the Graduate School of Design, Harvard University, April 15, 1982, as that year's Walter Gropius Lecture (a series established in 1958, on the occasion of Gropius's seventy-fifth birthday).

21. See Tom Wolfe, *The Kandy-Colored Tangerine-Flake Streamline Baby* (New York: Noonday Press, 1966), p. 8; cited in *Learning from Las Vegas,* p. 52.

22. *Complexity and Contradiction in Architecture,* pp. 118–21.

23. See *Learning from Las Vegas,* pp. 90–93, 100–03.

24. For Venturi's writing on elemental shelter, see "Architecture as Shelter with Decoration on It, and a Plea for a Symbolism of the Ordinary in Architecture," *Architecture and Urbanism,* 1 (January 1978), pp. 3–14; also in *L'Architecture d'aujourd'hui,* no. 197 (June 1978), pp. 7–8.

25. Forthcoming from Rizzoli International Publications, New York.

26. *Learning from Las Vegas,* p. 128.

1. Montgomery Clift in *Wild River*

Elia Kazan's *Wild River*

Charles Silver

Elia Kazan's *Wild River* is a film about the Tennessee Valley Authority's efforts to remove an aged matriarch, Ella Garth (played by Jo Van Fleet), from her family's island, which is about to be inundated in the name of progress.* The TVA is building a dam to control the frequent floods along the Tennessee River and provide electrical power to the region. The Authority sends Chuck Glover (played by Montgomery Clift) to persuade the stubborn Ella to leave, but after the long struggle that the film presents, he is finally reduced to the use of force to evict her. During the course of the film, not only the conflict between these characters but significant aspects of film history, of Kazan's career as a director, and of America at the beginning of the 1960s all come into play. Together, they give *Wild River* a unique resonance and a central place in Kazan's work.

Wild River was released in the spring of 1960. The Eisenhower era, which had officially certified bipartisan approval of much of the New Deal, was coming to an end. The political witch-hunts of the fifties were dying down, now barely smoldering in the ashes of the "witches" and of some of the hunters. At the same time, a young scion of New Deal aristocracy, John F. Kennedy, was campaigning for the Democratic presidential nomination. The country was ripe for change, but did not anticipate that the coming decade would shatter it as no other since the sixties of the previous century.

The cinema, too, was changing. The studio system was falling apart; its censorship code (a coincidental contemporary of the TVA) was being challenged; and such Hollywood titans as John Ford and Howard Hawks, nearing the end of their long careers, would mark the passage of time with elegiac masterpieces like *The Man Who Shot Liberty Valance* (1962) and *El Dorado* (1967). The classic cinema was starting a descent into the largely frivolous, uninspiring output of the seventies and eighties. Within filmmaking, *Wild River* was, even in 1960, a throwback to better and gentler times.

In April 1933, Congress had given legislative birth to the Tennessee Valley Authority. The confluence of particularly destructive flooding in 1932 and the Roosevelt electoral landslide of the same year had produced circumstances in which government action could be taken to confront an historic problem affecting seven Southern states. The TVA was mandated to build twenty-two flood-control dams for the dual purposes of stopping the erosion

*A synopsis and credits for *Wild River* appear at the end of this article.

of topsoil and providing cheap electrical power to the citizens of the region.

The monumental achievements of the Authority had been chronicled in such documentary films as *TVA* (a chapter in RKO's *This Is America* series) in 1948 and *TVA Town* (produced by the United States Army) in 1951. Like the ersatz newsreel at the beginning of *Wild River,* both of these films start by showing the ravages of the uncontrolled Tennessee River destroying property and lives and washing away "the essence of fertility," the precious topsoil made vulnerable by generations of planting row crops of cotton and corn. Both films argue persuasively that the TVA (with its motto, "Built for the People") had raised living standards by providing possibilities for alternative crops and industries (wheat, lumber, livestock, chemicals); by supplying inexpensive (but characterless) bungalows; by creating malaria-free lakes for recreation; and by ensuring commercial viability for isolated towns through the new navigability of the river.

Like some technological tunnel-of-love ride at Epcot Center, both documentaries extol Progress: the TVA's application of the "tools of science" to rescue puny man from the primeval maelstrom. *TVA Town* concludes with the annual pilgrimage of Decatur, Alabama, schoolchildren to their local dam, an almost religious procession to a shrine of concrete and steel, as the narrator dramatically announces: "We have tried to show them the truth!" Earlier in this same film, however, before TVA's "triumph," a citizen of Decatur had asked the question that Ella Garth would raise in *Wild River:* "At what cost to our way of life?" The United States Army left this unanswered.

Both of these films owe much to Pare Lorentz's *The River* (fig. 2), produced by the Farm Security Administration in 1937. Arguably the best propaganda documentary made in this country, *The River* is ostensibly a history of the Mississippi. A collaborative effort, it relies heavily on a stirring score by Virgil Thomson synchronized with superb film editing. The film is vividly photographed by Floyd Crosby, who had begun his career shooting F. W. Murnau's exquisite *Tabu* (fig. 3) in the South Seas, and Willard Van Dyke, who went on to direct numerous creditable documentaries before serving as director of the Department of Film at The Museum of Modern Art between 1965 and 1973.

The River, with its rhythmic aural and visual cadences, approaches genuine poetry in its evocation of nature and American mythology. It ends somewhat anticlimactically with a desultory paean to the TVA's "truth" and model for the

2. *The River.* **1937. Pare Lorentz**

future. Like *TVA Town,* it too does not answer Ella Garth's question.

The lives of folks like Ella Garth and her kith and her tenants had been photographically authenticated by Margaret Bourke-White (in *You Have Seen Their Faces;* see fig. 4), Walker Evans (in *Let Us Now Praise Famous Men*), and Eudora Welty.[1] The faces of the region, which we have indeed seen, both black and white, were to be a regular feature of television news throughout the 1960s. Even as *Wild River* went into production, the Civil Rights movement was already realizing Ella Garth's fears of the end of white dominance over blacks. By undermining the barriers of job discrimination and segregation through its hiring policies, the Authority had acted as a catalyst to the gradual development of the movement toward racial equality. Famous men, Orval Faubus and George Wallace, James Meredith and Martin Luther King, Jr., were riding the political torrent of rough waters that the TVA had helped to unleash. The events of the 1960s were to provide a partial answer to Ella Garth's question.

The credits for *Wild River* indicate that Paul Osborn's screenplay is indebted to two novelistic sources: William Bradford Huie's *Mud on the Stars* and Borden Deal's *Dunbar's Cove.*[2] Little of consequence in the latter book found its way into Osborn's script or Kazan's film. The novel at times appears to aspire to be a *Moby-Dick* of dam building. There are long descriptive passages on the subject, substituting for Melville's epic digressions into the history and methodology of whaling. What the film does borrow from Deal is the assertion of the monumentality of the TVA's effect on the South. Characters proclaim, "This river is to be tamed and civilized as no other river in the history of civilization," and "TVA is going to do more for this country than God ever did." Clearly, these lines are echoes of the Army documentary's proclamation from its dam (Sinai transported to Alabama): "We have tried to show

3. *Tabu.* 1931. F. W. Murnau and Robert Flaherty

them the truth!" But although some of *Wild River*'s plot elements are adapted from Deal's novel, all that makes the film worthy springs from other sources: Huie's novel and, primarily, the talent and imagination of the film's director.

The Huie elements in the film are derived from the first half of his *Mud on the Stars,* and he must receive due credit for the depiction of Ella Garth. Huie provides a detailed Garth family history as it relates to the island over two centuries. Ella, in the novel, is a Civil War widow who is allowed to speak at greater length than in the film: "I know we were right. This part of the world was ours. Our folks had fought and died for it, and it was no goddam

Left:
4. Margaret Bourke-White. *Okefenokee Swamp, Georgia,* from Bourke-White and Erskine Caldwell, *You Have Seen Their Faces,* 1937

Right:
5. Montgomery Clift and Lee Remick in *Wild River*

Yankee's business what we did down here. . . . You see the land and the river. Well . . . that's all in God's world we've got." Huie's narrator describes her, much as she appears in Jo Van Fleet's portrayal in the film, with a pipe and a walking stick: "As we walked down the path I thought that she would have made a great actress. She had more fire and energy than ten average women, and she knew how to time an entrance."

The film softens Ella's image regarding her relations with her black tenant farmers. Huie presents her as a stern overseer making impassioned speeches about hard work: "She'd lay on a verbal lashing that'd make Simon Legree's efforts appear weak and ineffectual." She shouts, "The Gover'mint is a comin'!" when the men are being hired away, and she tells them as they leave her: "Now you deserters get the hell offa Garth land, an' if you or any of your children ever put a foot back on it, I'll have ya shot like I would a belly-crawlin' blacksnake."

Huie's vision of the backwardness of rural Alabama is more graphic than anything in the film. It is a land devoid of running water, indoor toilets, and, of course, electricity. Politics is the domain of "Yaller Dawg Democrats."

Kazan's version of Garth Island is smaller than Huie's, but the scene of the departing black tenants ferrying their wagons full of meager belongings is derived from the novel. Huie compares it to a Hollywood rendition of the Israelites crossing the Red Sea. The cemetery is in the book, as is the final image of the film as the island is all but submerged, the Garth world "covered by cool, clear, clean Government water."

Mostly, though, it is for Ella that the filmmakers are in Huie's debt. In the book, she is never forced from the island, but simply dies shortly after the "deserters" leave and is buried in the island's cemetery. Huie's final eloquent testimony is:

She believed that, by and large, the strong will always be the custodians of the earth, and that the concern of the weak should be to seek out the strongest and most desirable masters. . . . And above all . . . she believed in the Land . . . as a way of life [emphasis added]. . . . She had lived too long. Bodies as old as hers don't bend in the wind; they only break.

Elia Kazan was and is highly conscious of the filmmakers who preceded him and has fashioned for himself a pantheon of personal mentors whose work he particularly respects. He has often spoken of them:

Why did old man Flaherty and his Mrs. spend at least a year in an environment before they exposed a foot of negative? [3]

When I was young, I admired . . . most of all Dovzhenko. He was my God. [4]

Jean Renoir's famous phrase, "Everyone has his reasons," was true here. Both sides were "right." [5]

I was eager to have a long talk with Ford (Jack Ford, whom I admired as much as I did any American director). I . . . asked him how he got his ideas about how to stage a scene. "From the set," he said. . . . "Get out on the location early in the morning . . . before anyone else is there. Walk around and see what you've got. . . . Tell it with pictures. Forget the words." [6]

The very same success as a stage director which had paved Elia Kazan's road to Hollywood left him ill-equipped to meet the visual measure of such masters as Dovzhenko and Ford. Although, for example, Kazan cannot be personally blamed for the back-projection prairies of his second film, *Sea of Grass* (1947), much of his early work was cinematically uninspired. *Gentleman's Agreement,* which won a cornucopia of Oscars for its noble intentions, pales before other films of 1947 like Ford's minor *The Fugitive,* King Vidor's *Duel in the Sun,* or Raoul Walsh's *Pursued.* These were intuitive men who had spent their youth working in the silent cinema, learning by doing. For Kazan, the New York intellectual, it would take years before his pictorial sense reached fruition in *Wild River* — before he could "tell it with pictures."

Robert Flaherty, the director of such poetic anthropological works as *Nanook of the North* (1920) and *Man of Aran* (1934), did, indeed, uproot his family in preparation for his films to immerse himself in the life and locale of his projects. By 1960, half of Kazan's pictures had been set in the American

South, and he had a youthful experience of bumming through the region. In those films, he had traveled from urban New Orleans (*Panic in the Streets,* 1950) to that New Orleans which existed only as a figment of Tennessee Williams's imagination (*A Streetcar Named Desire,* 1951). Another of Kazan's Southern films was *Pinky* (1949), a racial problem picture on which he replaced an ill John Ford. In none of his earlier films, however, had Kazan captured the pace and texture of the South nearly so well as he does in *Wild River.* Whatever else it is, this film feels authentic and natural, real and true. As he told *Cahiers-du-cinéma:*

Wild River . . . *was shot where it should be, in Tennessee. And the river was there, and the trees were there, the fruit was there, and the people were there. Everything stimulated me and . . . each day we extracted some material from all that was there.*[7]

This aspect of the film also links it to Aleksandr Dovzhenko, the bard of the Russian soil, whose *Earth* (1930) was so resplendently evocative of nature and the peasantry that Stalin's functionaries found it counter-revolutionary. At last, *Wild River* afforded Kazan a subject and a location with which to redeem his faith in the credos of Flaherty and Dovzhenko, in their standards of authenticity.

As the phrase he quoted from Jean Renoir might remind us, moral ambivalence had been a hallmark of Kazan's best work, most notably in Marlon Brando's character in *On the Waterfront* (1954). And in *Wild River,* the fact of Chuck Glover, confronted by Ella Garth's question — "At what cost to our way of life?" — presented the director with a legitimately Renoirian dilemma. Indeed, both did have their reasons; both Ella and Chuck had moral standing.

Kazan's autobiography, *A Life,* is painfully direct on the question of subtly shifting, subjective moral viewpoints. On both the matters of "cheating" on his wife ("duplicity had become my way of life")[8] and of naming names before the House Un-American Activities Committee in 1952, he has been brazenly honest in his revelations and elusive in his rationale. Ultimately, he contends that each individual must make his or her own ethical choices through a complex process of evaluating their own unique experience. As in Renoir, there are no moral absolutes, and no other person is fit to pass judgment. Chuck and Ella are thus both right on their own terms, just as Renoir's characters in *Rules of the Game* are right, regardless of the negative consequences of their behavior. With reference to *Wild River,* the British critic Robin Wood has called this "a finely balanced and defined complexity of attitude, an extreme emotional delicacy, a corresponding *absence* of rhetoric."[9]

Kazan had been politically engaged since his Group Theatre days in the 1930s. He had passed in and out of the Communist Party — the reason, of course, for his HUAC problems. Whatever his critics may think, he remains a

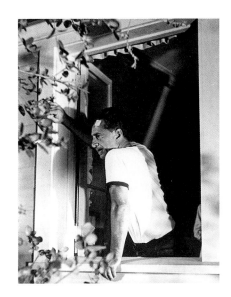

6. Elia Kazan

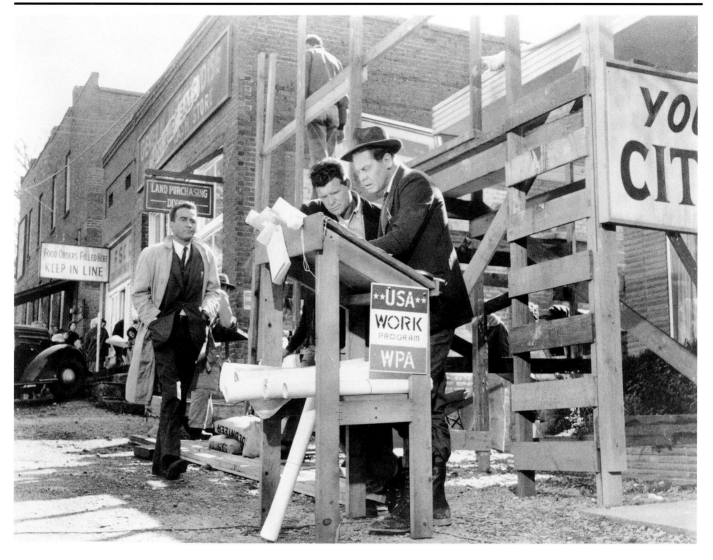

7. Montgomery Clift and Frank Overton (right) in *Wild River*. (All remaining illustrations are from the film)

committed liberal to this day. In *A Life*, he confessed to a conflict of feelings regarding *Wild River*:

In talking to him [Paul Osborn], I soon discovered an astonishing thing: I'd switched sides. I'd conceived of this film years before as an homage to the spirit of FDR; my hero was to be a resolute New Dealer engaged in the difficult task of convincing "reactionary" country people that it was necessary, in the name of the public good, for them to move off their land and allow themselves to be relocated. Now I found my sympathies were with the obdurate old lady who lived on the island . . . I was all for her. Something more than the shreds of my liberal ideology was at work now, something truer, perhaps, and certainly stronger. . . . The way the reversal in the film's central emotion was carried out illustrates how drastically a director can change the meaning of a story he's chosen to tell.[10]

What Kazan is getting at in this last sentence is illustrated in many works by one of his masters — John Ford. When Kazan speaks of "the film's

central emotion," he is suggesting a process whereby Ella Garth becomes a kind of icon, whereby she is mythologized. In Ford's *The Searchers* (1956), John Wayne's Ethan Edwards is a distinctly disagreeable man, cynical and overbearing (a character much like the one Ford himself affected in real life). On paper, the script is definitely stacked against him. Yet, in the film, thanks to Ford's direction and Wayne's emotionally complex and resonant performance, he emerges as a figure of heroic stature, evoking an intricate set of feelings.

Similarly, while our intellect, reflecting on the facts presented by the screenplay of *Wild River*, knows that Ella Garth is wrong, our heart is so moved by Jo Van Fleet's sympathetic embodiment of this narrow-minded old woman that we, too, wind up having "switched sides." Such is the mystic and mythic power of movies to pull us into their grasp. We are drawn to what our *feelings* tell us is authentic — Ethan Edwards, Ella Garth — to, as Kazan says, "something truer . . . and stronger."

Kazan, of course, had long since established himself as a first-rate director of actors on both stage and screen. What was different in *Wild River* was the lower key, the lack of even momentary histrionics, the simpler truth. What was different was the product of a maturation process that finally enabled him to transcend mere craftsmanship, and become an artist.

8. Jo Van Fleet as Ella Garth with the tenant farmers

Direction, finally, is the exertion of your will over people.[11]

Wild River, like virtually all other sound films, started with a screenplay. It was written by Paul Osborn, a man of taste and competence. It is not the screenplay, however, which makes *Wild River* a special film.

9. Montgomery Clift and Lee Remick

When Robert Flaherty and F. W. Murnau had a falling-out during the preproduction period of *Tabu,* they agreed that Murnau would receive credit for directing the film, which turned out to be his last. Flaherty left the project, but he received screen credit for having "told" *Tabu.* In a variation on this, Kazan said in 1990, "The director *tells* the film, using a vocabulary the lesser part of which is an arrangement of words. . . . We learn to feel for the skeleton under the skin of words."[12] Citing Meyerhold as his mentor, Kazan goes on to say the director must "appreciate non-verbal possibilities" and know "that beneath the surface of his screenplay there is a subtext, a calendar of intentions and feelings and inner events."[13] It is, in part, the application of these principles which makes *Wild River* such an extraordinary experience.

Control is an important element in the art of film direction. The conventional wisdom is that greater control can be exercised in the artificial environment afforded by a studio, rather than submitting to the vagaries of a location. In the old days, wily directors like Ford and King Vidor had preferred location shooting as a simple means of evading control and interference by the producer. In the case of *Wild River,* Kazan, for only the second time in his career, was his own producer. (The first instance, *A Face in the Crowd,* 1957, whatever its virtues, might have benefited from some outside, moderating influence.) As both producer and director, Kazan could blame no one else for any of *Wild River*'s failings. As he says in his discourse "On What Makes a Director": "The final limitation and the most terrible one is limitation of his own talent."[14]

Elia Kazan was totally in control in the Tennessee countryside. He shaped this milieu brilliantly to capture the textures of this period and its people with his widescreen lens. There are, of course, the requisite superficial touches like FDR portraits and NRA signs. More important is the citizenry. The mayor, who doubles as the town barber, tells Glover that he cannot hire blacks for his project and, most certainly, not at the same wage as whites (a wage policy that, ironically, had changed little since Lincoln recruited freedmen for his Grand Army).

Ella Garth treats the blacks with maternalistic condescension, telling them they are free to get "relieved" by the government, if they see fit to leave her island domain. The choice is framed by her as having electricity put in place of their souls. Only Ben (played by Robert Earl Jones, father of James) is recognized by her as a figure of sufficient dignity and independence to be worthy of particular respect.

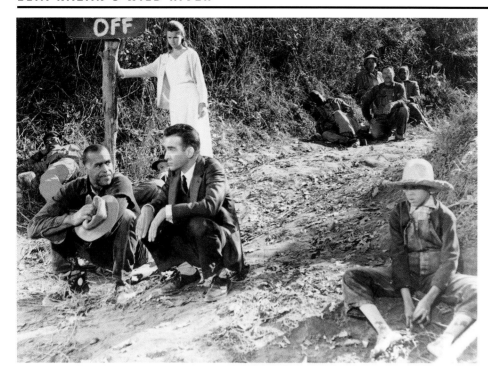

10. Robert Earl Jones, Lee Remick, and Montgomery Clift

If the black characters are pictured as abjectly ignorant, the peripheral white characters are also lacking in culture, as well as moral stature. Little old ladies sit around the hotel lobby and listen to the radio. The common men are rednecks, spoiling for a fight, and the self-designated responsible business leaders are blatant racists. Kazan knows and we know that time and the TVA will eventually change much of this, but his vision of 1934 Tennessee seems unflinchingly true.

Kazan, the actor become director, also understands that the most crucial test of a director's control of his medium turns on the performances he is able to coax out of those on the far side of the camera:

The director, that miserable son of a bitch. . . . There is something of himself, after all, in every character he properly creates. He understands people truly through understanding himself truly. . . . Some directors . . . still fear actors instead of embracing them as comrades in a task.[15]

Kazan has devoted a substantial part of his life to such coaxing and is most appreciative of the rare privileged moments acting can provide. Commenting on great performances that have lived on in his memory, Kazan suggests that these actors (Garbo, Brando, Walter Huston, Lee J. Cobb, and Takashi Shimura, among others) "gave you pieces of their lives. . . . You were the witness to a final intimacy . . . they gave you the genuine thing, the thing that hurt you as it thrilled you. . . . When that happens, your own life has grown."[16] In *Wild River*, Montgomery Clift, Jo Van Fleet, and Lee Remick each give us genuine "pieces of their lives."

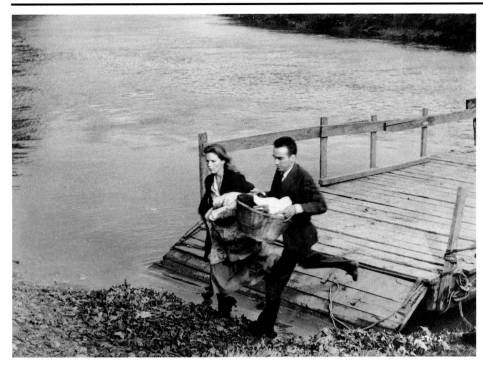

11. Montgomery Clift and Lee Remick

There are essentially two interwoven dramas in *Wild River* — Chuck Glover's efforts to remove Ella Garth from her island and the romance between Chuck and Ella's granddaughter, Carol (played by Remick). This second story has no real counterpart in either of the books on which Paul Osborn based his screenplay, and the story, as told by Kazan on screen, transcends Osborn's writing. It is arguably the best and most deeply felt work Elia Kazan has ever done.

Although there are visually stirring passages in *Wild River,* its greatest virtues spring from the fullest flowering of Kazan's outstanding gift of sensitivity to actors. His true *métier* is not spectacle in the Dovzhenko or John Ford sense, but the more intimate fireworks sparked by two souls adroitly rubbed together.

Sixteen years earlier, he had directed Montgomery Clift in the original stage production of Thornton Wilder's *The Skin of Our Teeth.* Kazan recalled him as an insecure boy who had temporarily adopted the director's wife, Molly Kazan, as a surrogate mother. In the intervening period, Clift had gone on to become a major romantic star, before suffering an automobile accident in 1957 which altered his appearance. Biographers have later revealed that Clift was gay and have also suggested feelings of sexual inadequacy which contributed to his alcoholism. By the time of *Wild River,* Kazan says, he "was a tenderhearted shell of a man" who "didn't look like Monty Clift anymore."[17]

In Clift's scenes with both Remick and Van Fleet, Kazan used his fragility ("the accident of personality")[18] to create a characterization rooted in vulnerability and tentative masculinity. As the director puts it: "Monty seemed sexu-

ally uncertain. He was."[19] Kazan had extracted from Clift a piece of his life.

Turning down for the part of Carol his former lover Marilyn Monroe, Kazan chose instead his discovery from *A Face in the Crowd* of three years earlier, Lee Remick. Possessing a quiescently lyrical beauty and a "confident sense of her own worth,"[20] Remick was perfect for the role of a sexually aggressive young widow and mother, striving for self-definition outside the sensibilities of Garth Island.

Remick's is a magnificent performance. Her Carol is appropriately devoid of glamor, but Remick had luminously sensual eyes. Kazan has his camera linger over them and the quivering textures of her face. She is subtly expressive of an almost animal sexual hunger barely held in check by a fear reflective of past pain and of that which is likely still to come. She accuses Chuck of being a romantic (he tells her not to marry a man she doesn't love), but she is the greatest romantic in Kazan's cinema. She knows that Chuck is there only for the business of removing Ella from the island, but her heart and her naked need will the relationship into reality. She is simple and direct, and her love is pure and without conditions.

Kazan lovingly photographs the sequence of Carol taking Chuck across the river, singing hauntingly, "And he walked with me, and he talked with me . . . the joy we shared, none other has ever known." With this as instrumental refrain on the soundtrack, she takes him to the cottage she briefly shared with her husband, its rooms now covered with faded leaves that have blown in through a broken window. It was here that she had a life and dignity of her own, free of Ella and her island. It was here that she had known love and pas-

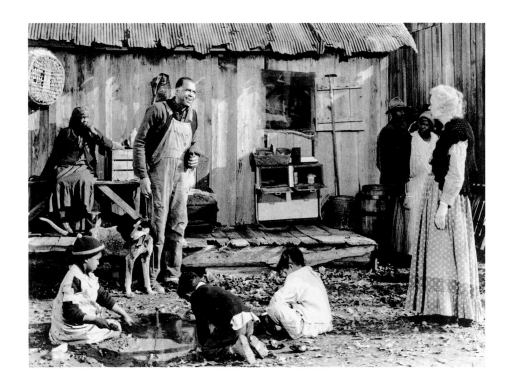

12. Robert Earl Jones and Jo Van Fleet

sion. It is here, now, that she seduces Chuck, and then returns alone to the island, singing as she ferries through the river's mist.

Kazan's cinema, famous for its grittiness and its *Sturm und Drang* of overstatement, has been transfigured for a few tender moments into a cinema of the most poignant and delicate poetry. At least one reel has been touched by the spirit of Renoir's *A Day in the Country* and Ford's *Young Mr. Lincoln,* and Lee Remick has given us a piece of her life.

Jo Van Fleet was only thirty-seven when she played the ancient Ella Garth. Kazan expresses his admiration for her submitting to the demands of the role:

Jo would barge into the makeup room at 4 a.m. and give five hours to transforming herself into an indomitable backwater matriarch. . . . She was the proof of the advantage of having a fine character actress much younger than the role she plays. Jo's emotions had the intensity that generally passes as youth passes.[21]

In the central, public drama of *Wild River,* Ella Garth's unyielding intensity overwhelms the polite hesitancy of Chuck Glover. While her granddaughter forces herself upon him physically, Ella holds Chuck at bay, displaying an acceptance of his humanity only after he shows up and passes out in the middle of a night of drunken desperation to which she has driven him: "First and only time I ever liked you." He wears a three-piece suit, symbol of authority and imposed order. Ella "likes things runnin' wild." He represents the TVA's intent to use "the tools of science," not just to change the course of the river, but to change the course of history. Ella "ain't a-goin' against nature."

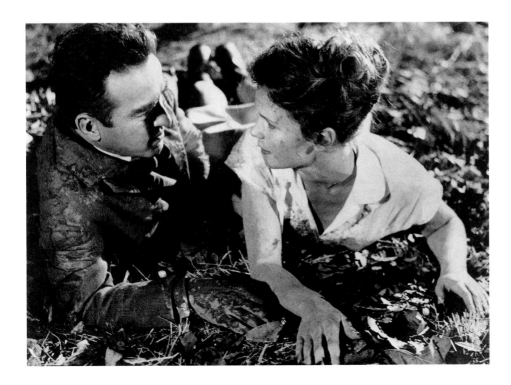

13. Montgomery Clift and Lee Remick

Finally, Washington directs Chuck to use force to evict Ella from the island that is her way of life. Ultimately, in spite of Chuck's efforts to conquer her will while still preserving her dignity, she triumphs over him and the TVA by willing her own death. She has given Carol sixteen cents to pay off a debt. "That's all I owe anybody!" Van Fleet's immutable stoicism on Ella's final day is extraordinarily poignant.

Kazan will not let Chuck or us off so easily. For Ella Garth, there is no shred of compromise. Van Fleet plays not for pity, but for respect. Her time is the past, but, as in John Ford, that time compares favorably with the present. She is not parted from the land for long. She is brought back to the island cemetery for burial, but, again as in Ford, the end of physical life is the beginning of life in memory. In Kazan's film, through Van Fleet's vivid performance, Ella survives as a richly delineated legend who hasn't sold her soul for electricity. She has denied and defied the TVA's "truth." As the film ends, Chuck and Carol and her children fly in a small plane over Ella's nearly submerged grave and then on over the great dam. Jo Van Fleet has also given us a piece of her life. As Huie envisioned Ella as "a great actress," Van Fleet, too, "had more fire and energy than ten average women, and she knew how to time an entrance," and her character's exit from life.

Critical reaction to *Wild River,* as was generally true of Kazan's films, flowed over a wide delta of opinion. Jonas Mekas, reviewing it on release, dismissed it as the director's "least successful" film to date.[22] With a quarter-century's hindsight, Dave Kehr called it Kazan's "finest and deepest film."[23] The only serious analysis of *Wild River* (in English) is by Michael Walker.[24]

For Elia Kazan himself it is a clear favorite, surpassed in his affection only by the intensely personal saga of his uncle's immigrant experience, *America, America* (1963).

Kazan had told it with pictures. He was fifty when he made *Wild River;* he is now eighty-two. There is a very real sense in which this film was central to a process within his mind comparable to Ella Garth's paying off "all I owe anybody." *Wild River* helped to liberate him as an artist and reach a stage of maturity where he felt less encumbered by the demands of others. A very healthy selfishness set in, and he began making films of his own choosing and under conditions of greater personal control. He became a successful novelist and wrote a superb and frank autobiography. His private life eventually became more settled, and he outlived most of his political enemies or rebuilt bridges to estranged friends. He appears to have achieved his own Garth Island, and, as he says at the end of *A Life,* "I'm happy — on the whole."[25]

14. The leveling of Garth Island

Wild River. 1960. Twentieth Century–Fox. Produced and Directed by Elia Kazan. Screenplay by Paul Osborn. Based on novels by William Bradford Huie and Borden Deal. Music composed and conducted by Kenyon Hopkins. Director of Photography (CinemaScope): Ellsworth Fredricks. Art Direction: Lyle R. Wheeler, Herman A. Blumenthal. Set Decoration: Walter M. Scott, Joseph Kish. Film Editor: William Reynolds. Costumes designed by Anna Hill Johnstone. Makeup by Ben Nye. Hair Styles by Helen Turpin. Assistant Director: Charles Maguire. Sound: Eugene Grossman, Richard Vorisek. Color by De Luxe. Color Consultant: Leonard Doss.

Cast: Montgomery Clift (Chuck Glover). Lee Remick (Carol). Jo Van Fleet (Ella Garth). Albert Salmi (Hank Bailey). J. C. Flippen (Hamilton Garth). James Westerfield (Cal Garth). Barbara Loden (Betsy Jackson). Frank Overton (Walter Clark). Malcolm Atterbury (Sy Moore). Robert Earl Jones (Ben). Bruce Dern (Jack Roper).

Synopsis

Wild River begins with a "newsreel" showing the devastation caused by the flooding Tennessee River. Chuck Glover (Montgomery Clift) is the third man sent by the Tennessee Valley Authority in Washington to persuade matriarch Ella Garth (Jo Van Fleet) to leave her island, which is soon to be flooded by a dam being built. He retains Betty Jackson (Barbara Loden) as his assistant, who, along with others, warns him of the difficulty of his task.

He visits Ella, is rebuffed by her, then thrown in the river by her sons. He returns to the island the next day and receives an apology and an explanation from Ella of her commitment to the land. Her granddaughter, Carol (Lee Remick), accompanies them to the cemetery where Carol's husband is buried. She goes back with him across the river and takes him to the cottage where she had lived with her husband and their two young children. There, she seduces Chuck.

Returning to his hotel, Chuck is beaten by Hank Bailey (Albert Salmi) for stirring up trouble in the community by offering jobs at equal pay to blacks. Chuck continues his romance with Carol and his unsuccessful efforts to persuade Ella. Walter Clark (Frank Overton), Carol's fiancé, tries to convince Chuck to leave, but the two men become wary friends, get drunk together, and then visit Ella in the middle of the night; Chuck passes out on Ella's doorstep.

As the TVA's efforts gain momentum, the offended townspeople finally corner Chuck, Carol, Walter, and the children in Carol's house. Forcing them outside, Bailey beats up both Chuck and Carol; as both of them lie in the mud, Chuck proposes to her.

The black tenants, except for loyal Ben (Robert Earl Jones), leave the island for new jobs, and Washington sends a federal marshal with Chuck to forcibly evict Ella. The Garth home is burned, and the island is leveled. Ella is taken to a new house on the mainland, but she refuses to enter. Soon afterward, sitting on the front porch, she dies. She is buried on the island.

Chuck, Carol, and the children fly over Ella's grave on what little of the island remains above water. Their plane takes them over the giant dam and then off to Washington.

Biographical Notes

Paul Osborn (1901–1988) had written plays produced on Broadway since 1928. These included *Mornings at Seven, On Borrowed Time,* and *The World of Suzie Wong.* He wrote screenplays for *Madame Curie* (1944), *The Yearling* (1946), *Portrait of Jennie* (1948), *Sayonara* (1957), *South Pacific* (1958), and Kazan's film of John Steinbeck's *East of Eden* (1955).

Montgomery Clift (1920–1966) had been directed by Kazan on the stage. His films include *The Search* (1948), *Red River* (1948), *The Heiress* (1949), *A Place in the Sun* (1951), *I Confess* (1953), *From Here to Eternity* (1953), *Raintree County* (1957), *The Young Lions* (1958), *Lonelyhearts* (1959), *Suddenly Last Summer* (1959), *The Misfits* (1960), *Judgment at Nuremberg* (1961), and *Freud* (1963).

Lee Remick (1935–1991) made her film debut in Kazan's *A Face in the Crowd* (1957). Her other films include *The Long Hot Summer* (1958), *Anatomy of a Murder* (1959), *Experiment in Terror* (1962), *Days of Wine and Roses* (1963), *Baby the Rain Must Fall* (1965), *Sometimes a Great Notion* (1972), *The Europeans* (1979), and *Tribute* (1980). She worked extensively in television.

Jo Van Fleet (b. 1922) had worked on Broadway for a decade before appearing in Kazan's *East of Eden* (1955), for which she received an Oscar as Best Supporting Actress. Her other films include *The Rose Tatoo* (1955), *I'll Cry Tomorrow* (1955), *Cool Hand Luke* (1967), and *The Tenant* (1976).

Barbara Loden (1932–1980) had been directed by Kazan in Arthur Miller's play *After the Fall,* and she also appears in Kazan's *Splendor in the Grass* (1961). They were married in 1967. In 1970, she directed a critically acclaimed film, *Wanda.* Kazan has said in "On What Makes a Director": "The painters of the Italian Renaissance used their mistresses as models for the Madonna, so who can blame a film director for using his girlfriend in a leading role — unless she does a bad job." And so he did, and she didn't.

Notes to the Text

1. See Erskine Caldwell and Margaret Bourke-White, *You Have Seen Their Faces* (New York: Modern Age Books, 1937); James Agee and Walker Evans, *Let Us Now Praise Famous Men* (Boston: Houghton Mifflin Co., 1941); and Eudora Welty, *Photographs* (Jackson, Miss.: University Press of Mississippi, 1989).

2. William Bradford Huie, *Mud on the Stars* (New York: L. B. Fischer, 1942); and Borden Deal, *Dunbar's Cove* (New York: Charles Scribner's Sons, 1957).

3. Elia Kazan, "On What Makes a Director," *DGA Newsletter,* January 1990, p. 9.

4. Elia Kazan, "A Natural Phenomenon" (interview with Michel Delahaye), *Cahiers-du-cinéma in English,* no. 9 (March 1967), p. 34.

5. Elia Kazan, *A Life* (New York: Alfred A. Knopf, 1988), p. 600.

6. Ibid., pp. 254–55.

7. Kazan, "A Natural Phenomenon," p. 34.

9. Robin Wood, "The Kazan Problem," *Movie,* no. 19 (Winter 1971–72), p. 31.

10. Kazan, *A Life,* pp. 596–97.

11. Kazan, "On What Makes a Director," p. 11.

12. Ibid., p. 6.

13. Ibid.

14. Ibid., p. 12.

15. Ibid., pp. 9–12.

16. Kazan, *A Life,* p. 146.

17. Ibid., pp. 597–98.

18. Ibid., p. 599.

19. Ibid.

20. Ibid.

21. Ibid., p. 598.

22. Jonas Mekas, "Movie Journal," *The Village Voice,* June 1, 1960.

23. Dave Kehr, "Critics Choice: *Wild River,*" *The Los Angeles Reader,* January 27, 1984, p. 37.

24. Michael Walker, "Wild River," *Movie,* no. 19 (Winter 1971–72), pp. 24–28.

25. Kazan, *A Life,* p. 825.

Contributors

John Elderfield is Director of the Department of Drawings, Curator in the Department of Painting and Sculpture, and Editor of *Studies in Modern Art.*

Rosalind Krauss was recently appointed Professor of Art History at Columbia University.

Joseph Ruzicka is Research Coordinator for *Studies in Modern Art.*

Charles Silver is Supervisor of the Museum's Film Study Center.

Robert Venturi is a principal in the architectural firm of Venturi, Scott Brown and Associates, in Philadelphia.

Wendy Weitman is Associate Curator in the Department of Prints and Illustrated Books.

Stuart Wrede is Director of the Department of Architecture and Design.

Lynn Zelevansky is Curatorial Assistant in the Department of Painting and Sculpture.

Photograph Credits

Photographs of works of art reproduced in this publication were provided in most cases by the owners or custodians of the works, cited in the captions. The following list, keyed to page numbers, applies to photographs for which an additional acknowledgment is due.

© Archivi Alinari/Art Resource, New York: 145. Rudolph Burckhardt: 51 right, 75 top right, 95 top, 126 lower right. Leo Castelli Gallery, New York: 129 left. Geoffrey Clements: 32, 122 left, 129 right. Ivan Della Tana: 43. Marisa del Re Gallery, New York: 103 left. Film Stills Archive, The Museum of Modern Art, New York: 164, 166, 167, 168 right, 171–77, 179. Foto Marburg/Art Resource, New York: 158 center, 159 top. © 1987 Dick Frank Studio, Inc.: 154. © Gemini G.E.L., Los Angeles: 58, 60 left. Giraudon/Art Resource, New York: 156 bottom right. © Charly Hersovici/ARS, New York: 41 bottom. Jasper Johns: 60 right. Kate Keller, Chief Fine Arts Photographer, The Museum of Modern Art: 25, 26, 46 left and right, 47 left, 49 top left, 50, 51 left, 52 left and right, 95 bottom, 103 right, 116, 124, 139 bottom. Rollin R. LaFrance: 152 left. Life Magazine, © Time Warner Inc.: 168 left. James Mathews: 27, 98 top left, 113 left and right, 114, 115 top and bottom, 137. Robert R. McElroy: 96, 98 bottom right, 99 top and bottom, 101 left, 104. Meritor, Philadelphia: 155 bottom. © 1991 Robert Morris/ARS, New York: 129 left and right. Ugo Mulas: 69 bottom right. © 1990 Hans Namuth: 76 middle. Elizabeth Novick: 106. Douglas M. Parker, Los Angeles: 61. Rolf Peterson: 66, 101 right, 108, 110 left and right, 111 left, top right, and bottom right, 122 bottom right, 151 top right. Eric Pollitzer: 57, 127. G. E. Kidder Smith: 158 bottom. Ezra Stoller, Esto Photographics, New York: 146 bottom. Soichi Sunami: 75 bottom right. Malcolm Varon: 17. Venturi, Scott Brown and Associates, Inc.: 146 top, 147, 149 right, 151 bottom right, 152 left and right, 153 bottom. Walker Art Center, Minneapolis: 38. William Watkins: 147. John Webber Gallery, New York: 30.

Trustees of The Museum of Modern Art

Index of Illustrations